Camille Pissarro

Camille Pissarro, pen and ink self-portrait

KATHLEEN ADLER

Camille Pissarro

a biography

B. T. Batsford Ltd London

To Patrick

First published 1978
Copyright Kathleen Adler 1978

Printed by
J. W. Arrowsmith Ltd. Bristol
for the Publishers B. T. Batsford Ltd
4 Fitzhardinge Street, London W1H 0AH

ISBN 0 7134 3255 1

Contents

Acknowledgements

I would like to express my thanks to Mr John Rewald for his prompt, courteous and helpful responses to requests for information; to Mr John Bensusan-Butt for his revision of my draft of the Pissarro family tree and other information; to Senor Alfredo Boulton for his enthusiasm and readiness to assist; to the Ashmolean Museum, Oxford, for their permission to use the material contained in the Pissarro Gift to the museum; to Mrs Eva Ganneskov for her tireless research in Copenhagen; to Mr Jul. Margolinsky, Librarian, The Jewish Community, Copenhagen; to Miss Enid M. Baa, Director of Libraries and Museums, St Thomas; to Mr Tommy Pissarro; and to Mrs Ulla Neil for her help with translations; as well as the many individuals and institutions who responded to my requests for assistance.

I wish particularly to thank my parents, Hilde and Hugo Adler, and my sister, Susan Horwitz, for their interest and help; Mr Samuel Carr, for his patience; and above all, my husband Patrick, for his moral support and encouragement when I flagged.

Illustrations

Pissarro Family Tree

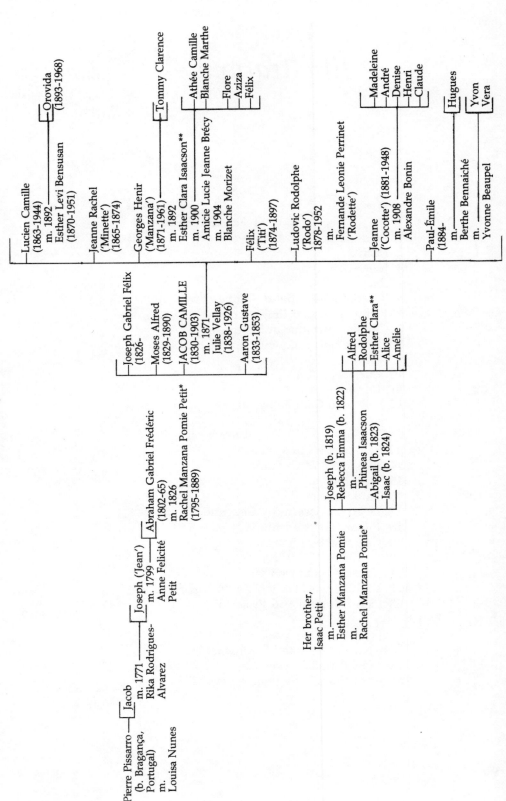

Early Life and Education, 1830–1855

WHEN Christopher Columbus sighted the island he named St Thomas in the West Indies, he marvelled at its beauty and its climate. In the journal of his first voyage in 1493, he wrote that from the entrance to the main harbour of the island, he saw a broad, well-cultivated valley surrounded by mountains so high they seemed to touch the sky, covered by a tangle of verdant growth. It was 'like the month of March in Castille, from the point of view of temperature, and like the month of May, from the point of vegetation'.

Early in the nineteenth century, tales of this tropical paradise, a Danish colony, attracted a family from Bordeaux in France, Joseph (or Jean) Pissarro, his wife Anne Félicité, their young son Abraham Gabriel Frédéric, and Anne Félicité's brother, Isaac Petit. They heard of the prosperity of the island, of the opportunities it offered enterprising settlers, and of its fine climate, and they decided to embark on the long and hazardous sea voyage to this golden land.

The Pissarro family had sought a new home before, for Jean's grandfather, Pierre, was a Sephardic Jew who had been forced to leave Portugal with his wife Louisa, and had settled in Bordeaux, which had a sizeable Jewish population. Jean's mother, Rika Rodriques-Alvarez Pissarro, was also of Sephardic origin. Her family had moved from Gibraltar to Bordeaux.

Conditions were difficult for the family in France and the New World promised to be a sanctuary. Although the number of Jews on St Thomas was small, it was growing steadily, and the first synagogue was built in 1796. Since 1781, the family learned, the Jewish population of St Thomas had increased appreciably, for many of the Jewish traders on the nearby island of St Eustatius had fled there after the destruction of St Eustatius by the British admiral Rodney.

Charlotte Amalie, the capital of St Thomas, was the centre of the slave trade and the sugar industry in the Caribbean, and it attracted people from all over the world. The Pissarros soon settled there, and found that although their expectations of paradise were not fulfilled, life was comfortable and enjoyable. Jean's brother-in-law, Isaac Petit,

met and married a Creole girl, of French extraction, Esther Manzana Pomie, the daughter of Moses and Rebecca Manzana Pomie. Frédéric Pissarro grew up on the island and took over the family business, a trading store at 14 Droningens Gade, one of the main streets of the town. Here he sold fabrics, linen, glassware, and ironmongery, and the family prospered.

His uncle's wife Esther died, and in accordance with Jewish custom, Isaac married her younger sister, Rachel Manzana Pomie, who was born on St Thomas in 1795. They had three children, a boy, Joseph, and two girls, Rebecca Emma and Abigail. While Rachel was pregnant with her fourth child, Isaac died, and the child, a boy, was named Isaac after his father.

To the consternation and dismay of the Jewish community of Charlotte Amalie, Frédéric became involved with his uncle's widow, who was seven years older than he. Rachel fell pregnant, and their first child, a boy named Joseph Gabriel Félix, was born in February 1826.

The marriage of Frédéric and Rachel was opposed by the elders of the Jewish community of St Thomas because it was believed that it infringed two decrees of prohibition of marriage. The first was that of kinship, for although Frédéric and Rachel were not blood relatives, both Jewish and Christian law states that marriage between aunt and nephew is forbidden. (Leviticus 18:14, 'Thou shalt not uncover the nakedness of thy father's brother, thou shalt not approach his wife: she is thine aunt.') Under Jewish law, although such a relationship is forbidden, should the marriage have been contracted it would not require divorce. All the children born of such a union are regarded as illegitimate. The proposed marriage also infringed a decree in Jewish law which states that it is forbidden to marry a pregnant woman or nursing mother until the child has reached the age of 24 months, for the good of the child.

The regulations concerning the marriage were confusing, and the officers of the congregation, President Sarguy, Vice-President Wolff, and Treasurer Pretto felt that they needed the guidance of other authorities. They wrote to the Rabbi of Copenhagen for his opinion before they would consent to sanction the marriage. They told him, 'In September last an application was made to us . . . by Mr Abraham Gabriel Frederick Pissarro for our permission to marry the widow of his mother's brother which we considered to be forbidden by our religious laws . . . Fearing that an application might be made to the Government here, we communicated the circumstances to His Excellency the Governor who replied to our letter, that it was equally prohibited by the Christian religion as it was by ours.'

The Rabbi of Copenhagen agreed with this opinion, and when the

Pissarros themselves sought the judgement of the Rabbi of London, he too informed them that the marriage would be invalid. Similar views were expressed by the Rabbis of Paris and Bordeaux.

Frédéric decided to seek royal sanction for the marriage as a last resort. He wrote to the King of Denmark requesting his approval. The King, unaware of the complexity of the situation, granted his permission.

Frédéric and Rachel were married on 8 September 1826 in spite of the refusal of the synagogue to ratify the marriage. In 1829 a second son, Moses Alfred, was born. Grudgingly, the authorities had to concede that the relationship would continue whether or not they were prepared to recognize it, and when they learned that Rachel was again pregnant, they decided that it would be in the interests of the children to legitimize them.

On 10 July 1830 Rachel gave birth to a third son, who was named Jacob Camille. The birth was entered in the records of the synagogue using the Spanish version of the family name,

> Pizarro, Jacob 1830. In the year 5590 Tammuz 19, corresponding with the 10th July 1830, Jacob Pizarro was born to Abraham Pizarro and Rachel Petit.

The register was subsequently amended and 'Pizarro' was added in parenthesis in pencil after Rachel's name.

Frédéric's and Rachel's third son was born at a time when Charlotte Amalie was booming. The sugar industry, which had been the main factor in the development of the island, was entering a decline, but the town had become a thriving commercial centre, and the great majority of the islanders, who totalled some 14,000, were involved in commerce, especially in shipping. A commentator on life in the West Indies observed that 'the business of the islands was business . . . the islands were not where one really lived, but where one made one's money.'

The population consisted of many nationalities, and Danish, French, English and Spanish were equally frequently used. The native population spoke Spanish, and the traders who made Charlotte Amalie their base, and who represented English, French, German, Italian, Spanish, Danish and American companies slipped readily from one to another of several tongues. The harbour was constantly crowded, serving some 2,550 ships from many different countries of origin yearly, and the merchants were assured of a market.

Like many of the islanders, the Pissarro family retained strong links with Europe, and they regarded France as their spiritual home, although Rachel had been born on the island. They spoke French at

home, and their sons were often told of the wonders to be seen in Paris, and of the primacy of French culture.

The family were fluent in Spanish, which they used constantly in conversing with the native population, and they had some knowledge of English. Although the island was a Danish colony, they did not speak Danish. This was not unusual, for even official documents such as census reports were not written in Danish, but in English.

When Camille was three years old, a fourth son, Aaron Gustave was born, and the Hebrew Congregation finally relented and declared Frédéric's and Rachel's marriage to be a legal one. The lengthy wrangle about the status of the marriage had led to continual tension between the Pissarros and the remainder of the Jewish community, and to their comparative isolation from the community, both because the more conservative of its ranks were outraged by Frédéric's behaviour and would have nothing to do with him, and because the Pissarros themselves proudly asserted the validity of their marriage and refused to be daunted by the opposition they encountered.

As soon as Camille was old enough, he was sent to one of the small private schools in Charlotte Amalie. He showed an interest in drawing and painting which his father viewed with displeasure, regarding these as frivolous pursuits which would distract the child from serious learning. When school was over for the day, Camille and his brothers were required to help in the shop, sorting goods, tidying, running errands, and delivering parcels. The family lived above the shop, which was the centre of their lives.

There were no secondary schools on St Thomas, and rather than have his sons privately tutored, Frédéric decided that they would receive their secondary education in France. He made arrangements for Camille to enter a school in Passy. Frédéric selected Passy because his step-daughter, Rebecca Emma, Rachel's eldest daughter by her first marriage, was living there with her husband Phineas Isaacson, and Camille would not be entirely alone, so far from his home.

In 1842, when Camille was 12 years old, the arrangements for his education were completed, and he left home for France. His father gave him a farewell lecture, telling him that although he would find France very different from St Thomas he was to remember that it was the fairest and richest country in all the world. He was instructed to apply himself to his studies, and to reap the benefits of his stay there.

The voyage was a difficult one, for the sailing ship was becalmed in the middle of the Atlantic for some days, and supplies of food and water had to be severely rationed. The crossing took over a month, and the passengers were forced to eat salt meat at every meal. They arrived in France weakened and exhausted, on the verge of scurvy.

The school to which Pissarro was sent was run by M. Savary; it had been established for some time, for it had been featured in the *Almanach Royal* as an officially recognized school since 1824, the first year that such notices appeared. It was regarded as the best of its kind in Passy, which had four other schools. Pissarro's father warned M. Savary of his son's propensity for drawing, and his dislike of this trait, but fortunately for Pissarro, M. Savary was himself keenly interested in art, and ignored Pissarro *père*'s wish to see this failing eradicated. Instead, he encouraged the boy and instructed him in the basic arts of drawing. Pissarro was homesick, and found it difficult to concentrate on his lessons. He covered the pages of his books with drawings of banana plantations, coconut trees, and riders with Spanish-style hats. M. Savary soon perceived from these drawings that his pupil had exceptional talent.

While the other pupils were set to copy lithographic examples of 'great art' as closely as possible, Pissarro was allowed to select studies from Savary's own studio to work from. Savary was convinced of the importance of drawing from nature, and he laid stress on developing the qualities of observation and perception. Although he believed that there was a correct approach to art, his teaching methods allowed favoured pupils like Pissarro considerable latitude in their approach, and they were encouraged to develop an individual style. The drawing masters who succeeded M. Savary, M. Marelle in 1844 and M. Poncet in the following year, adhered to his ideas, and fostered Pissarro's rapidly developing ability.

Another artist-to-be, the etcher Charles Meryon, had been a pupil at the school eight years before Pissarro's arrival. He was later to describe his liking for the school's situation, for Passy was still in the midst of the open fields, and he said that the school encouraged its pupils to participate in outdoor activities, to aid their physical development. These factors made the transition from life in the tropics easier for Pissarro, and he slowly became accustomed to his new surroundings.

During the school holidays he remained with his relatives in France, and occupied himself with visits to Paris. He wandered fascinated along the *quais* of the Seine, stopping to examine the engravings that were displayed at the print-sellers' stalls round the *Palais-Royal*, and made forays into the Louvre to study the masters there. Gradually the city became more familiar to him, and he enjoyed its many attractions without feeling entirely at ease in it.

In 1847 his father decided that it was time for him to return to St Thomas, and to enter the family business. Pissarro soon revealed to the disappointed Frédéric that his stay in France had not eliminated his liking for drawing. M. Savary had recommended to him that he

remember to draw coconut trees, and he lost no time in putting this injunction to draw from direct observation into practice.

He would spend hours at the harbour, sketching the activity of the port, making quick notations of people walking past who caught his eye, or more elaborate drawings of groups of figures, instead of supervising the unloading of consignments of goods for the store, the task which Frédéric had set him. It soon became clear to his father that he could not rely on this son for help in the business.

Returning to the island was a disquieting experience for Pissarro. When he had left it, he had been too young to question its codes and values, but his years in France were important for his development, and he acquired some knowledge of and interest in the concept of individual rights and freedom. In St Thomas he found a situation where, in spite of the decline of the sugar industry, 'the slave plantation . . . penetrated every aspect of life - economy and politics, religion and family, sexual mores and social relationships - and generated its own pervasive community ethos.' A traveller in the West Indies earlier in the century described the pattern of life there as being 'like a rotten apple', and this was the young Pissarro's view. He could not share his parents' unquestioning acceptance of the values prevailing on the island, and their bourgeois standards became more and more irksome to him as he reacted against his father's stern control and constant insistence on attention to business.

Politically, the island was at a crisis point. Denmark was the first country to abolish the slave trade, in 1803, but it had adopted a policy of gradual emancipation for the slaves. In 1847, the year Pissarro returned from France, the Danish government issued a decree abolishing slavery but proposing to maintain the powers of existing slave owners until 1859. The children born to slaves during this interim period were to be free.

The slaves reacted violently to this plan of protracted emancipation, and on 2 July a slave revolution occurred in the neighbouring island of St Croix. The slaves delivered an ultimatum to the Governor-General: either they were freed by 4 o'clock that afternoon, or they would burn the town of Frederikstad. The governor, who was described as a 'friend of the blacks', capitulated to the slaves' demands with what some of the white settlers regarded as disquieting ease, and he proclaimed the immediate emancipation of all the 'unfree'.

This was announced to the inhabitants of St Thomas on 4 July, with the arrival of the schooner *Vigilant* from St Croix. There were reports that the slaves had stopped work, and were preparing to enter Charlotte Amalie. Special patrols were organized to protect the town from the mob, and the warship *Thunderer* dropped anchor in the harbour to

cover the town. The town was not attacked, but the slaves only returned to work after brutal public whippings. The Governor-General resigned, and returned to Denmark. He was tried on a charge of negligence, but was acquitted. The Emancipation Proclamation was ratified by the Danish government, and calm returned to the islands.

Pissarro was becoming increasingly interested in politics, and was beginning to crystallize his political views. Throughout his life he was to be an ardent supporter of the rights and privileges of the individual, and he saw a callous disregard for such rights in the treatment of the slaves on the island. He was at odds with his parents on many issues, and the idea of entering the family business made him feel restless and unhappy.

He found a new interest in the landscape and vegetation of St Thomas, and made many excursions on foot, exploring his surroundings and sketching what he saw. He was interested in the history of the islands, and read what he could on the subject. In later years, he was to continue to delight in talking about the islands and their history, and his own experiences there to his family. He was never to forget the exotic vegetation of St Thomas, with its white beaches, luxuriant plant growth, and blazing colours. He was to write from Holland in 1894: 'I can say that we really have been tipsy with the local colour, atmosphere and extremely primitive style of this little corner of Holland . . . We went as far as Westcapelle, the extreme point of the island of Walgrave, so abundantly fertile that it reminds me in a way of the islands surrounding St Thomas.'

Pissarro was sketching aspects of the harbour of Charlotte Amalie while ostensibly attending to business matters one day in 1852 when he met a Danish artist, four years older than himself, Frederik Siegfried Georg Melbye, or Fritz. The tall, blond Dane had been travelling in the New World for some time, and he had spent part of the previous year in Venezuela. He was fascinated by the beauty of the tropics, and he went on long walks exploring the places he visited, recording his impressions in sketches and paintings. He was impressed by the liveliness of Pissarro's pencil studies, and praised his efforts. They soon became friends, and went sketching together. Pissarro showed Melbye interesting parts of the island, while Melbye, an established marine and landscape painter, was able to give Pissarro the expert advice and guidance he needed to supplement the limited training he had received at Savary's school.

Melbye had undergone a conventional academic training, but he found that the techniques of the academies did not enable him to render his perceptions of the places he visited and the people he saw satisfactorily. He had developed a rapid method of notation which

15

enabled him to retain the spontaneity and boldness of his first impressions. His finished paintings were usually executed in a more conventional manner. Melbye was curious and enthusiastic about the countries he visited, quick to talk about his experiences, and very willing to impart his knowledge of painting to his young friend. He did so without pedantry or condescension, and Pissarro responded eagerly to this approach. From Melbye he learned how to express the play of light on forms, and how to render the sky and clouds so as to capture the effect of luminosity. He rapidly assimilated all that Melbye could teach him, and began to feel a growing confidence in his own ability.

Melbye encouraged Pissarro's ideas of renouncing the family business and devoting himself to painting. When he decided to return to Venezuela, he persuaded Pissarro to accompany him. In spite of his father's implacable opposition to this plan, Pissarro left St Thomas with Melbye, aboard the French sailing ship *La Caraquena*. They arrived at the port of La Guaira in Venezuela on 12 November 1852, and found lodgings in a *pension* in the town.

They stayed in the small town for a few weeks, exploring their surroundings in long expeditions on foot, and often painting together. Pissarro benefited greatly from his contact with Melbye, and he began to develop a personal approach which was less concerned with fastidious observation of detail than was Melbye's style. He found it challenging to attempt to record the characteristics of the landscape around La Guaira, which was starker and harsher than that of St Thomas.

The pair moved from La Guaira to Caracas in December, and Melbye bought a spacious house there, in the vicinity of the main square. They established a studio together, and worked in close harmony, enjoying each other's company, and finding that their association was beneficial to their work. Pissarro delighted in the liveliness of Caracas, the thronged marketplace, the crowded *tavernas*, and the street musicians. He recorded these scenes in pencil sketches, pen and wash drawings, and water-colours. He was interested in the ornate architecture of the town, and made some careful studies of it.

When he felt the need for solitude, he would pack his rucksack with his pencils and a sketchbook and a few provisions and go for long hikes in the neighbourhood of the city or further afield. He sketched continually, noting the vegetation, the landscape, people at work and at play. His knowledge of Spanish assisted him; people willingly posed for him wherever he went. He returned to La Guaira for a time during 1853, and then spent a few weeks visiting a big coconut plantation.

Melbye was already known to the small but flourishing artistic community of Caracas, who welcomed his return. His young protégé was made equally welcome. To Pissarro, this coterie of intellectuals, writ-

ers, poets, musicians and painters, was the key to a new life. He was fascinated by their far-reaching, impassioned discussions about art and philosophy. Their way of life was a revelation to him, the antithesis of the constant talk of business he had heard at home, and of the narrow values and rigid codes of the people of Charlotte Amalie.

He and Melbye were drawn into the musical activities of Caracas, and belonged to a group of music lovers organized by a Latvian pianist called Kurt de Bohlschwing. Here Pissarro was initiated into an understanding of music, listening to the music of Chopin and of Offenbach. He participated in some of the musical evenings organized by de Bohlschwing. Caracas newspapers reported on a 'Great Venetian Festival with Chorus and Lyrical and Dramatic Scenes', held on 8 December 1853, in which both Pissarro and Melbye played a part, although it is not recorded what instruments they played.

Gradually Pissarro gained the confidence to join in the conversations of the group. He and Melbye would continue the discussions in their shared studio, for both were intensely interested not only in painting but in philosophical concepts. Through these talks, Pissarro felt that his world was opening, revealing previously unconsidered possibilities, and stimulating his work as a painter. Later in his life, group discussion was again to play an important role, and he was always to value it.

His stay in Venezuela clarified many directions for him and indicated to him the manner of working which best suited him. This working method was not to vary throughout his life. He preferred to work mainly in the country, alone or in the company of one or two companions, but he relished the stimulation of contact with many different shades of opinion which he could find only in the city.

While Pissarro was in Venezuela, in 1854, 40,000 slaves were granted their freedom, but they were accorded no political rights or economic opportunities until Monagas's reign was ended by revolution in March 1858. For the second time, Pissarro was made forcibly aware of the hypocrisy involved in dealing with the slaves, and the turbulence of the situation created by their 'freedom' affected him. So too did the structure of society in Venezuela, with its extreme contrasts between rich and poor.

Pissarro decided that he would return to St Thomas in 1854. He sailed on the Danish ship *Isabel* on 12 August, and the local newspaper reported, 'Camilo Pizarro leaves for overseas.' During his stay, he had made up his mind that he would not enter his father's business, but would persevere with painting. He considered this decision carefully, and his life in Venezuela was sufficiently difficult for him to realize the hardships which might result from this choice. Many years later, he

was to refer to it in a letter to his friend Eugène Murer:

'Let Guillaumin think over his position a little . . . He would do miles better to send his City job to blazes. Of course you've got to have a bit of grit in you; there mustn't be any chopping and changing about it. I was at St Thomas in '52 in a well-paid job, but I couldn't stick it. Without more ado I cut the whole thing and bolted to Caracas to get clear of the bondage of bourgeois life. What I have been through you can't imagine, and what I am suffering still is terrible, very much more than when I was young and full of enthusiasm and ardour, convinced as I now am that I have no future to look forward to. Nevertheless it seems to me, if I had to begin over again, I should do precisely the same thing . . .'

Melbye remained in Venezuela, where he continued to live for some years before making his way to the United States. His friendship was important to Pissarro; through it Pissarro had been given some indication of the course his life would take. They parted on friendly terms, but they lost touch with one another and did not see each other again.

Pissarro remained in St Thomas for about a year after his return from Venezuela, sketching and painting continually, refining the lessons he had learned from Melbye, and developing a personal style that had little to do with the accepted conventions of academic teaching. Cézanne was to say in later years that Pissarro 'had had the good fortune to be born in the Antilles; there he learned to draw without a master.' This meant that he did not have to struggle to free himself from the rigid constraints of the approach favoured by the *École des Beaux-Arts*, but he was very aware that his isolation was hampering his development. He realized from his stay in Caracas how vital the interchange of ideas and the availability of constructive criticism was for an artist, and in St Thomas there was nobody with whom he could discuss his work or the concepts which he regarded as important. He was aware, too, that his lack of knowledge of current movements in French art was a hindrance to his growth as a painter.

On his return from Caracas, he had made it clear to his parents that he intended to further his studies as a painter, and that this would necessitate his returning to Paris. Frédéric saw that he was determined, and that no amount of argument would change his mind, and he finally agreed to his son's plans. He himself was considering leaving the West Indies, for business on St Thomas was not as profitable as it had been and future prospects did not appear bright. This made his opposition to Pissarro's departure less resolute than it might otherwise have been. In the autumn of 1855 he set sail from Charlotte Amalie for France, never to return to the West Indies.

Paris, 1855–1860

PISSARRO arrived in Paris in time to see the last three or four days of the Universal Exhibition, which closed in November. The city was crammed with visitors, and the exhibition was a massive and spectacular display. It was intended to impress all who saw it with France's achievements in the realms of commerce and industry and in the field of culture, and to outdo the British exhibition of 1851 held in the Crystal Palace. Pissarro was confronted with an exhibition of more than 5,000 works of art, displayed in a two-storeyed Palace of Fine Arts set apart from the other exhibition areas. More than half the exhibits were French, and he was presented with the entire spectrum of French art, including retrospective exhibitions of the work of Ingres, Delacroix, Decamps and Horace Vernet.

He found that the paintings which attracted him most strongly were not the massive *salon 'machines'*, nor the paintings of Gustave Courbet, rejected by the jury and on view in Courbet's own exhibition pavilion, just outside the entrance to the main display, but the paintings of Camille Corot. Corot showed six paintings, *Souvenir de Marcoussis, Effet de neige, Souvenir d'Italie, Une soirée, Printemps* and *Soir*. Fritz Melbye had suggested to Pissarro that he might find Corot's work interesting, and he immediately sought it out. As Melbye had foreseen, he recognized that his own approach to landscape painting had affinities with Corot's, and Corot's studies of light in the Italian countryside reminded him of the Caribbean. Pissarro determined to visit Corot and to show him his own work.

Although Corot had exhibited at the *salon* for many years, he had only recently begun to receive critical acclaim; the 1855 exhibition was a decisive one for him, bringing him recognition and praise. One of his paintings, *Souvenir de Marcoussis*, attracted the attention of Napoleon III. He spontaneously decided to acquire it, in spite of the opposition to Corot's work expressed by the Director of the Beaux-Arts, Count Nieuwekerke, who accompanied him to the exhibition. Nieuwekerke was furious at the Emperor's decision, and turned to the Marquis of Chennevières, a friend of Corot's and the chief curator of the Louvre in

charge of the *salon*, hissing, 'Well, are you happy? The Emperor is with you!'

Corot wrote to a friend, Dutilleux, on 31 October, about the time when Pissarro saw the exhibition: 'I am fairly satisfied about my exhibition. The critics are unanimous in paying homage to its merit. The small circle of amateurs . . . grows day by day!' One of the critics, Edmond About, wrote of him in his review of the Universal Exhibition, '*Voyage à travers l'Exposition des Beaux-Arts, 1855,*' 'M. Corot is a unique painter, exceptional, and apart from all styles and schools; he does not imitate anything, not even nature, and he is inimitable.'

Pissarro visited Corot's studio with some trepidation, uncertain of the reception he would receive, but eager to obtain advice and guidance. Corot was warm and friendly towards him, and looked at the studies which he had brought with him with interest. He found signs of talent in the work, and greatly encouraged Pissarro by telling him, 'You are an artist . . . and do not have need of advice save this: you must study values . . . ' Since the paintings which Pissarro had shown him were all of the West Indies or of Venezuela, Corot recommended that he go and paint in the surroundings of Paris. He suggested that when Pissarro had some more recent work to show him, he should return to the studio and they would discuss it.

Pissarro was grateful for Corot's concern, but he did not immediately follow his advice. He spent some time acclimatizing himself to Paris, finding that in spite of the knowledge he had gained on his excursions to the city during his school days, it was a strange and difficult place in which to live. He was homesick and lonely, and the city seemed hostile and cold to him. For some months after his arrival, he continued to paint scenes of the West Indies from memory, while he gradually became accustomed to his new surroundings and to the light and coloration of France, so different from that of the tropics.

Fritz Melbye had told him that when he went to Paris, he should contact his eldest brother, Anton, who had been working there since 1847. He had given Pissarro a letter of introduction to his brother, and Pissarro decided to call on Melbye. Anton Melbye received him with great cordiality, as a close friend of Fritz's and as a fellow Danish citizen. He had established himself as a successful landscape and seascape painter in Paris, and had exhibited a vast seascape, *Naval Battle*, at the 1855 exhibition, a painting which had been commissioned by the Danish government. He had recently returned from an expedition to Constantinople, where he had served as an attaché to the Danish ambassador, and had also worked for the Sultan.

In order to assist Pissarro financially, and to provide him with some experience, Melbye suggested that he might like to work for him,

finishing the skies in some of his pictures. Pissarro agreed, and found that this task gave him the opportunity to extend the range of his technical proficiency. Melbye's practical advice was useful to him, for the unorthodoxy of his training had restricted his knowledge of the craft of painting. He found that Anton Melbye shared his brother's ability to advise without appearing to patronize, and although he was employed as Melbye's assistant only for a short time, they remained on cordial terms for many years. When Pissarro first began to submit work to the *salon* in 1859, he designated himself 'Pupil of A. Melbye'; he continued to describe himself this way until 1866, although by that time Melbye had left Paris and contact between the two men had ceased.

Pissarro returned to Corot's studio, and was made welcome. He began to visit Corot frequently, and became one of the group of young painters who gathered around Corot. Corot did not admit pupils for formal tuition, but he enjoyed the company of young artists, and he would discuss his work and ideas with them at great length. Pissarro liked the informality of Corot's approach, shown both in the manner in which his advice was given and in his lack of concern with appearances. He would paint dressed in a blue peasant smock and a striped cotton cap with a tassel, or sometimes in a flannel vest and long pants, and as he worked at his easel he would comment on what he was doing, urging particular attention to certain points, and encouraging his admirers in their own efforts.

Corot was insistent about the importance of values, stressing that the question of values was one which had been applied by the good painters of all epochs. The values are the harmony between two tones, like a musical interval, and by considering each tone in relation to all other tones, harmony could be attained throughout the canvas. Corot did not commence his studies with the sky, but established his picture by working all parts of it simultaneously with patches of tonal values which he considered would create the effect of the motif.

Provided that his protégés retained the necessary respect for values, he did not object to their following different paths from himself. He soon saw that Pissarro's approach differed from his, and said: 'We do not see in the same way; you see green and I see grey and blonde. But that is not a reason for you not to consider values. No matter how one perceives or expresses things, there is no good painting without them.'

Pissarro admired Corot's ability to see beauty in modest and gentle landscapes, without dramatic weather effects or spectacular natural features. He too was developing a preference for quiet, unassuming landscapes which he could study patiently and carefully, rural scenes which were in complete contrast to the brilliantly coloured, exotic landscape of St Thomas. Many years later he was to quote a saying of

Corot's, 'I have only a small flute, but I try to strike the right note', in defence of this preference.

Corot encouraged Pissarro to paint in the open rather than in the studio. With the exception of his memory studies of St Thomas, he had already found this method to be the best approach to landscape painting. In Corot's own work there was a separation between studies made in the open air and finished studio paintings, in which he conformed to some extent to the requirements of the Academy with regard to composition and finish. In spite of this, painting *en plein air* was an essential starting point for him.

Corot was insistent on the importance of drawing, and the necessity for self-discipline. No carelessness or neglect was permitted. Berthe Morisot, later an Impressionist colleague of Pissarro's, for whom Corot had made an exception to his rule of not admitting pupils, recalled that she had been severely reprimanded for omitting a step in a copy she had made of one of Corot's drawings. Corot gave Pissarro a drawing, *Le Martinet near Montpellier*, executed in 1836, which he felt illustrated his conviction that a firm grasp of form, together with close and careful observation of nature, were the essential qualities to strive for.

Pissarro valued Corot's advice. Its effects pervaded his thinking and influenced his ideas to such an extent that an echo of Corot was to be apparent in the advice he in his turn gave to young artists in later years. In 1883 he was to write to his son Lucien: 'The drawing of Turner [of the *Cours de Reine*] seems to be very good; it seems to me that you have not copied it on the spot, you have neglected the trees. If you want to make a good copy, you must do it there. No negligence at the beginning, one becomes accustomed to it too easily!'

Corot's informal instruction provided the kernel of Pissarro's ideas about art, which he added to and amended in the light of personal experience, but did not wholly diverge from. In 1857 Corot wrote:

> 'Be guided solely by feeling. Only, being mere mortals, we are prone to error; listen to comments; but follow only those you understand, and which fuse with your own feeling. - Firmness: docility - follow your convictions. It is better to be nothing than to be the echo of other painters. As the sage observed, when one follows anybody, one is always behind. Beauty in art is truth steeped in the impression made upon us by the sight of nature. I am struck on seeing some place or other. While seeking conscious imitation, I do not for an instant lose the emotion that first gripped me. Reality forms part of art, feeling completes it. In nature seek first of all for form; then for the values or relationships between tints, for colour and style; and the whole must obey the feeling you have had . . .'

In 1890, Pissarro was to give a young painter this advice:

'Look for the kind of nature that suits your temperament. . . . Paint the essential character of things, try to convey by any means whatever, without bothering about technique. When painting, make a choice of subject, see what is lying at the left and at the right, then work on everything simultaneously. Don't work bit by bit, paint everything at once by placing tones everywhere, with brushstrokes of the right colour and value, while noticing what is alongside . . . Cover the canvas at first go, then work at it until you can see nothing more to add . . . Don't proceed according to rules and principles, but paint what you observe and feel. Paint generously and unhesitatingly, for it is best not to lose the first impression. Don't be timid in front of nature: one must be bold at the risk of being deceived and making mistakes. One must have only one master - nature; she is the one always to be consulted.'

Corot spoke to his admirers as colleagues, as one practising painter to others, giving advice in a spirit of equality, and recognizing the ability and skill of the person to whom he spoke. He preferred his own methods to be followed fairly closely, and did not take kindly to total defection, but his approach permitted the development of individuality to a greater extent than the rigid system of instruction provided in the *ateliers* of the *Ecole des Beaux-Arts*. As Pissarro had already found from his friendship with Fritz Melbye, this type of informal instruction suited his temperament. When he himself began increasingly to assume the role of guide and mentor to younger painters, he developed the approach which Melbye and Corot had followed with him, and his noteworthy success as a teacher was due in large measure to his sympathetic manner and to the unpatronizing spirit in which his advice was offered.

At Corot's studio, Pissarro became friendly with two painters who introduced him to a Paris previously unknown to him. They were Antoine Chintreuil, 14 years his senior, and Jean Alfred Desbrosses, who was five years younger than himself. Chintreuil had been a close friend of Henry Murger, the author of *La Vie de Bohème*, and of Jean Alfred's elder brothers, Joseph, a sculptor, whose noble character had led to his being named 'Le Christ', and Léopold, a painter, who was known as 'Le Gothique'. They had been members of an artistic freemasonry called the Water-Drinkers, who had agreed to help each other's careers and to assist each other in times of acute distress.

Chintreuil talked vividly of his experiences to Pissarro, who was fascinated by his revelation of *la vie Bohème*. Chintreuil told him that each member of the Water-Drinkers had paid a small subscription into a

fund which was used to help those in the greatest need, and that they drank water at their monthly meetings in order not to offend those members too poor to afford wine. The Desbrosses brothers had been amongst the poorest. Murger had written on them in the winter of 1841: 'The Desbrosses spend half the day not eating and the other half dying of cold . . . As for a fire, all they have is their pipes - very often without tobacco.' By the following year, the entire group had found themselves in the same condition, and Chintreuil, Murger, and the Desbrosses brothers had been constantly in and out of hospital, and had been forced even to share each other's clothing. Murger had written that their condition was 'an interminable ballad, whereof the refrain, "Poverty, poverty, poverty!", never varies.'

Chintreuil had been promised a commission by the Minister of Fine Arts, which would have improved the group's miserable financial position, but this commission had never materialized, and in April 1843 Murger had written: 'We are starving. We've reached the end of our tether. Without question, we shall have to blow our brains out, if we can't find a niche somewhere.' In 1844 Joseph Desbrosses had died, and his death had had a deep and lasting effect on his friends and on his brothers.

For years Chintreuil had been in a position where his desire to paint landscapes in the countryside had been thwarted by his lack of money. He had written in despair: 'If only I had 150 francs to support me for two months, day and night, right away from this city! A trip beyond the *Barrières* for a few hours doesn't give you time to study the effects of nature. For that, it's necessary to live with a landscape.' But the best the group had been able to afford were Sunday excursions outside Paris, often accompanied by the writer and critic Champfleury.

In 1849 Murger's fortunes had been completely altered by the stage production of a series of stories which he had been publishing for some years previously, *La Vie de Bohème*. The lives of the artists, as shown in this and later tales set against similar background, became romantic and idealized, far from the sordid struggles of reality, and sightseers began to seek out the cafés and other haunts of the Bohemian set. At about the same time, Chintreuil had begun to achieve some success, and he had been praised for his *salon* contribution of 1850. He was regarded by some as Corot's remarkable pupil, adhering closely to Corot's principles while retaining a personal vision and displaying great sincerity in his approach.

Through Chintreuil, Pissarro learned what *la vie Bohème* had meant, and he learned also of the pleasures and charm of living with a coterie of fellow artists, wholly absorbed by art. The promise of such a life which he had sensed in his contact with artistic circles in Caracas was

renewed and intensified by Chintreuil's anecdotes and descriptions.

Pissarro began to accompany Chintreuil and Desbrosses on painting expeditions. Desbrosses had been too young to participate in the activities of the Water-Drinkers, but he was imbued with the same spirit as his brothers had been, and he was determined to succeed as a painter without making any concessions to bourgeois expectations and standards. He and Chintreuil had been living together in the village of Igny, south-east of Versailles, since 1849, painting in the woods around the village and in the valley of the Bièvre river. Pissarro found that his new-found friends shared his belief in painting outdoors, observing changing effects of light and colour. All three were strongly opposed both to the sterility of the approach to painting advocated by the *Ecole des Beaux-Arts*, and to the requirements for admission to the *salon*, which were selection by a jury and such conformity to the standards prescribed by the Academy of Fine Arts and the *Ecole des Beaux-Arts* that Champfleury spoke of 'the mediocre art of our exhibitions in which a universal cleverness of hand makes 2,000 pictures look as if they have come from the same mould.'

The concerns they shared and discussed with such heat and enthusiasm were enduring ones. In 1863 both Chintreuil and Desbrosses were to be members of the committee appointed to look after the interests of the participants in the extraordinary *Salon des Refusés*, while Pissarro was to exhibit three paintings at this *salon*.

Pissarro began to acquire a new understanding of Paris, and a greater appreciation of its surroundings through his conversations with Chintreuil and Desbrosses, and their painting expeditions together. The nostalgia he had felt for the West Indies left him, and he no longer felt inclined to paint scenes from memory. He absorbed himself in learning more about the art of the past and the present, and in developing a greater understanding of the technical procedures of painting.

He enrolled for a short time in the *ateliers* of three masters at the *Ecole des Beaux-Arts*, François Edouard Picot, Isidore Dagnan, and Henri Lehmann, in order to reassure his parents. They had left St Thomas in 1857 and were living in Paris, and they remained convinced that his choice of career was folly. Very little evidence exists of his period of instruction with these masters, which was short-lived, serving only to emphasise his dislike for the rigid and inflexible approach of the *Ecole*.

Picot was regarded as an excellent teacher because he did not impose a particular style on his pupils. His method was designed to lead to success in academic painting, and above all, to success in the *Prix de Rome* competition. He arranged monthly competitions in his studio, at which a jury of five pupils whose work had not been entered chose the

five best works. His pupils were well prepared for the method of selection employed at the *salons*, and were adept at achieving the obligatory polished surface (*'le fini'*) required by the Academy. Pissarro found this approach totally alien to his temperament. Although he welcomed the interchange of ideas that resulted from the close collaboration of painters, and was always to seek out or to create such situations for himself, he did not conceive of art as a contest for prizes and awards, and he withdrew from the competitive atmosphere of Picot's *atelier*.

Henri Lehmann was later to be a teacher of Georges Seurat. He was considered to be an arch-conservative, although his work was concerned with recording his immediate sensations during the act of painting. In 1853 he had executed the pendentives of the *Hôtel de Ville*, and the preliminary studies had rich surface textures and slashes of colour, with areas of heavy scumbling contrasted against more fluid pigment. Technically, his work anticipated advanced methods of a later period. He transmitted his procedures to his pupils, but Pissarro did not remain in his *atelier* for long enough to derive much benefit from his instruction.

Pissarro was more interested in the teaching methods employed by Thomas Couture, Manet's teacher, although he did not enrol as a pupil of Couture's. He learned of Couture's approach in discussions with a former pupil, Ludovic Piette, whom he met through Chintreuil. Couture stressed the importance of developing a spontaneous and rapid technique in rendering impressions of nature, Piette told him, and he would say, 'We must get into the way of catching nature on the wing.' He emphasized the necessity for landscape excursions, taking his pupils out on day trips into the fields, and sometimes on longer journeys. Once he wrote to a pupil: 'I must tell you how impressed I was by a landscape of yours . . . which you call a sketch but which I regard as a finished work. Your treatment of water gives a fine sense of airiness and transparency, and no hand, however skilful, could . . . recapture the effect of this initial spurt.'

Pissarro was encouraged to find that although his approach was at odds with the methods favoured by the majority of teachers and of painters who exhibited regularly at the *salons*, there were some who felt as he did about the necessity of working outdoors and attempting to render one's first impression of a scene.

Ludovic Piette was four years older than Pissarro. He came from the Mayenne district of Normandy, where his family owned a farm called Montfoucault. His father, Christopher-Benjamin Piette, had been an enthusiastic amateur painter, and he had decorated the family home with large murals. Piette himself had been studying in Paris with

Isidore Pils, as well as with Couture. He shared many of Pissarro's views on painting, and they became close friends. Their friendship was to last until Piette's death in 1877. They found their meetings stimulating and rewarding, and Piette was later to be a staunch defender of Pissarro's work. The support he gave Pissarro, both moral and financial, was of great importance to Pissarro, and there were to be times when only Piette's assistance enabled Pissarro to continue painting instead of turning to a more lucrative career.

Pissarro had rapidly become familiar with the rules and requirements of the Academy and the *Ecole des Beaux-Arts*. As he studied the submissions to the *salons* and the paintings in the museums, the feeling of isolation he had experienced in St Thomas vanished. He was able to assess the work of the academic and the more *avant garde* Parisian art circles, and to determine his own position. He delighted in the stimulation offered by his contacts with other painters, and by the accessibility of the art of the past, but he soon realized that it would be preferable for him to live outside Paris in order to be able to paint *en plein air*.

In 1858 he decided to move to Montmorency, about 11 miles from Paris, on the south-east edge of the forest of Montmorency, famous for its chestnut trees. The village was renowned, too, as Jean-Jacques Rousseau's home. He lived in or near Montmorency from 1756 until 1762, during which time he wrote *Julie, ou la nouvelle Héloise*, and completed *Du Contrat Social* and *Emile*. A collected edition of Rousseau's writings in eight volumes was published by Hachette in 1856-8, and it is likely that Pissarro had read some of Rousseau's work, since he was extremely interested in social philosophy, and his own ideas accorded with Rousseau's in several respects.

Since his school days in Passy, he had been developing his interest in social and political theories by extensive reading. He came to believe that man would regain values he had lost through contact with the earth and with the routine and demands of country life, and he advocated a simple rural life. Although the adoption of this way of life was dictated for him to some extent by financial necessity, not choice, the initial decision which Pissarro made to renounce the bourgeois life and its resultant material comfort was a deliberate one, from which he did not swerve.

In his studies of the forests around Montmorency, Pissarro put into practice the advice Corot had given him, and the methods he had learned from his study of the paintings of Corot and other members of the Barbizon school such as Daubigny, observing the play of light among the trees, and attempting to render this effect on his canvas.

He decided in 1859 that the time had come to submit work to the

salon. His entry, *Landscape at Montmorency*, was accepted, although the jury was extremely harsh, and rejected works by Manet, Whistler, Fantin-Latour, and even Millet. Pissarro's submission was modest enough not to offend the jury, but it failed to attract much attention. Zacharie Astruc mentioned it in passing in his review of the *salon*, but otherwise it was ignored by the critics. Claude Monet, visiting Paris for the first time, said nothing about it in the detailed account he sent his teacher in Le Havre, Eugene Boudin, of his impressions of the *salon*.

To Pissarro, the hanging of his picture at the *salon* was an important milestone, for while he and his friends were becoming increasingly critical of the *salon*, acceptance there was a mark of recognition for a young painter, and a spur to greater efforts. To his parents, his *salon* entry was a reassuring sign, the first they had received, that their son had not been entirely foolish in renouncing the world of commerce for art, since they were well aware that regular submission to the *salon* was regarded as essential to an artist's success.

When he went to Paris, Pissarro liked to visit the 'free studios', where artists would sketch or paint from a live model without receiving any formal tuition, and without any of the constraints imposed by the *ateliers* of the *Ecole des Beaux-Arts*. He found the atmosphere of these studios congenial, and he met several painters there who shared his views on art. One of these 'free studios' was the *Académie Suisse*, on the Quai des Orfèvres, near the Pont St Michel. It was owned by *père* Crébassolles, who wore a monk's habit and was reputed to be a former professional model of Swiss origin. The dingy, dusty studio was furnished with a low divan or model throne, and a number of four-legged padded stools of varying heights. With their drawing boards resting on their knees, students sat or squatted on these stools. Fierce arguments often raged as they outlined their ideas, expressed their vigorous opposition to the *Ecole des Beaux-Arts*, and taunted each other and *père* Crébassolles, who appeared always to be reading the same book.

It was here, in 1859, that Pissarro met the 19-year-old Claude Monet, recently arrived in Paris from Le Havre, where he had established a reputation as a caricaturist. The dark-haired, formidably bearded Pissarro appeared to Monet as a veteran, particularly after his *salon* showing, although he was only ten years Monet's senior. In discussion, Pissarro remained calm and judicious, and the aggressive, sharp Monet did not feel threatened by him. They soon became friends and discussed their views at length and with enthusiasm. 'At this juncture I met Pissarro, who was not then thinking of posing as a revolutionary, and who was tranquilly working in Corot's style,' Monet recalled many

years later. 'The model was excellent; I followed his example . . .'

The work of both men revealed the influence, not only of Corot, but of Daubigny and other members of the Barbizon group. Monet was later to speak bitterly of Corot, saying. 'The *good* Corot. I don't know about that, but what I do know is that he was very bad for us. The swine! He barred the door of the *Salon* to us. Oh, how he slashed at us, pursued us like criminals. And how all of us without exception admired him!'

In April 1860 Pissarro and Monet made a short excursion to Champigny-sur-Marne to paint together. Champigny was a small village, about ten miles from Paris, on the left bank of the river Marne. Here, they set up their easels side-by-side and tested their theories *sur le motif*. As his opposition to the teaching offered by the *Ecole des Beaux-Arts* hardened, Pissarro came to value more and more highly the practice which he had established in his association with Fritz Melbye, that of working in close conjunction with another painter in order to permit mutual discussion, criticism, and evaluation. He welcomed any opportunity to paint in the company of like-minded colleagues, and he believed that it was essential to be receptive to the ideas of other painters.

The friendship between Pissarro and Monet was one which was to survive many storms and disagreements, sustained by the two men's respect for each other's personality and paintings. Pissarro was impressed by Monet's talent, and as Eugene Boudin had been, he was attracted to the youth's liveliness and brightness. In Pissarro, Monet found a patient but critical and perceptive companion.

The 1860s: New Friends and Ideas

ONE afternoon in 1861, when Pissarro was making a round of the studios in the company of a Puerto Rican friend, Francisco Oller y Cestero, with whom he took pleasure in speaking Spanish, he noticed an awkward young man whose efforts at painting were scorned by his colleagues at the *Académie Suisse*. He was Paul Cézanne, who had arrived in Paris from his home in Aix-en-Provence in April 1861.

Cézanne was unhappy and disappointed by life in Paris. He had hoped, as he confided to his friend Joseph Huot, that 'by leaving Aix I should leave behind the boredom that pursued me. Actually I have done nothing but change my abode and the boredom has followed me.' His closest companion of his schooldays, Emile Zola, despaired of him, writing to their mutual friend Baptistin Baille:

'. . . Paul is still the same fine and strange fellow I knew at school. As evidence that he loses none of his originality, I need only tell you that no sooner had he arrived here than he spoke of returning to Aix. To have fought for his trip for three years and now not to give a straw for it! Confronted with such a character and such impulsive and unreasonable changes of behaviour, I admit that I keep silent and suppress my logic. Proving something to Cézanne would be like trying to persuade the towers of Notre Dame to dance a quadrille . . .'

Pissarro discerned talent in Cézanne's drawings from the model at the *Académie Suisse* and did his best to encourage him to remain in Paris. Zola tried with every means at his command to dissuade Cézanne from returning to Aix, without success. Angry and upset by Cézanne's behaviour, he questioned their friendship, and he was later to ask: 'Does our friendship need the sun of Provence in order to exist joyously?' Ignoring all entreaties, Cézanne returned to Aix in September and entered his father's bank. He realized almost immediately that he would never become a banker, and wrote in one of the bank's ledgers:

'The banker Cézanne does not see without fear
Behind his desk a painter appear.'

In 1862 he returned to Paris. He had been heartened by Pissarro's encouragement, and hoped to renew their acquaintance. Pissarro was confident that if Cézanne could master his doubts and persevere with painting, he would eventually succeed. He felt that his belief had been justified when, more than 30 years later, he saw the first comprehensive exhibition of Cézanne's work ever held. 'I see that I was right in 1861 when Oller and I saw this strange Provençal at the *Atelier Suisse* where Cézanne made academic studies to the derision of all the impotents of the school . . .,' he was to write then.

Pissarro was interested in the work of another painter whom he met at the *Académie Suisse* at this time. He was Armand Guillaumin, and Pissarro discovered that Guillaumin relished the discussion of art theories almost as much as he himself did. Cézanne also found Guillaumin sympathetic. Guillaumin was shy, wary of company, and fiercely defensive about his ideas. Human relationships were difficult for him to establish and to maintain, but over the years his friendship with Pissarro and with Cézanne was to develop, and apart from a brief interlude at the height of the Dreyfus Affair, Pissarro and he were to remain on good terms until Pissarro's death. Cézanne said of him that he was an artist with a great future and a 'good chap' whom he liked very much, and Pissarro soon became a mentor as well as a companion to him.

Although Pissarro was only in his early thirties, and had achieved virtually no success or recognition with the single exception of his *salon* entry in 1859, he was regarded as a teacher and a guide. His gift for encouragement without condescension, and for discerning an individual's particular talents and potential, so marked in later years, was already apparent, and men like Cézanne and Guillaumin, who were both extraordinarily difficult and sensitive, were prepared to trust and rely on him.

When Pissarro's parents had moved to France from St Thomas, they had brought with them an entourage which included a black housekeeper. Rachel Pissarro decided that she required an additional servant, and she employed a young French girl as her maid. To his parents' horror, Pissarro found the maid very attractive and established a liaison with her. She was Julie Vellay, the daughter of Joseph Vellay, a navvy, and Jeanne Vellay, born Basset, a seamstress. She was eight years younger than Pissarro, who had encountered many of the *grisettes* who hovered round the artists like gilded butterflies. He found her country ways and outspoken frankness refreshing.

In spite of the opposition of his parents, the liaison continued. In 1862 Julie discovered that she was pregnant, but she suffered a miscarriage. Pissarro's parents urged him to end the relationship

immediately, but he refused to do so, and ignored their protests. They were furious, both because the difference in class between Pissarro and Julie troubled them, and because Julie was not Jewish, which meant according to Jewish law that any children she bore Pissarro could not be Jewish.

Shortly after her miscarriage, Julie again fell pregnant, and on 20 February 1863 her first son, who was named Lucien Camille, was born in Paris. Pissarro was sharing a studio at 23 rue Neuve-Breda with a Danish painter, David Jacobsen, and for a time the couple were forced to live in the studio, in cramped and uncomfortable conditions, for they were desperately short of money. Slightly mollified by the charm of their grandson, Pissarro's parents made a small financial contribution, and Julie's parents sent occasional gifts of a few francs. Julie found employment at a nearby florist's, while Pissarro tried without success to interest collectors and dealers in his work.

He prepared three paintings for submission to the 1863 *salon*, hoping that their acceptance would improve his position, and win him some degree of recognition. To his disappointment, all three entries, *A Landscape*, *A Study*, and *A Village*, were rejected by the jury. Their fate was shared by so many works that there was an outcry which reached such proportions that the Emperor felt compelled to take action.

He eventually gave permission for the rejected works to be shown at a special *salon*, the *Salon des Refusés*. The official announcement of his decision read:

> 'Numerous complaints have reached the Emperor on the subject of works of art that have been refused by the jury of the exhibition. His Majesty, wishing to leave the public as judge of the legitimacy of these complaints, has decided that the rejected works of art be exhibited in another part of the *Palais de l'Industrie*. This exhibition will be elective, and the artists who may not wish to take part will need only to inform the administration, which will hasten to return their works to them. This exhibition will open on May 15. Artists will have until May 7 to withdraw their works. Beyond this limit, their pictures will be considered not withdrawn and will be placed in the galleries.'

Pissarro chose to leave his paintings for inclusion in the *Salon des Refusés*, seeing this as an opportunity to protest at the unfairness of the jury's selection. A special committee was hastily organized to protect the interests of the participating artists.

The extraordinary *salon* opened two weeks after the regular *salon*, and it was besieged by huge crowds. Thousands of curious visitors poured into the hall where the rejected works hung, mainly to laugh at

the exhibits and to assure themselves that the official, accepted *salon* art was the only true art. They jeered in particular at Edouard Manet's *Le Bain* or *Le Déjeuner sur l'Herbe*, which became the *succès de scandale* of the exhibition, and attracted mobs around it. Emile Zola gave an account of the scene in his novel *L'Oeuvre*, as it appeared to the hero, Claude Lanteir:

'As soon as the visitors came through the doorway, he saw their jaws open, their eyes pucker up, their faces swell, and heard the heavy snorts of stout men, the rusty grating of thin men, topped by the shrill, fluty squeaks of the women. In front of him young fops were leaning against the wall, squirming as if their ribs were being tickled. One lady had just collapsed on to a bench, her knees pressed together, suffocating, trying to get her breath back, her face buried in her handkerchief. Rumours about this comical picture must have been spreading, people were storming in from every corner of the exhibition hall, arriving in droves, pushing and shoving, anxious not to miss the fun . . . It was turning into a scandal, the crowd kept growing bigger, the faces reddening in the warmth of the room, each with the round, stupid mouth of the ignoramus pronouncing judgement on art, all of them together uttering every idiotic remark, incongruous reflection, inane and malevolent guffaw that the sight of an original work can arouse in the vacant mind of the bourgeois.'

Genuine attempts to understand the exhibits were few, and Zacharie Astruc, the one critic who had noticed Pissarro's *salon* entry in 1859, commented, 'One has to be doubly strong to keep erect beneath the tempest of fools, who rain down here by the million and scoff at everything outrageously.'

Pissarro's entries escaped the venom of the crowds, and went almost unnoticed by the critics. Only Castagnary, writing in *l'Artiste*, observed: 'M. Pissarro - Not finding this name in previous catalogues, I suppose this is a young man. The manner of Corot seems to please him: a good master, sir, but beware of imitating him too closely.'

Pissarro decided to leave Paris for the summer, and the family moved to La Varenne-St Hilaire, where they were able to live more cheaply than in Paris. La Varenne-St Hilaire is about 11 miles from Paris, on the banks of the river Marne, across the river from the village of Chennevières, to which it was linked by a bridge. Here, Pissarro discovered *motifs* which pleased him, and life was more tranquil than in Paris. He and Julie preferred the quiet life of the village to the pressures they had been experiencing in the city, and they found it a relief to be free for a time of the weight of disapproval they

encountered from Pissarro's parents. Julie was adept at making the most of their meagre resources, and in the country she found it easier to feed her family than she did in Paris. She always was to be more at ease away from the city, although Pissarro himself needed the stimulation which he derived from contact with his fellow artists in the cafés and studios of Paris.

He was never a regular member of the group which gathered almost nightly at the Café Guerbois, in the avenue de Clichy, the 'Batignolles Group', but he enjoyed an occasional visit to the café. The fierce debates on art which raged there encouraged him to persevere with his work at a time when he was receiving very little support, either from his family or from buyers. He was a welcome visitor at the café; his careful appraisals of the work of other painters and his sympathetic judgements provided a foil to the hot-headed arguments of some of the regulars. A theme he often explored was the relationship between art and social issues, and he crossed swords with some of the more conservative members of the group, such as Degas, over his views.

Most of the group were extravagant in their praise of the beauty of the early morning light, and it struck Pissarro as ironical, as it did Renoir, that they talked so late into the night that it was debatable whether they ever glimpsed that light. Pissarro enjoyed the challenge of intellectual debate as much as the *camaraderie* of the group. He would come away from a gathering at the café reassured that he was not working in total isolation, and that although success seemed a remote prospect, there were growing numbers of artists who were resisting the tenets of the *Ecole des Beaux-Arts* and the Academy.

It was in this year, 1863, that Pissarro first met Renoir, who had been working in Gleyre's *atelier* with Monet, and had provoked Gleyre's disapproval by his apparently light-hearted approach and frank enjoyment of what he was doing. Pissarro met Renoir through Frédéric Bazille, an earnest young man and dedicated painter who was eager to bring like-minded artists together. He introduced Renoir to Cézanne in the same year. Pissarro thought that Bazille was the most talented member of the Batignolles group, and he respected his judgement and opinions. In Renoir, he found an artist who shared his love of nature and his desire to depict its beauty without employing the rigid formulae prescribed by the Academy. Renoir found Pissarro's tendency to search for an intellectual basis for his art somewhat intimidating. Although he agreed that the object of the new approach to painting was to transcribe an immediate perception of nature onto the canvas without any pictorial explanation, he found it difficult, as he was later to tell his son, to forget 'Fragonard's enticing bourgeois women'.

During the winter of 1863, Pissarro and Julie returned to Paris, to

lodgings at 57 rue de Vannes. The accommodation was less confined than the shared studio they had lived in before had been, but the struggle to subsist on their meagre income continued.

In spite of representations from several artists urging that it be made an annual event, the *Salon des Refusés* was not repeated in 1864. The *salon* jury was more liberal in its selections than it had been the previous year, in an effort to avert controversy, and both Pissarro's entries, *Banks of the Marne* and *The Cachelas Road at La Roche-Guyon*, were accepted. He was still described in the *salon* catalogue as a pupil of Melbye and of Corot.

Renoir had work accepted for the first time at this *salon*, and so did another future member of the Impressionist group, Corot's pupil Berthe Morisot. Public opinion was more tolerant than it had been the previous year, and Manet's submissions, *Incident in the Bull Ring* and *Dead Christ with Angels*, were received with far less hostility than *Luncheon on the Grass* had met. Many critics felt that he relied too heavily on Spanish sources for the *Incident in the Bull Ring*, and Thoré-Bürger, writing in *l'Indépendence Belge,* observed; 'Manet has the qualities of a magician, luminous effects, flamboyant hues, copies from Velasquez and Goya, his favourite masters. He thought of them while composing and executing his *Bullfight.'*

Pissarro's work began to be bolder and surer as his technical ability increased and his ideas about painting crystallized, but the paintings were still dark, making abundant use of black and dark brown. His working method was similar to that of the Barbizon group: winters spent in Paris, summers spent in the forests surrounding Paris, painting in the open air and attempting to capture on canvas the fugitive effects of light and colour. Corot's influence on his work was still discernible, but he was diverging increasingly from Corot. Corot was not pleased to find a disciple slipping away from him, although he professed not to advocate too-precise imitation of his own work. They quarrelled, and Pissarro abruptly ceased to appear in *salon* catalogues as a 'pupil of Corot'.

Corot was uneasy about acknowledging that a small group of painters, Pissarro, Monet, Renoir, Bazille, and Berthe Morisot, were developing a new approach which owed a great debt to him and to other members of the Barbizon group such as Diaz and Daubigny. Pissarro was always conscious of Corot's place in a tradition of landscape painting and of the influence Corot had had on his own development. In 1898 he was to write to Lucien:

'That Corot comes from Lorraine and reflects him is evident, but it is also clear to what degree he transformed what he took, in this lies

his genius; his figures are as modern as you please. In short, it is only here [in France] that artists are faithful to the tradition of the masters, *without robbing them.'*

Monet, in spite of his bitterness at Corot's attitude to his admirers, commented, 'As for us, we are nothing when compared with him.' Corot became increasingly hostile, and was never reconciled to the path the future Impressionists were taking.

Pissarro's acceptance at the *salon* did not aid his material position, and he was grateful to Ludovic Piette for an offer to spend the summer of 1864 on Piette's farm in Normandy. It was the first of several visits to Montfoucault. The change of environment was beneficial to Pissarro and Julie. Piette was a sympathetic friend and an enthusiastic painter, and Pissarro enjoyed their conversations and shared painting excursions. He was pleased that Julie was able to relax from the unending effort to make ends meet, particularly since she was pregnant again.

On 22 January 1865 Frédéric Pissarro died. Rachel moved to 42 rue Paradis-Poissonnière, very close to Corot's residence, to stay with Pissarro's brother Alfred. She had no desire to return to the West Indies, although the family still had business interests there, and she owned the house in Charlotte Amalie, which had been let. Once or twice she visited her daughter Emma, who lived in South London with her husband Phineas Isaacson.

Later in the year Julie gave birth to a daughter, who was called Jeanne-Rachel, a combination of the names of Julie's mother and her mother-in-law. She was known to the family as 'Minette'. For a time they continued to live in Paris, but it soon became clear to Pissarro that he would be better able to provide for his enlarged family if they moved outside the city, and he began to consider suitable alternatives, within easy reach of Paris.

In 1866 he had a single canvas accepted at the *salon*, *Banks of the Marne in Winter*, and the catalogue indicated a change of address. Pissarro and his family had moved to Pontoise, and were living in the rue du Fond de l'Hermitage. Pontoise, 19 miles from Paris, was an ideal place for them. There were many potential *motifs* in the area, in the town itself and along the banks of the river Oise and in the hills of the Hermitage. The gentle hills and soft light of the region suited Pissarro's taste, as it had appealed to Daubigny, who lived in the nearby village of Auvers. It was conveniently situated in relation to Paris, and Pissarro could visit the city easily and cheaply. Julie liked the town, where she quickly felt at home and more secure than she had been in Paris.

Pissarro occasionally left his family to visit his friends Monet, Renoir and Sisley, who were staying in the village of Marlotte, in the forest of

Fontainebleau. They studied the play of light on the leaves, and recognized that they had no need of dramatic or flamboyant effects. Renoir was later to say, 'Give me an apple tree in some suburban garden. I haven't the slightest need of Niagara Falls.' After a day spent in intense concentration before their easels, they would gather at the inn of Mother Anthony, where they were made welcome by the proprietress and her daughter Nana.

Pissarro's *salon* entry attracted the attention of Emile Zola, recently appointed editor of the newspaper *l'Evénement,* who wrote:

'M. Pissarro is an unknown, about whom no one will probably talk. I consider it my duty to shake his hand warmly, before I leave. Thank you, *Monsieur,* your winter landscape refreshed me for a good half-hour during my trip through the great desert of the *Salon*. I know that you were admitted with great difficulty, and I offer my sincere congratulations. You should realize that you will please no one, and that your picture will be found too bare, too black. Then why the devil do you have the arrogant clumsiness to paint solidly and to study nature frankly . . . An austere and serious kind of painting, an extreme concern for truth and accuracy, a rugged and strong will. You are a great blunderer, sir - you are an artist that I like.'

From Zola's comments, it is evident that the view later expressed by many critics, namely that Pissarro had eliminated black, brown and ochre from his palette in 1865, is far from correct. Joachim Gasquet was to quote Cézanne as saying: 'In '65 he eliminated black, bitumen, sienna, and ochres. That's a fact. Never paint except with the three primary colours and their immediate derivatives, he said to me.' Cézanne, however, knew very well what Pissarro's work at this time looked like. It was almost certainly he who attracted Zola's attention to it, since Zola was not well trained in the visual arts, although his spirited defence of Pissarro, Manet and Monet in *l'Evénement* put them in his debt.

Pissarro and Zola became friendly, and remained on good terms for many years. Pissarro was an avid reader, and enjoyed discussing literature, and he and Zola found much pleasure in their talks. Pissarro was an admirer of Zola's work; he read each of Zola's novels as they were published, often commenting on them in his letters.

Zola was becoming increasingly impatient with Cézanne's uncertainties, and Pissarro was often more sympathetic to Cézanne than his childhood friend. Cézanne was sharing a house in Paris with Pissarro's Puerto Rican friend Oller, and Pissarro visited them whenever he was in Paris.

They shared a growing admiration for the work of Gustave Courbet. As Pissarro developed confidence in his own ability, he was attracted more and more to the boldness and daring of Courbet's art, and he began to emulate his use of the palette knife. Monet, Renoir, and Bazille were equally enthusiastic. Monet worked beside Courbet on the Normandy coast at Trouville in the summer of 1865, and he was infected by Courbet's exuberance and by his bold, broad technique, so well suited to conveying the expansiveness of his response to nature. He and Renoir found that Courbet's paintings warranted careful study.

Cézanne had been turned down by the jury in 1866. He wrote to the Superintendent of Fine Arts, Count Nieuwekerke, pleading for the reinstatement of the *Salon des Refusés*, but to no avail. He returned to Aix in the autumn, and wrote affectionately to Pissarro, appending a note from their mutual friend Antoine Guillemet, who wrote that they often talked of Pissarro and looked forward to seeing him again.

Pissarro was admitted to the *salon* in 1866 only because Daubigny, who was a member of the jury, intervened on his behalf with a strong plea for the merits of his entry. In the following year he was less fortunate and his submission was rejected. He joined Renoir, Sisley, and Bazille in signing a petition requesting that the *Salon des Refusés* be held annually. Their petition met with no response. Rejection by the *salon* meant almost certain failure, since only by showing there could a painter or sculptor obtain public recognition; even the *Salon des Refusés* was preferable to total obscurity.

Monet suggested holding a private exhibition in the following year in order to escape the stranglehold of the *salon*, following the example of Manet and of Courbet. They had both elected to build independent exhibition pavilions rather than submit their work to the official art section of the 1867 Paris World's Fair.

A pamphlet explained Manet's intentions in exhibiting on his own:

'Since 1861 M. Manet has been exhibiting or attempting to exhibit. This year he has decided to offer directly to the public a collection of his works . . . The artist does not say, today: 'Come and look at works without fault,' but: 'Come and look at sincere works.' It is sincerity which endows works of art with a character that makes them resemble a protest, although the painter has only intended to convey his impression. . . . To exhibit is the vital question . . . for the artist, because it happens that after several examinations people become familiar with what surprised them and, if you will, shocked them. Little by little they understand and accept it . . . For the painter, it is thus only a question of conciliating the public, which has been his so-called enemy.'

Monet and his friends agreed with this point of view, and Monet felt sure that they could rent the hall Courbet had used for his one-man show for a small sum. Each artist invited to participate would be allowed to show as many paintings as he liked, they agreed, instead of being limited to three as was the case at the *salon*.

Bazille wrote to his parents that 12 young artists had decided to 'rent each year a big studio where we can show as many pictures as we please'; he added: 'We shall also invite painters we admire to send canvases. Courbet, Corot, Diaz, Daubigny, and many others you have not heard of have promised to send us pictures and think our idea is a good one . . . With these men and Monet, who is better than any of us, we shall be sure to succeed . . . You will see how we shall be talked about.'

The group's plans failed because, in spite of desperate efforts, they were only able to accumulate 2,500 francs which was not sufficient to stage the exhibition. They were forced, as Bazille said, to 'go back to the maternal lap of the *salon*.' The idea of breaking away from the *salon* and expressing their rejection of its values by holding an independent exhibition remained in the minds of Pissarro and his colleagues. With each succeeding year, it became increasingly clear that an alternative to the *salon* would have to be found if the Batignolles group were not to perish in obscurity.

Pissarro and Julie were still living in Pontoise. There, undaunted by the lack of recognition he had achieved, he worked with constant, dogged persistence. His mother agreed to make a contribution of 1,000 francs a year, but the struggle to survive continued. In the autumn he was pleased to receive an invitation from Guillemet to spend some time at La Roche-Guyon. Guillemet wrote:

'I absolutely count on you for La Roche. Besides, you promised, didn't you? It will be marvellous for me to see again good painting and to work with a real buddy like you. I am so disgusted with the painters I meet here [in Ypres], all grocers and fobs. Cézanne will probably come too.'

Guillemet was a charming young man, handsome, good-tempered, and assured of manner. He enjoyed the good things of life, and since his father, a wholesale wine merchant, made him a generous allowance, he was able to indulge his tastes. He was serious about painting, and, despite their very different personalities, a close friend of Cézanne's.

Pissarro liked him, and enjoyed his company, and he accepted the invitation with pleasure, delighted to spend a few days with his friends, and glad to avail himself of an opportunity to vary his *motifs*.

He had two pictures accepted for the 1868 *salon*. They were *Hill of Jalais* and *The Hermitage*, and once again it was Daubigny's intervention which secured their admission. Daubigny was far more tolerant of the work produced by Pissarro and his friends, who had so apparently studied the school of 1830 with close attention, than Corot, and he always tried to help them. Castagnary complained that they were hung too high, 'but not high enough to prevent admirers from noting the sterling qualities which distinguish the artist who produced them.'

Zola singled Pissarro's work out for praise:

'The originality here is deeply human . . . It forms part of the very temperament of the painter. It seems to me that no painting has ever been of a more masterly greatness. Here you can listen to the deep voices of the soil and imagine the strength of the trees growing . . . A quick glance at such a work is sufficient to make one understand that the man who created this was a straight and strong person, unable to be dishonest, and a man who turned his art into a pure and eternal truth.'

Pissarro's submissions were also praised by Redon, who wrote :

'The colour is somewhat dull, but it is simple, large and well felt. What a singular talent which seems to brutalize nature. He treats it with a technique which in appearance is very rudimentary, but this denotes, above all, his sincerity. M. Pissarro sees things simply; as a colourist he makes sacrifices which allow him to express more vividly the general impression; and this impression is always strong because it is simple.'

Pissarro's paintings had become bolder, and the effects of his study of Courbet were more noticeable. Corot's softer, gentler style had been in keeping with his diffident mood in the years of his apprenticeship, when he was conscious of his lack of training, and felt ill at ease in his new environment. By the late 1860s, this mood was long passed: he had growing confidence in his abilities, a confidence not entirely shared by Julie, who complained bitterly of his lack of success.

In spite of the favourable comments on his *salon* entries, his work did not find buyers, and the family's financial situation was so precarious that he was forced to seek some employment which would ease their plight. He moved to Paris for part of 1868, to 108 Boulevard Rochechouart in the 9th *arrondissement*. For a short time he and Armand Guillaumin accepted commissions to paint blinds. Both men accepted this setback philosophically, and Guillaumin painted Pissarro at work on the blinds, attacking his task with energy and determination.

On this visit to Paris, Pissarro met a dealer who was prepared to handle his work, although the sums he paid were small. He was *père* Martin, who had a shop on the rue Laffitte. He paid between 20 and 40 francs a canvas, depending on their size.

This amount was scarcely enough to cover the cost of paint and canvas involved in the production of the picture. Colours cost at least 25 centimes a tube, more often a franc, and rarer colours might cost 10 or 15 francs a tube. Brushes cost four or five francs each, while a canvas size 120, measuring 6'4" by 4'4", cost 33 francs. A frame cost up to 100 francs, and the rental of a studio in Paris was between 600 and 1,000 francs a year. By the end of the century these prices were almost double. Often the choice was between a tube of colour or a day's food. It was only possible for Pissarro to continue painting because the house in Pontoise had a garden where Julie grew vegetables and kept poultry, and because of her skill as a housekeeper.

In 1869 the Pissarro family moved again, leaving Pontoise for Louveciennes. Pissarro wandered around the village and its surroundings, familiarizing himself with the landscape, noting potential *motifs* and sketching and painting constantly. Only one of his submissions was accepted by the *salon* jury in 1869, *The Hermitage, A Landscape*. Both Monet and Sisley were rejected, and Degas only had one entry accepted. Manet exhibited two pictures, *The Balcony* and *The Luncheon in the Studio*, which attracted a great deal of critical attention.

The financial plight of Pissarro and his friends reached an extreme point in this year. Renoir wrote to Bazille: 'We don't eat every day, yet I am happy in spite of it, because as far as painting is concerned, Monet is good company. I do almost nothing because I don't have much paint.' He and Monet were working together at *La Grenouillère*, a bathing place and restaurant on the river Seine at Croissy. The canvases they produced capture the spontaneity and gaiety of a boating party on a summer day, and indicate nothing of their hunger and hardships. Together, they advanced their investigation into light and colour, and evolved a method of conveying changing, fugitive light effects. This was a short, broken brushstroke, which did not seek to imitate surface textures, and which permitted rapid notations of the scene before their eyes. Their palettes were becoming lighter and brighter, and they used more primary colours and less black than had previously been the case.

Pissarro emphasized a greater solidity of structure in his work. He often created a strongly defined sense of perspective by the introduction of a road or a river receding sharply into the background. Two landscapes of Louveciennes with these characteristics were accepted by the 1870 *salon*. His work was still experimental, searching for

resolution. He recalled many years later: 'I remember that, though I was full of ardour; I did not have the slightest idea, even at the age of 40, of the profound aspect of the movement which we pursued instinctively. It was in the air.'

Rodo by Camille Pissaro

CHAPTER 4
London, 1870–1871

IN JULY 1870 the outbreak of the Franco-Prussian War shattered the tranquillity of Louveciennes, only 11 miles from Paris. Soon, Prussian guns were mounted at Fort Mont Valérian, unpleasantly close to the village. Pissarro decided to take Julie and the two children to the safety of Ludovic Piette's farm in Brittany. He did not expect their stay there to be a long one, for the general feeling was that the war would soon be over. He left most of his own paintings, and some that Monet had entrusted to his care when he visited Pissarro on his way to Le Havre after his marriage to Camille Doncieux on 26 June, in the safekeeping of his landlady, Mme Ollivon.

Piette was delighted to see his friend, but he was concerned about the gossip which would result in the small village of Melleray, near the farm, if the villagers learned that Pissarro and Julie were not married. He cautioned Pissarro: 'In order to avoid tittle-tattle . . . I must believe that you are married and you must make me believe this. It is stupid but necessary.'

At Montfoucault, Pissarro could forget for a time the constant struggle to make ends meet, Julie did not need to improvise meals from scraps, and the threat of war seemed distant. The farm and surrounding countryside provided a welcome change of *motif* for Pissarro, and for a few weeks the family was content.

The disastrous failure of the French troops at Sedan, and the declaration of the Third Republic on 4 September 1870 ended this peaceful interlude. Refugees packed the cross-Channel boats at Le Havre, and in the autumn of 1870 the Pissarro family joined their ranks and fled to England. Virtually penniless, confused and distressed by events in France, they descended upon Camille's half-sister Emma and her husband Phineas Isaacson. Pissarro's mother also left France hastily to stay with Emma in London. With the Isaacson's help, lodgings for the family were obtained at 2 Chatham Terrace, Palace Road, Upper Norwood.

Aided by his knowledge of English, Pissarro managed to adapt to his new surroundings fairly easily. He found the area in which they were

staying charming, and explored it thoroughly. Julie, however, was deeply suspicious of the British and hostile to her strange environment. She was unable even to do her daily shopping without assistance, since she could not speak a word of English, and made no attempt to learn, saying, ' . . . this succession of curious sounds could not be a language.' The neighbourhood children laughed at Lucien's wooden clogs, and at his inability to speak to them, and Julie felt herself to be the target of local gossip. The longer the family stayed in London, the more vociferous her complaints became, and the more her feelings of homesickness for France grew.

Pissarro always tried to stay clear of Julie's rages, and in London he took refuge in visits to the museums, which fascinated him, and in long walks around the South London suburbs. He recorded his impressions in several sketches and paintings. He painted some of the architectural landmarks of the area, including the Crystal Palace, Dulwich College, St Stephen's Church, Lower Norwood, and the church at Westow Hill.

There were many other French artists in London at this time, and occasionally he enjoyed their company. François Bonvin, one of Pissarro's colleagues, recalled his arrival in London in a letter of 4 January 1871:

'I left Dinan on 7 November 1870 and . . . embarked at St. Malo for Southampton . . . After a crossing of six hours and five hours in the train, I arrived in London, where I encountered an exceptional fog. The devil! It was not pleasant! . . . The following day, I visited the French painter Legros, married here for ten years. A good reception and good news. Many French painters are refugees here: Gérôme, Heilbuth, Regamey, Daubigny, Le Rochenoire, Monet, Wagrez, the etcher Morand, and others too, the names escape me.'

Pissarro saw Bonvin, and he also went to visit Alphonse Legros, who had lived in London since 1863. He was to write to Lucien in 1883: 'I know Legros quite well, Monet and I had lunch with him when we were in London, he may remember me, he may have totally forgotten me.'

Legros's home became a central meeting point for the refugees. He was able, with his knowledge of London, to guide and advise his confused fellow-countrymen, although he himself had never fully mastered English, and was accustomed to delivering his comments on his students' work at the Slade School of Art in French.

Either through Legros, or through Daubigny, Pissarro was given an introduction which was to have far-reaching repercussions for him, to the art dealer Paul Durand-Ruel. Like Pissarro, Durand-Ruel had left

France hastily to escape the war. He had brought with him not only his own stock of paintings, but also the collections of many of his clients, among them that of the tenor Faure.

He had initially obtained premises in Haymarket, but shortly afterwards he had leased a vacant gallery at 168 New Bond Street which, ironically, was called the German Gallery. He specialized in the paintings of the Barbizon school, but he had been aware of the promise of Pissarro, Monet, and Degas before he left France. A review which he edited, the *Revue internationale de l'art et de la curiosité*, in its comments on the *salon* of 1870 had stressed the importance not only of Pissarro, Degas, and Manet, but also of Monet, although Monet's *salon* entries had been rejected.

Durand-Ruel was interested in the paintings which Pissarro brought to show him, and he agreed to buy from him, paying him 200 francs a canvas. He was to recall later that he had met Pissarro through Monet, but his memory on this point seems to be at fault, since on 21 January 1871 he wrote to Pissarro:

> 'You have brought me a charming picture and I regret not having been in my gallery to pay my respects in person. Tell me please, the price you want and be good enough to send me others when you are able to. I must sell a lot of your work here. Your friend Monet asked me for your address. He did not know you were in England. He is living at Bath Place No. 1, Kensington.'

Monet and Pissarro were delighted to see each other. They visited the museums and galleries together, and avidly discussed the merits of British paintings, and the similarities with their own aims which they found in the work of some of the English landscapists. 'The watercolours and paintings of Turner and Constable, the canvases of Old Crome, have certainly had influence upon us. We admired Gainsborough, Lawrence, Reynolds, etc, but we were struck chiefly by the landscape-painters, who shared more in our aim with regard to 'plein air', light, and fugitive effects. Watts, Rossetti, strongly interested us among modern men . . .', Pissarro was to tell Wynford Dewhurst in November 1902.

They were surprised and pleased to find that two of Turner's canvases, *Sun rise in the fog* and *Dido building Carthage*, were hung in the National Gallery between two of Claude Lorrain's paintings, *Landscape: The Marriage of Isaac and Rebecca*, and *Seaport: The Embarkation of the Queen of Sheba*. This, they discovered, had been done at Turner's express wish, as a condition of the entry of his own work. Pissarro was to be indignant with Dewhurst in 1903 because Dewhurst, in writing of Pissarro and his associates, omitted ' . . . the influence which Claude

Lorrain, Corot, the whole eighteenth century and Chardin especially exerted on us.' He was interested to see Turner acknowledging Claude Lorrain's influence on his own development. He examined Turner's paintings carefully, and was particularly captivated by his snow and ice effects, and by the results which were obtained by using a number of brushstrokes of different colours placed next to each other, rather than white alone, to produce the desired effect.

Hippolyte Taine, in his *Notes sur l'Angleterre 1860-1870*, had discussed the impact of the collection of Turner's work at the National Gallery:

'The collection of his work fills three rooms . . . By degrees the appeal to the eye, and the optical effect came to be of secondary importance to him, and the feelings and dreams of the speculative and reasoning brain became sovereign . . . *The Flood, The Burning of Sodom, Light and Colour after the Flood, Rain Steam and Speed in a Train, Steamships in a snow squall* - these and thirty or forty others carefully collected together by himself and hung according to his instructions in a place apart, comprise an inextricable slushy mess, a sort of whipped froth, an extraordinary jumble in which all form is drowned. Place a man in a fog in the midst of a storm, with the sun in his eyes, and a giddyness in his head, and then, if you can, convey his impressions onto canvas, and there you have something like it: these are the confused visions, dazzlements and delirium of an imagination driven mad by its own straining.'

Pissarro and Monet were as overwhelmed as Taine had been by the collection as a whole, while totally disagreeing with Taine's assessment of it as the work of a madman. They recognized in Turner's paintings a close affinity to their own attempts to record the effect of light and colour on canvas. The influence of his study of Turner was not directly reflected in Pissarro's paintings, but he always remembered the lessons he had learned from Turner, and he was to urge several young painters, among them his own sons, to look carefully at Turner's works.

Some examples of Constable's art were on view at the South Kensington Museum, at the National Gallery, and at the Royal Academy's Winter Exhibition. At the Royal Academy Pissarro and Monet saw *The Hay Wain*, which had impressed Delacroix greatly in 1824. At the same exhibition, they were able to study paintings by Crome, Gainsborough, and Reynolds, as well as by Claude Lorrain and Watteau. This gave them an opportunity to assess the principal artists of the British School, and to evaluate their relationship with

French painting. The two men found that while the work of the English painters interested them greatly, their affinity with the art of their own countrymen was deeper and more profound.

Durand-Ruel opened his new gallery with an exhibition of French paintings in December 1870. It included works by Ingres, David, and Delacroix, as well as many examples of the School of 1830 - Diaz, Dupré, Millet, Daubigny, Rousseau, and Corot. Work by Pissarro and by Monet was added to the exhibition in February 1871. The *Art Journal* of 1 February 1871 commented: ' . . . From this exhibition there is much to be learned by those who know something of the recent and living school of French painting. The exhibition, therefore, cannot fail to be very attractive: it will, no doubt, be added to from time to time.' Durand-Ruel was not able to promote much interest in Pissarro's and Monet's paintings among buyers, and their submissions to the exhibition, two landscapes by Pissarro painted in England, and a view of Trouville by Monet, remained unsold.

In May 1871, Pissarro and Monet decided that they would submit work to the annual exhibition at the Royal Academy. The Royal Academy proved to be no less critical of their approach than the *salon* had been, and their paintings were rejected, to their great disappointment. In the same month, their submissions to the International Exhibition held at the South Kensington Museum were accepted. Pissarro showed two snow scenes, which were cursorily mentioned in the *Art Journal* of 1 September 1871 in a lengthy review of the exhibition: 'By C. Pissarro are two winter-subjects of much natural truth . . .'

Monet exhibited a portrait of his wife Camille, and a painting called *Méditation*. Among the other French artists whose work was on view at this exhibition were Corot, who exhibited 20 paintings, Daubigny, who showed 11 works, Courbet, represented by five canvases, and Fantin-Latour, who exhibited a portrait of Manet. Jongkind was represented by 11 pictures.

In spite of his acceptance at the International Exhibition, Pissarro was bitterly disappointed at the lack of response which he found in the British public. Julie's constant and growing dissatisfaction with their life in London increased his consciousness of being an outsider and the family began to consider returning to France. In June, hearing that Théodore Duret was planning to come to England before embarking on a voyage to America and the Far East with his friend Cernuschi, Pissarro wrote:

'I count on returning to France as soon as possible. Yes, my dear Duret, I shan't stay here, and it is only abroad that one feels how

beautiful, great and hospitable France is. What a difference here! One gathers only contempt, indifference, even rudeness; even among colleagues there is the most egotistical jealousy and resentment. Here there is no art; everything is a question of business. As far as my private affairs, sales, are concerned, I've done nothing except with Durand-Ruel . . . My painting doesn't catch on, not at all; this follows me more or less everywhere.'

Duret visited Pissarro in London shortly after receiving this letter. The two men had an opportunity to discuss the political situation in France. Duret had come close to being executed during the Commune, and he was able to give Pissarro detailed reports about the events of the past months. He saw and admired Pissarro's latest work, and Pissarro was cheered by his praise. Duret was appalled at the taste displayed by the British public. He wrote to Manet: 'The English, with regard to French artists, like only Gérôme, Rosa Bonheur, etc. Corot and the other great painters don't exist as yet for them. Things here are the way they were 25 years ago in Paris . . .'

Pissarro was still distressed by the news he had received some months earlier about the fate of the paintings he had left in Louveciennes. In February Edouard Béliard had written to him at length, giving him news about his friends and colleagues, and had warned him not to expect that the possessions he had left behind had remained intact. He said that he liked to believe that Pissarro's paintings would adorn Prussian salons, but that everything else had come to grief, although the close proximity of the forest had probably saved the furniture from being used as firewood. Dismayed by this news, Pissarro had written to Mme Ollivon to find out whether Béliard's fears were correct. She replied:

'You ask for information about your house. I can assure you the word is poorly chosen: stable would be more accurate. There were two carloads of dung in it. In the small room beside the living room horses were kept; the kitchen and pantry were used as a sheepfold, the sheep being slaughtered in your garden. You may well imagine that part of the trees and flowers served for pasture . . . The former occupants also put fire to your house . . . We have some of your furniture in our place, such as the mahogany beds, the mirrored wardrobe, the little round tables, its marble broken (but all the pieces are saved), the night table, the toilet stand, a large and a small mattress, and your sideboard, but this one is very sick, one door and one side of the shelves are missing . . . To sum it up the Prussians have caused plenty of havoc, and certain Frenchmen too. I forgot to tell you that we have some of your pictures well taken care

of. However there are a few which those gentlemen for fear of dirtying their feet, put on the ground in the garden; they used them as carpets. My husband has picked them up and they also are now in our house.'

Mme Ollivon had attempted to spare Pissarro some bad news in her chronicle of disaster, for he was subsequently to estimate that only 40 pictures of the 1,500 he had left at Louveciennes had survived the Prussian occupation.

Julie was pregnant again, and she was eager for the child to be born in France rather than in England. This wish spurred Pissarro into making plans for their departure. Before they left London, Pissarro and Julie decided to legalize their union, and they were married in the Register Office in Croydon by Edwin Bailey, the Registrar, in the presence of Alexandre Prevost and Charles Lecape on 14 June 1871. Prevost and Lecape were fellow refugees with whom the couple were friendly. Prevost was a painter, who had exhibited regularly at the *salon* since 1850.

Pissarro was 40 years old, and Julie was 32. She was no longer the pretty, compliant girl to whom he had been so attracted. She was difficult, bad-tempered and nagging, but she had great determination and perseverance. They decided to marry in order to avoid having to repeat the deception they had practised at Montfoucault, and Julie, about to bear her third child, wanted the security of marriage. Lucien was later to say that Julie had been unjustly prevented from marrying by Pissarro's family on account of their bourgeois narrowness.

Shortly afterwards the family left London and returned to the house at Louveciennes. The damage the Prussians had wrought shocked them, but they set to work to repair and clean their home, and they were happy to be back in familiar surroundings. Julie was particularly delighted, for their stay in London had been a harrowing experience for her. Pissarro was soon back at work, painting in the village and the surrounding countryside.

On 22 November their second son, Georges Henri, was born at Louveciennes.

Louveciennes; Pontoise; the First Impressionist Exhibition, 1871–1874

A T LOUVECIENNES Pissarro worked with Sisley, who was living at 2 Rue de la Princesse. Sisley was quiet and withdrawn, still depressed by the recent death of his father. His father had suffered severe financial reverses shortly before his death, and Sisley, his wife, and their two children no longer enjoyed the material comforts of earlier years.

Pissarro and Sisley shared many interests, and they were developing their approach to painting along similar lines. Both men were introducing more vivid colour into their works than in the past, and they were gradually eliminating black from their palettes. They both favoured compositions in which strong perspectival effects were achieved by a road or a river placed almost in the centre of the canvas. Pissarro liked Sisley's modesty, and he respected his ability as a painter. He was to write in 1899, on hearing that Sisley was gravely ill: 'He is a beautiful and great artist. I am of the opinion that he is a master equal to the greatest.'

Renoir was a frequent visitor to Louveciennes. His mother lived in the village, and he divided his time between his Paris flat and her Louveciennes home. When Pissarro, Renoir and Sisley met, their conversation often turned to the necessity of finding an alternative to the *salon*. Pissarro was convinced that success at the *salon* could only be achieved by compromising the beliefs which he and his friends shared. He attempted to persuade Renoir, who was sceptical of Pissarro's insistence, and preferred to remain non-committal about the matter.

Pissarro was strengthened in his conviction when the rules for the first *salon* since the Commune were published in December. Charles Blanc, the newly-appointed Director of Fine Arts, decreed that there would be no exemptions, and that all entries would be submitted for the approval of the jury. The jury was no longer to be elected by all admitted artists, the right to vote being restricted to those who had received medals. There was an outcry at this announcement, and a plea was made for the reinstatement of the *Salon des Refusés*. Pissarro, Sisley, and Monet did not submit work to the *salon*, but Renoir did,

only to be turned down by the jury.

When Georges was a few weeks old, Pissarro had occasion to renew his acquaintance with a doctor whom he met in Paris at the studio of Armand Gautier. He was Dr Paul Gachet, a specialist in homeopathic medicine. Both Pissarro and his mother were believers in homeopathy, and Dr Gachet was Rachel Pissarro's doctor in Paris. Lucien Pissarro was to recall the circumstances which led to a closer friendship between his father and Dr Gachet many years later to Gachet's son:

'It was in 1871, my brother Manzana (Georges) . . . had convulsions, and my father, extremely disturbed, begged your father to come and see the baby. Your father discovered that the convulsions were caused by poisoning due to the rubber teat (badly prepared) of the feeding bottle . . . This little incident retains a place in my memory because it was the starting point of closer relations between my father and yours . . .'

The friendship grew in the following year, when the Pissarro family left Louveciennes and returned to Pontoise, for Dr Gachet lived in Auvers, only four miles from Pontoise. He was keenly interested in art, especially in etching, and he and Pissarro saw each other frequently.

Pissarro decided that he preferred the landscape around Pontoise to that of Louveciennes, and the move was made in the spring. Julie was pleased to return to Pontoise. She set to work improving the vegetable garden of their new home, tilling the ground and planting seed, in order to provide for her family.

Pissarro hoped that the move would enable him to work with greater confidence than he had felt in the last few months of his stay at Louveciennes. His doubts about the value of his work were not shared by his friends. Guillemet wrote from Paris:

'I have *done* the Rue Laffitte and have visited the galleries, including Durand-Ruel's. What I wanted to say is that everywhere I saw charming and really perfect things of yours and that I felt anxious to tell you this immediately . . . Thus I saw especially at Durand-Ruel's bright and lively pictures, varied in a word, which gave me the greatest pleasure . . . You must be well satisfied, now that you have rounded the capes and tempests. You are successful in what you do and your paintings please. So much the better, and I am really happy for you.'

Ludovic Piette was equally convinced of Pissarro's success:

'You do not speak about yourself, my dear Pissarro, being as modest at the moment of victory as you were confident in your star during the days of painful struggle. Now that you are about to acquire a

great name - and you certainly deserve it - money, which has such good legs when it comes to escaping the chase of us other poor runners always eagerly after its scent, money I say, will no longer fail you. That is my hope. You will thus be able to travel while you work; why don't you come to Montfoucault?'

This optimism, particularly about Pissarro's financial position, was not justified by actual circumstances. Durand-Ruel had continued to buy Pissarro's work after his return to France, paying the same price that he had offered in London, 200 francs a picture. He exhibited nine of Pissarro's paintings in London in an exhibition in 1872, but this constituted his total purchase of Pissarro's work that year, which gave Pissarro a very modest income indeed. This was supplemented by occasional sales to a friend of Guillaumin's, a pastry-cook called Eugène Murer, who bought some of his paintings immediately he met Pissarro, and acquired other works frequently in the years that followed, although always at low prices, and to other dealers such as *père* Martin.

Another dealer who was prepared to handle Pissarro's work was *père* Tanguy. Julien Tanguy was of Norman stock, five years older than Pissarro. Pissarro had known him before the Franco-Prussian War, for Tanguy was a familiar figure to all the dedicated exponents of *plein air* painting. He would trudge about the popular painting spots outside Paris, a huge box containing tubes of paint on his back, a stocky man with a grizzled beard, wearing a blue peasant's smock. He had a small shop at 14 rue Clauzel, where he sold artists' requirements at slightly lower prices than other merchants. He had always liked Pissarro, sensing a comrade in his rough dress and lack of affectation, and over the years they had found that they shared many ideas about the necessity for change in the political and social order.

Tanguy was a dedicated Communard, while in painting his taste was for those who defied the established order represented by the *École des Beaux-Arts*. He loved painting, and would gaze at a picture as if it was a loved child before presenting it to a potential customer, looking at him over his spectacles and inviting his admiration. His shop was crammed with canvases, and although he did not sell many of his paintings, Pissarro was glad of his assistance.

Pissarro encouraged Tanguy to consider selling the work of his friends, and Tanguy was persuaded to carry stocks of Cézanne's paintings. He came to admire Cézanne's work greatly, and until the 1890s, he was the only dealer in Paris who bought Cézanne's pictures regularly. He kept the paintings in an inner room, showing them only on request, placing them on an easel one after another, in a respectful,

almost religious silence. But in the years when he first stocked Cézanne's work, his desperation at not being able to sell it was so great that he sometimes resorted to extreme measures, such as cutting a still life into sections and attempting to sell 'Just one apple!'

The doubts which Pissarro felt about his paintings were to afflict him throughout his career. He was seldom convinced of the merit of his work, and he veered very rapidly from a sense of achievement to one of discouragement. His lack of confidence was not aided by Julie, who would happily have seen him employed in some other, financially more rewarding occupation, and did not hesitate to tell him so. She did not understand the intention of his art at all, and as the years went by and success continued to elude him, she became more and more impatient and sharp-tongued. In spite of this, Pissarro never considered abandoning painting, and his daily routine of unremitting application to his work continued. When reminded of his lack of material success he often said, 'Only painting counts.'

He believed that painters would benefit from working together in an artistic community rather than in isolation, and after the move to Pontoise he endeavoured to establish such a community. Béliard, Aguiar, a painter from Cuba, and Guillaumin joined him there. They attempted to put into practice the theories expounded heatedly and at length by the habitués of the Café Guerbois. Early in the morning they set out into the fields to paint, and in the evenings they gathered to discuss their ideas, and to criticize each other's work. They gained a new insight into their own work from these shared sessions, and they were able to advise each other on the technical problems which they experienced. Pissarro was the focal point of the group, for he was able to teach without condescension, and he was humble enough to learn from his colleagues.

He invited Cézanne to join him at Pontoise, and Cézanne arrived in September. Pissarro wrote to Guillemet: 'Our friend Cézanne raises our expectations and I have seen, and have at home, a painting of remarkable vigour and power. If, as I hope, he stays some time at Auvers, where he is going to live, he will astonish a lot of artists who were in too great haste to condemn him.'

Cézanne first stayed at St Ouen-l'Aumone, across the river Oise from Pontoise. He then lived in Pontoise itself for a short time, and in December he moved to Auvers for over a year, until early in 1874. During this time he and Pissarro saw each other constantly, and Cézanne's approach to painting changed.

Cézanne learned much from Pissarro, lessons which affected his attitude to painting throughout his life, but their relationship was not one-sided, and Pissarro benefited from his contact with Cézanne. The

two men went out to paint together, their equipment carried in rucksacks, wearing stout boots and prepared for any vagaries of weather. On their return, they would spend hours at Pissarro's home, discussing theories of colour and arguing about the comparative benefits of painting outdoors and working in the studio.

Pissarro advocated working outdoors, using a light-toned ground, and covering the canvas rapidly with short broken brushstrokes, constantly checking the results with the appearance of the scene before one's eyes. He had stopped using bitumen, and was brightening his palette more and more, although he continued to use browns and ochres. After much discussion, Cézanne had decided that the best way for him to see whether he could accept Pissarro's procedures or not would be for him to take one of Pissarro's canvases and copy it. By doing this, he felt that he would thoroughly familiarize himself with Pissarro's methods.

Pissarro decided to give Cézanne his painting *Louveciennes* to copy, a painting of the trees behind the Pissarros' house at Louveciennes. The choice showed the sensitivity which characterized Pissarro's relations with others. He had already determined that Cézanne, although he could be convinced of the merits of painting patiently and lovingly from the *motif*, was a very different painter from himself and a far more monumental one. The canvas which he selected for Cézanne was unusual in that it was larger than his work normally was. It was the largest painting he had in his possession, measuring 3'7" by 5'4". It was a painting which did not illustrate his working method at its freest and most spontaneous, but one which had been laboured over and reworked carefully.

Cézanne took the painting to Auvers to study it. He chose to copy it using a canvas measuring 2'5" by 3'0" that bore no relationship to the proportions of the original. The result was an interpretation of Pissarro's painting rather than an exact copy.

Cézanne reinforced the knowledge he had gained about Pissarro's approach from this exercise by spending many hours watching him painting. Lucien was to recall how the local peasants enjoyed the sight of Pissarro working diligently at his easel while Cézanne lolled in the grass, observing what he was doing and occasionally asking him a question. 'Your workman does not overtax himself', they would comment to Pissarro as they went past.

Pissarro knew that if he was didactic or pedantic in his dealings with Cézanne, his advice would be ignored. His frank admission of his doubts about his own work endeared him to Cézanne. It was not easy to win Cézanne's confidence, for he bristled with suspicion, and his fears about his ability as a painter asserted themselves in an aggresive

and defiant manner. He had learned to trust Pissarro's honesty and directness over the years, and he acknowledged that Pissarro never attempted to 'get his hooks into him', his great fear in all relationships. Gustave Coquiot was later to say of Pissarro that only he could have overcome the falterings, the fears, and the dislikes of Cézanne.

Pissarro was able to give confidence to other painters and to encourage their attempts by pointing out the worth of their work and by being sensitive to their intentions, even where these intentions were incompletely realized. Cézanne responded to his soft-spoken, gentle manner, and his work changed dramatically in appearance.

He abandoned the imaginary compositions of the 1860s, and he changed his palette, adopting the lighter, brighter palette favoured by Pissarro. He learned to work slowly and patiently, instead of attacking the canvas in a violent, short-lived spasm of energy. He was to say later that it was only when he worked with Pissarro and saw his patient, dogged routine of painting that he developed a taste for work.

He taught Pissarro in his turn, and through him Pissarro gained new strength. The paintings he executed when Cézanne was with him were often bolder and more confidently painted than those done at other times. When he saw the exhibition of Cézanne's work which Vollard arranged in Paris in 1895, Pissarro was to say that Cézanne had been under his influence at Pontoise, and that he had been under Cézanne's. It was the shared nature of their relationship which afforded them so much pleasure. Each sensed the ways in which he could learn and benefit from the other, and their mutual respect was to grow and deepen throughout the 1870s. Cézanne was always a welcome visitor to the Pissarro home. Julie was not intimidated by his shyness and gruff manner, and she bullied him like one of her own family, telling him to write to Pissarro, on a short visit to Paris, not to forget the cereal for Georges or Lucien's shirts, and making him feel that he belonged to the family. The children enjoyed his company and he relaxed in these congenial surroundings, delaying his return to Aix.

Cézanne's sense of his own worth slowly developed, and he began to be more confident about his ability. In December 1873 Duret wrote to Pissarro: 'I shall visit you one of these Sundays, and if it were possible, I should like to see some of Cézanne's work. In painting I look more than ever for sheep with five legs.' Pissarro replied: 'If it is sheep with five legs you are seeking, I believe that Cézanne can satisfy you because he has made some studies that are very strange and are seen in a unique way.'

Pissarro believed that his art and that of his colleagues was a sane art based on sensations, and the discussions of the group at Pontoise were always a prelude to experimentation in front of their easels and in

contact with nature. They would go out in all weathers to set up their canvases in a field or alongside a river bank. On a fine day these excursions sometimes provided an excuse for a family outing, and Julie and the children would accompany them, making a fire and preparing a meal al fresco.

Pissarro also loved theoretical discussion, and he had a preference for information that was made assimilable by being presented in a systematic manner. He distrusted the application of preconceived theory to art, and he and Cézanne shared the view that 'everything is, in art above all, theory developed and applied in contact with nature.' In 1883 Pissarro was to write to Lucien:

'I can see no harm in drawing the nude, the figure, if you are permeated with the idea of not following Legros in the field of Greek theory, and are resolved not to seek formulas, not to be influenced by apt pupils, not to fix the proportions in advance, in a word if you can learn to see for yourself and to draw without relying on a ready made system.'

Cézanne became so painstaking in his application of his new-found beliefs that he had difficulty in finishing a picture, and Dr Gachet recalled that he would go on working on a painting for so long that what had begun as a spring effect in 1873 eventually became a snow effect in 1874. He and Pissarro would attempt to persuade Cézanne to leave a picture, telling him that there was nothing to be gained by reworking it, and occasionally, grumbling and complaining, he would yield to their arguments.

Pissarro's moral support sustained Cézanne, and he permitted himself to be more optimistic about his future than was his wont. He wrote to his mother after his return to Paris from Auvers:

'Pissarro has not been in Paris for about a month and a half . . . but I know that he thinks well of me, who think well of myself. I begin to find myself superior to those around me, and you know that the good opinion that I have of myself has only been reached after mature consideration.'

Pissarro was more optimistic about his own prospects than he had been for some time. An auction sale of the Hoschedé collection at the Hôtel Drouot on 13 January 1873 realized exceptionally high prices. Pissarro had six pictures at this sale, and they were all bought by a dealer called Hagerman, of 1 rue Auber. The prices ranged from 210 francs for a view of the river Oise, measuring only 13" by 18", to 950 francs for *Fabriques et barrage sur l'Oise*, which measured about 22" by 36". He wrote to Duret: 'The effects of the Drouot sale have made

themselves felt as far away as Pontoise. People are greatly surprised that a picture of mine should run up to 950 francs. They even say such a figure is amazing for a mere landscape.'

To Duret's encouraging letters, he replied:

'You are right, my dear Duret, we are beginning to make our mark. We meet a lot of competition from certain masters, but mustn't we expect these differences of view, when we have succeeded - as intruders - in setting up our modest little flag in the midst of the crowd? Durand-Ruel is steadfast; we hope to advance without worrying about opinion.'

As the year went on, his optimism faded. In October he wrote again to Duret: 'I haven't a halfpenny to bless myself with. I have worked very hard and I hope that this year I shall at last put myself beyond the reach of want, at all events during the dead season . . .'

His daughter Jeanne was extremely ill, and for a month he put aside all thought of painting while he and Julie anxiously nursed her. Gachet came to see Jeanne, and Pissarro wrote to him to tell him of the success or otherwise of the various medications he prescribed. When Jeanne finally appeared to be recovering, he and Julie decided that it would be advisable to move to new surroundings. At the end of October the family moved to larger and more pleasant accommodation at 26 rue de l'Hermitage in Pontoise.

Pissarro, Monet and Sisley did not submit work to the *salon* of 1873, but once again Renoir decided to send in an entry. It was rejected, but this time the jury rejected so many works that the inevitable request for a *Salon des Refusés* was upheld, and his work was seen at the special exhibition.

Pissarro devoted much thought to the problem of finding an acceptable alternative to the *salon*. He felt that the best solution would be a co-operative society which would enable painters to exhibit and sell their work without the intervention of dealers, and which would allow each painter to exhibit as many pictures as he wished. He discussed his ideas with Piette, who thought that the theory was laudable, but that Pissarro was headed for certain disaster if he persisted with his plans. He wrote to Pissarro:

'You are trying to operate a useful reform, but it can't be done; artists are cowards . . . Where are those who protested against the exclusion of Courbet from the exhibitions of Paris and Vienna? Should not all painters have objected massively by abstaining? Of solidarity there is not a shred in France. You and some other ardent, generous and sincere spirits, you will have given a legitimate

impulse. Who will follow you? The gang of incapables and blunderers. Then, as these will gain in strength they will be the ones to abandon you. If they can manage to curry favour with the official Salons, they will join these and become your enemies. If you add to this your responsibilities, the disgust for the problems of administration, the breaches of trust committed by unscrupulous employees - for painters, like all artists, are easy to dupe - then you will be drowned in a sea of disappointments, my poor Pissarro. I would say nothing against such an association restricted to people of talent, who work, are loyal, and inspired by enlightened daring, such as you and some of those around you. I would anticipate much of an association of this kind and do believe that it would be profitable and just to establish it, but I am distrustful of the mass of idle and perfidious colleagues without moral or political convictions who only want to use others as a stepping stone. It is that rabble which will be the ruin of your association and which, on the other hand, causes the destruction of France.'

Duret agreed with Piette's views; and he told Pissarro; 'You won't get anywhere with exhibitions put on by special groups. The public does not go to these exhibitions. There will only be the same nucleus of artists and admirers that know you already.' He was convinced that the *salon* was the only place for an artist to establish himself, and felt that 'dealers, art lovers and critics will never look to you anywhere else.'

Pissarro stubbornly persisted with his beliefs, and continued to work for the formation of a co-operative society. He used the constitution of the local bakers' co-operative as a model. At the end of the year an agreement was concluded by which a co-operative society was established. Its formation was reported in *La Chronique des Arts* on 17 January 1874:

'An anonymous co-operative society, of variable size and capital, has been formed by painters, sculptors, engravers and lithographers, for a period of ten years, from the 27 December last, having for its aim, (1) the organisation of free exhibitions, without a jury or honorary reward, where each of the members may exhibit his work; (2) the sale of said works; (3) the publication as soon as possible, of a journal exclusively concerned with the arts.

Until the first general meeting, the society is provisionally administered by MM. Pissarro, Mettling, Feyen-Perrin, Meyer, de Molins, Monet, painters. The provisional supervisory council consists of MM. Béliard, painter; Ottin, sculptor; Renoir, painter. As a result of these nominations, and of the payment of a dozen shares, the society is definitely constituted . . .'

Pissarro was elated by the formation of this society. He believed that through it a modern and healthy art could come into being, not bound by rigid rules and precedents, but experimental and explorative. The organisation of the society on co-operative lines assured every member, regardless of wealth or fame, equal representation, and this permitted a sense of community to be retained, for the members would not be competing against each other.

His pleasure was clouded by Jeanne's illness. He wrote to Gachet on 20 February 1874, describing her symptoms. Although she was free of fever during the day, she developed a high fever every evening. A doctor in Pontoise diagnosed scarlet fever and was concerned about the unnaturally prolonged duration of the disease. Neither this doctor, Dr Menier, nor Dr Gachet were able to cure Jeanne. She died on 6 April 1874, aged nine.

Her death was a severe blow to the family. Pissarro's portraits of his daughter reveal the love and tenderness he felt for her, and he and Julie were extremely distressed by her death. Pissarro believed that work was a solace for grief, and he continued to make arrangements for the first exhibition of the co-operative society, which was to open in the following week.

The exhibition was organized by the committee at the studio of the photographer Nadar, at 35 Boulevard des Capucines. The studio was on the first floor, but a staircase provided direct access from the street. The studio was a prominent landmark in the neighbourhood because it had a large sign outside, and the whole exterior was painted red. The exhibition was scheduled to run for a month, from 15 April to 15 May. It was to be called simply 'An Exhibition of the Society of Painters, Sculptors, Engravers, etc.' Renoir was later to explain why this anonymity had been decided upon:

'The title in no way indicated the tendencies of the exhibitors; but I was the one who objected to using a title with a more precise meaning. I was afraid that it it were called the "somebodies" or "The So-and-Sos" or even "The 39", the critics would immediately start talking of a "new school", when all that we were really after, within the limits of our abilities, was to try to induce painters in general to get in line and follow the masters, if they did not wish to see painting definitely go by the board. "Getting in line" meant, you understand, relearning a forgotten craft. Except for Delacroix, Ingres, and Courbet, who had flourished so miraculously after the Revolution, painting had fallen into the worst sort of banality. Everyone was busy copying everyone else, and Nature was lost in the shuffle.'

Pissarro was in favour of determining the position of each canvas by drawing lots, in order to ensure that each submission received scrupulously fair treatment. Renoir was to recall that 'Pissarro in particular, always filled with his egalitarian theories, wished the position of each canvas to be determined by a draw or vote. For him it was a matter of principle. Happily, we did not listen to him.'

A committee was appointed to be responsible for the hanging, under the supervision of Renoir, but Renoir finally hung almost the entire exhibition himself, and his brother Edmond edited the catalogue.

The walls of Nadar's studio were hung with brownish-red cloth, but the effect pleased the participants, and Degas wrote to James Tissot shortly before the exhibition opened:

'Yesterday I saw the arrangement of the premises, the hanging and the effect in daylight. It is as good as anywhere. And now Henner (elected to the second rank of the jury) wants to exhibit with us. I am getting really worked up and am running the thing with energy and, I think, a certain success. The newspapers are beginning to allow more than just the bare advertisement and though not yet daring to devote a whole column to it, seem anxious to be a little more expansive. The realist movement no longer needs to fight with the others , it already *is*, it *exists*, it must show itself as *something distinct*, there must be a *salon of realists*.'

In all 30 artists exhibited their work. In addition to those artists who have subsequently been regarded as the core of the Impressionist group, Pissarro, Degas, Monet, Berthe Morisot, Renoir, and Sisley, they included Béliard, Boudin, the engraver Félix Bracquemond, Lepic, Lépine, de Nittis, and Rouart. Pissarro had with some difficulty persuaded his colleagues to allow Guillaumin and Cézanne to participate. Degas had been dubious about this, for he feared that Cézanne's paintings would outrage public opinion, but Pissarro was so eloquent about the worth of Cézanne's art that Degas and other sceptics allowed themselves to be persuaded. Pissarro was represented at the exhibition by five paintings. They were *Le Verger, Geleé blanche, Les châtaigniers à Osny, Jardin de la ville à Pontoise,* and *Une matinée du mois de juin*.

The exhibition provoked much the same effect as the *Salon des Refusés* in 1863. Crowds flocked to the studio to see and to jeer, and most of the critics poured forth streams of heavy-handed, uncomprehending ridicule. A few critics showed some perceptivity, among them Armand Silvestre, who wrote in *l'Opinion nationale* on 22 April:

'What is certain is that the vision of things which affects these three

landscapists (Monet, Sisley, Pissarro) does not at all resemble that of past masters: it has a plausible side, and it is affirmed with such conviction that one cannot debunk it. If one is searching for a definition, one will find that it is above all *decorative*. It is an effect of an *impression* which they pursue solely, leaving research into *expression* to devotees of line.'

An article in *La République Française*, published anonymously, but known to be by Philippe Burty, discussed the freshness of colour and the freedom of composition of the pictures, and concluded:

'Let us not dwell too long, but even if some gaps are noticed in these works, even if feelings are registered that are at times as fleeting as the feeling of the freshness of the forest, a breeze of warmth from the hay, the listlessness of an autumn evening, the scent of the sea, the redness of the cheeks or the brightness of a dress - one must be grateful to those young artists who have been able to pursue and catch those impressions. And this is how they have joined their work to that of the Old Masters.'

More typical was the comment of Emile Cardon in *La Presse* on 29 April. 'The famous *Salon des Refusés*, about which one could not speak without laughing, that *salon* where one saw women the colour of Spanish tobacco, on yellow horses in the middle of forests with blue trees, that *salon* was the Louvre in comparison with the exhibition at the Boulevard des Capucines,' he wrote.

The novelty of the exhibition attracted a constant stream of visitors, particularly during the first two weeks. The final attendance figures showed that 2,996 people saw the exhibition during the day, and 514 attended it in the evening. Only 160 catalogues were sold, which was an indication of how few of the visitors were seriously interested in the work on view, and Pissarro earned only 130 francs as a result of sales.

He wrote bitterly to Duret on 9 May: 'Our exhibition goes well. It is a success. The critics destroy us and accuse us of not having studied; I am returning to my work, it is better than reading the reviews. One learns nothing from them.'

Pissarro was again desperately short of money. The critics' scathing comments had turned public opinion completely against his work and that of his associates, who had now been dubbed 'the Impressionists'. *Père* Martin would no longer handle his paintings, and told his customers that Pissarro had no chance of success while he continued to paint in his 'heavy, common style with that muddy palette of his.' The family's need for money was critical, for Julie was pregnant again. Their fourth child, Félix Camille, was born at Pontoise on 24 July.

The 2nd and 3rd Impressionist Exhibitions, 1875–1877

A LL THE participants at the first Impressionist exhibition suffered from the lack of understanding manifested by critics and public alike, but Pissarro was particularly depressed by the reception they had received. He was 44 years old, and beginning to wonder when his years of effort would yield results. Jeanne's death had shaken him, and Julie was more insistent than ever that he was wasting his time and would never be able to provide for his family if he persisted with painting.

Cézanne left Paris suddenly, without even saying goodbye. He wrote from Aix, apologizing for his hasty departure and expressing his sympathy with Pissarro's problems:

'. . . I understand all the troubles you are going through. You really have not had a chance: - always illness in the house . . . But what do you think of the climate in which you live? Don't you think it affects the health of your children? I am sorry about the new circumstances which deter you from your studies, since I know well what a hardship it is for a painter not to be able to paint.'

Guillaumin attempted to cheer up his friend:

'Your letters are truly distressing, even more than your pictures which you say are so gloomy. What is it that makes you always doubt yourself? This is an affliction of which you should rid yourself. I know very well that times are hard and that it is difficult to look at things gaily, yet it is not on the eve of the day where all will turn better that you should give in to despair. Don't worry, it will not be long until you will occupy the place you deserve . . . I do not at all understand the disdain with which you speak of your canvases; I can assure you that they are very fine and you are wrong to speak of them as badly as you do. That is an unfortunate frame of mind which can only lead to discouragement, and that, my dear Pissarro, is not right. The utmost anarchy reigns in the opposite camp and the day is near when our enemies will tumble.'

Théodore Duret analysed the prevailing situation realistically in a letter of 2 June:

'You are beginning after quite a long time to acquire a public of select art lovers, of taste, but they are not the rich patrons who pay high prices. In this small circle, you will find buyers in the 300, 400 and 600 franc class. I am afraid that before getting to where you will readily sell for 1,500 and 2,000 francs you will have to wait for many years . . . The public does not love, does not understand good painting, the medal goes to Gérôme, Corot is left behind. People who understand it and who brave the ridicule and the disdain are few and very few are millionaires. Which doesn't mean that you should be discouraged. Everything is achieved in the end, even fame and fortune, and while counting on the judgement of connoisseurs you compensate yourself for the neglect of the stupid.'

Ludovic Piette evidently did not read the critics' comments on the exhibition, for he wrote to Pissarro:

'And you, my poor old fighter, young in spirit despite your hair turned white too early, what has become of your attempt so well begun, I mean your association and your exhibition? I want to know about your financial success since you were assured of the other. Have your receipts covered the expenses? . . . I hope, my dear Pissarro, that you are not as hard up as I am. But if an inimical fortune is harassing you, too, then at least you should come here: we could make excursions in my horse-drawn buggy and you will find new *motifs* in the surroundings.'

Pissarro decided to accept Piette's invitation. He thought that a change of environment and the company of his friend might lift his depression. On 22 October he wrote to Duret to tell him that he was leaving for Piette's and did not expect to return before January. He intended to use this opportunity to paint studies of figures and animals in the landscape, working on a larger scale than usual. He had thought of doing this for some time, but found difficulty in obtaining models in Pontoise.

On 11 December Pissarro wrote again to Duret to tell him that he was thinking of leaving Piette's farm earlier than originally planned. He requested Duret to send him 100 francs, the price of a painting Duret had bought. He told him: 'I haven't worked badly here. I have been tackling figures and animals. I have several genre pictures. I am rather chary about going in for a branch of art in which first-rate artists have so distinguished themselves. It is a very bold thing to do, and I am afraid of making a complete failure of it.'

Soon after, he changed his mind about leaving Normandy, and remained at Montfoucault until well into the new year. Piette's friendship and encouragement was more valuable than ever to him in his present mood of pessimism and uncertainty about the future direction of his art. He was unwilling to return from the shelter of Montfoucault to the numbing lack of recognition he found in Paris, and, at Piette's urging, he postponed his departure several times.

His colleagues also found that times were very difficult and that only work by the academic painters was selling. Cézanne told his mother : 'It is a very bad time for selling; all the bourgeois are unwilling to spend their *sous*, but this will end . . .' After the reception of the group exhibition, they felt that they could not cope with a second show in 1875, but they desperately needed sales.

Renoir suggested that an auction sale at the Hôtel Drouot be arranged. It was unusual for painters to arrange auctions on their own behalf, but Daubigny had done so in the previous year, and the results attained at the Hoschedé sale encouraged their hopes of success. Duret was in favour of the idea, for he felt that apart from the *salon*, the Hôtel Drouot offered the best means of finding a wide and varied public for painting. Renoir, Monet, Sisley and Berthe Morisot arranged for the sale to be held on 24 March. Pissarro decided not to participate.

The auction of 73 pictures caused a riot, and the police had to be called in to stop altercations which turned into battles. The public howled and catcalled at each bid, and Gygès wrote in *Paris-Journal*: 'We had much fun with the purple landscapes, red flowers, black rivers, yellow or green women and blue children which the pontiffs of the new school presented to the admiration of the public.' Durand-Ruel, who acted in the capacity of expert at the auction, bought 18 paintings, some for himself and some on behalf of the painters. Monet bought back seven of his own pictures. The four artists had the humiliating experience of seeing prices plummet from previous levels, and the auction further undermined the status of Impressionist painting in the eyes of most collectors.

To work his way out of the depression he felt about his work, Pissarro turned back to the painters who had so impressed him in earlier years, attempting through a renewed study of their pictures to retrace his steps and to establish whether he could proceed along another route. He painted a *Sower* in 1875 which was indebted to Millet, a homage to Millet in the year of his death, and he experimented with a change in technique which owed much to Courbet.

In the summer of 1875 Pissarro returned to the use of a palette knife, which he had not employed for many years. Lucien was to recall that

1&2 Rachel and Frédéric
Pissarro. Courtesy of
Dr A. H. Riise, Horsholm,
Denmark

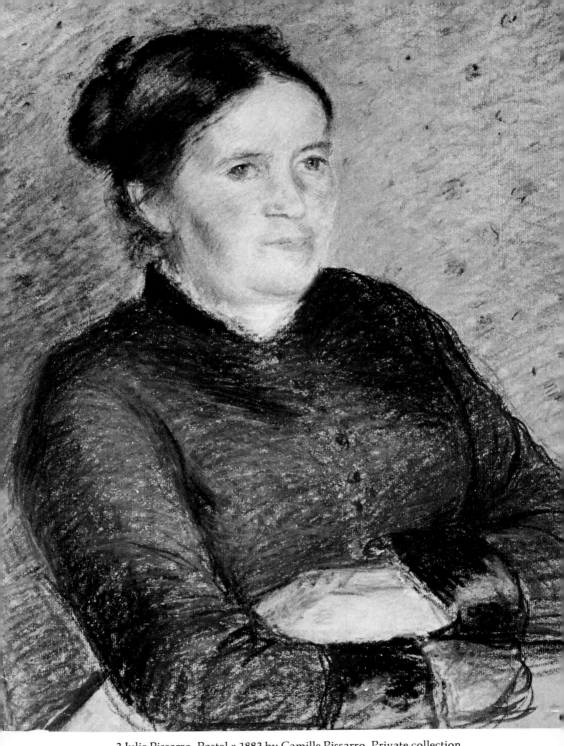

3 Julie Pissarro. Pastel c.1883 by Camille Pissarro. Private collection

4 Rachel Pissarro. Courtesy of Dr A. H. Riise, Horsholm, Denmark

5 'Grandmère (Effet de lumière)': etching and aquatint by Camille Pissarro, 1889.
Museum of Fine Arts, Boston

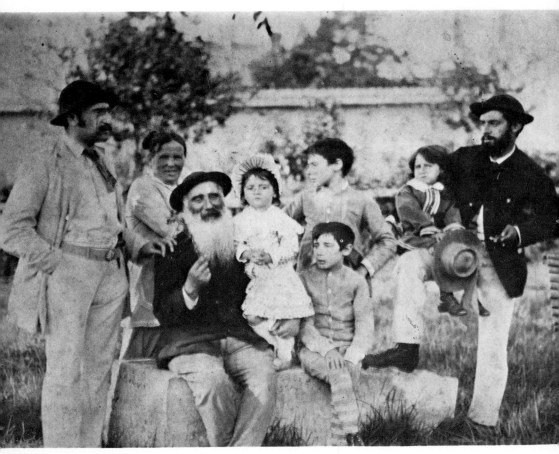

6 Family group at Eragny, 1884: *left to right*, Alfred Isaacson, Madame Pissarro, Camille holding Jeanne, Georges behind and Félix in front, Rodo on Lucien's knee. John Rewald, New York

7&8 Eragny: *above* Camille and Julie; *below* Julie, Paul Emile, Camille and Jeanne. John Rewald, New York

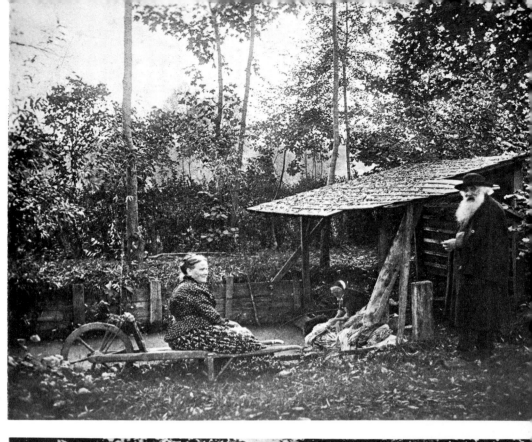

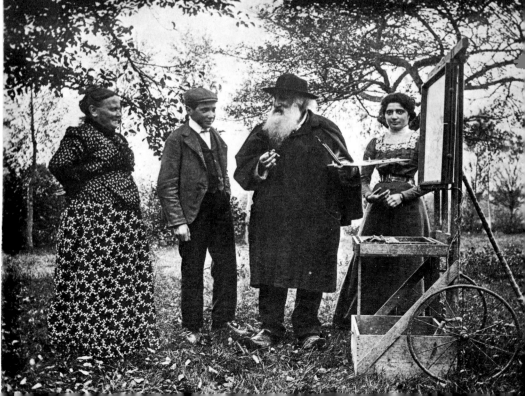

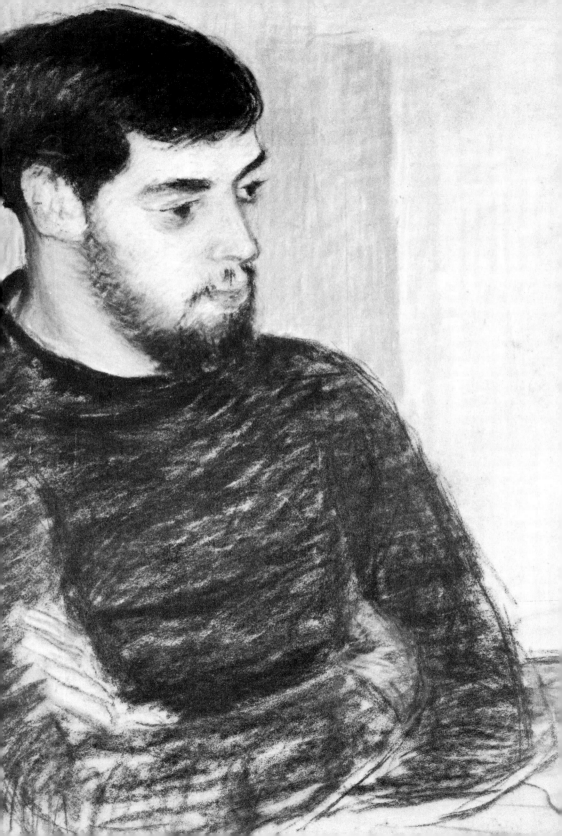

Left 9&10 Lucien and Jeanne drawn by Camille Pissarro. Ashmolean Museum, Oxford

11 *below* Lithograph of Lucien by Camille Pissarro, 1874. Museum of Fine Arts, Boston

12 Félix and Camille Pissarro. Drawing by Lucien Pissarro. Ashmolean Museum,
Oxford

at some point in their association his father and Cézanne bought palette knives to work with. Cézanne must have visited Pissarro during this summer, for he was living in Paris; he continued to find enjoyment and satisfaction in working with Pissarro, although he did not spend a prolonged period at Pontoise or Auvers as he had done previously.

Pissarro painted several bold pictures using a palette knife, delighting in the dense vegetation of summer, and using one of *père* Tanguy's specials, a particularly vivid green, to capture his *motifs*. The emphasis on structure of these pictures was a departure from the general direction of Impressionism, but he found the palette-knife technique limited, and abandoned it after a short time.

He was interested in painting larger and more monumental paintings than he had undertaken to date, and he told Duret on 17 June:

> 'I have always thought about painting, as you advise me to do, a biggish picture with people, people out in the open. There is no lack of subjects; the thing is to find a suitable person in the proper character who would be willing to pose. Money is the only way to get over the difficulty, and money is unhappily just what I haven't got. It is no good thinking of painting anything of a picture save from life, especially on the lines that I want to follow. But never fear. As soon as I see a chance to carry out my plan, I shall take it.'

Pissarro was aware that his own preferences were different from those of Monet or Renoir. He did not share Monet's almost fanatical interest in water and reflections, and he had a greater concern than Monet with painting people. He was never a part of the group which gathered at Argenteuil, although he and Monet were friends, and saw each other regularly in Paris. Both he and Cézanne were uneasy about associating themselves completely with the direction Renoir and Monet were taking. Cézanne had shown from the beginning of their association that although there was much he was willing to learn from the researches into light and colour of the Impressionists, he was not prepared to sacrifice his concern with structure, and he was not interested in capturing a fleeting, momentary effect. He reinforced Pissarro's belief that structure was important, although to him, overriding all other considerations was the importance of harmony.

Pissarro and Cézanne were involved in negotiations to form a new organization to arrange exhibitions, a substitute for the organization which had arranged the first group exhibition, and which had been dissolved in December 1874. In August they participated in the establishment of this new society, called *l'Union*. Like the previous society, it was a co-operative venture, having as its aims the organization

of exhibitions, without a jury, at which every member could show his work, and the selling of the work at terms that were most advantageous to the members. In addition to Pissarro and Cézanne, Edouard Béliard and Alfred Meyer, both of whom had been associated with the formation of the previous co-operative, were members, and Guillaumin also joined the new association.

The co-operative which had organized the 1874 exhibition had lacked the insistence on absolute equality which Pissarro valued. The other Impressionists, Monet, Renoir, Sisley and Degas, were far less politically aware than he was, and they tended either to humour his views or, on occasion, to reject them with hostility, as Renoir was to do some years later when he wrote in a draft of a letter to Durand-Ruel:

> 'I have only one aim in my life, that is to show my paintings. The means I use is not perhaps the best, but it suits me. To show with Pissarro, Gauguin', and Guillaumin is like showing in some kind of commune. Next, Pissarro will invite the Russian Lavrof or some other revolutionary. The public does not like that which smells of politics, and I do not wish, at my age, to be a revolutionary. To remain with the Israelite Pissarro, that is revolution.'

Pissarro was an admirer of the Russian anarchist Kropotkin. He wanted to bring about a society of the kind Kropotkin advocated, one 'in which all the mutual relations of its members are regulated, not by laws, not by authorities whether self-imposed or elected, but by mutual agreements between the members of that society and by the sum of social customs and habits - not petrified by law, routine, or superstition, but continuously developing and continually readjusted in accordance with the ever-growing requirements of a free life stimulated by the progress of science, invention and steady growth of higher ideals . . .'

Pissarro saw in the organization of exhibitions an opportunity to employ these principles, albeit on a small scale, and the manner in which they were arranged was important to him beyond their being a vehicle to display paintings. They were also the expression of some of his most deeply-felt beliefs. He thought that in a co-operative organization, the injustices of the jury system and of the method of hanging at the *salons* could be eliminated, and that art would be enabled to develop without the artificial constraints imposed on it by the inflexible hierarchy of the Academy and the *Ecole des Beaux-Arts*.

To escape his ever-present financial worries, and to consider the future of his paintings in tranquillity, Pissarro returned to the refuge of Piette's farm in the autumn of 1875, accompanied by his family. They spent a pleasant few months there, finding the change of environment

beneficial. Pissarro produced several paintings, and he was fairly pleased with the results of his work. He wrote to Duret after his return that he had worked a great deal and hoped he would be free of financial worries during the 'dead' season, the winter months. He had had the good fortune to meet the collector Antoine Personnaz from Bayonne in this year. Personnaz had bought some of his work and was to remain a supporter of his through the years. He was still in need of further sales in order to consolidate his position, and he was anxious to exhibit his work.

During the winter he worked in the vicinity of Pontoise and the nearby village of Osny, and he made occasional journeys into Paris. On these visits, he and the other members of the Impressionist group discussed the possibility of holding a second exhibition. It was agreed that a second group show should be held, even if it provoked the violent reaction of the Hôtel Drouot sale, and arrangements were made in collaboration with Durand-Ruel.

The exhibition opened in April 1876 at Durand-Ruel's gallery at 11 rue de Peletier. Pissarro exhibited 12 paintings. Degas submitted the greatest number of paintings, 24, while Monet was represented by 18 works, Renoir by 15, and Sisley by eight. Cézanne decided that he would not exhibit with the group, but would continue to submit work to the official *salon*. He was in Aix at the time of the exhibition, but he wrote to Pissarro to tell him that his entries to the *salon* had once again been rejected. As he said, this was 'neither new, nor surprising'. Pissarro regretted Cézanne's decision, but many of the other particip-ants in the show were relieved, since Cézanne's work seemed to inspire the most violent invective from the critics.

Even without Cézanne's presence, critical response was hostile, and Pissarro was singled out for attack by some of the critics, notably by Albert Wolff in *Le Figaro* on 3 April. He wrote:

'Try to make M. Pissarro understand that trees are not violet, that the sky is not the colour of fresh butter, that in no country do we see the things he paints and that no intelligence can accept such aberrations. One wastes one's time as much as one would trying to make an inmate of Dr Blanche's, who believes that he is the pope, understand that he lives in the Batignolles and not in the Vatican . . .'

The majority of the critics were as uncomprehending of the aims and intentions of the Impressionists' work as they had been two years earlier, although there were some favourable comments, such as Armand Silvestre's in *l'Opinion* of 2 April:

'This interesting school with its passionate beliefs and persistence in its attempts, deserves that we pause briefly to contemplate its objectives. Its basic principle is the completely new way of simplification, the very existence of which cannot be disputed. Entirely preoccupied by its justification, its other principle is one of rudimentary harmonies: little concern is given to the form, it is above all decorativeness and colourfulness. Its ideal is, in our modest opinion, absolutely incomplete, but its work will, without any doubt, take its place in the history of contemporary art . . . It has shown an 'open air' as never before; it has brought into fashion a whole scale of particularly bright and charming shades, it has sought new ways of combination. Looking at such refinements, almost dazzling, yet disadvantaged by its lack of conventions, it presents a very brief but very clear analytical impression. As far as I am concerned, I can only compare it to the beauty of a perfect harmony after an avalanche of discords. It is not an orchestra but the tuning instrument.'

This show was a financial disaster for Pissarro, as the earlier exhibition had been. After it closed, the works that remained unsold were auctioned, and the highest bid made for any of the four canvases which he submitted for auction was 230 francs.

He wrote a despondent letter to Cézanne, who replied on 2 July: 'If I dared, I should say that your letter bears the mark of sadness. The business of pictures does not go well, I am afraid you are rather gloomily affected by this, but I am convinced that this is only a passing thing.'

The *Union* group was also contemplating holding an exhibition at this time, and Meyer had made his hostility to some of the Impressionists, Monet in particular, clear. Such an exhibition would have been regarded as being in opposition to the Impressionists, and Cézanne was anxious that this should not occur. He felt that 'since there is a common tendency among some of us, let us hope that necessity will force us to act jointly and that self-interest and success will strengthen the ties which goodwill, as often as not, is unable to consolidate.' Pissarro agreed that the only viable course of action was for the painters whose work had diverged from the official approach to present a united front against the 'enemy', the critics and the *Ecole des Beaux-Arts*. The issue was shelved for the time being because the group could not raise sufficient funds to begin the preparations for an exhibition.

The Impressionists' work was affecting the approach of other painters, as the entries to the *salon* of 1876 showed. Many of the

submissions revealed that the lessons of Impressionism were beginning to be absorbed, but they were being watered down and presented in such a fashion as to be acceptable to jury and public alike, a palatable compromise which found wide favour but which depressed Pissarro and his friends still further. They saw the principles and techniques which they had laboured to achieve used to attain easy success, while they, who refused to bow to public taste, still struggled to provide sufficient for their families to eat.

Pissarro's bitterness at the failure of the exhibition was dispelled by a visit from Piette to Pontoise in the summer. Piette was able to encourage Pissarro, and to make him feel more optimistic. Their relationship was one of few in Pissarro's life where he himself did not provide moral support and encouragement, but could instead rely on receiving it. As had been his custom in previous years, he visited Piette's farm in Normandy in the autumn, and as always, found Montfoucault a congenial environment where he produced work that he considered to be reasonably satisfactory.

He decided to spend more time than usual in Paris in 1877, in order to maintain closer contact with various dealers, and to boost his confidence by more regular meetings with other painters. His depression at the results he obtained increased when he remained in the isolation of Pontoise, and he appreciated the benefits of working in close association with like-minded painters on occasion. He rented a room on the Quai d'Anjou, where both Cézanne and Guillaumin were staying, and the three men saw each other frequently.

They continued their discussions about whether it would be advisable to affiliate themselves completely with the *Union* group, or whether they should remain affiliated to the Impressionist group. They finally decided that the time was not yet ripe for a division in the ranks of those who opposed the *Ecole des Beaux-Arts* and the Academy, and all three resigned from the *Union* group. The group was disbanded without having held an exhibition.

Pissarro, Cézanne and Guillaumin participated in the third Impressionist show, which was held in premises close to Durand-Ruel's gallery at 6 rue de Peletier, in the Salle Le Peletier, in April 1877. The Salle Le Peletier was on the site of the old opera, which was destroyed by fire in October 1873. Guillaumin wrote to Dr Gachet: 'The expenses, which will probably be rather heavy, are to be borne by the two or three millionaires of the gang (as an advance). They will be reimbursed with the entrance fees. Should a deficit remain, it will have to be met by the exhibitors under conditions which have not yet been fixed . . .'

Pissarro submitted 21 paintings to the show, mainly landscapes of the Pontoise region, but also several paintings of Montfoucault. As

before, a rash of hostile criticism greeted the exhibition, and spectators came mainly to laugh at the paintings, understanding what they saw no better than they had done at the first exhibition. 'Baron Grimm', writing in *Le Figaro* on 5 April, had this to say:

'The opening for the press of the Salon of the Impressionists has taken place today. It is without doubt that one must attribute the hail and snow that has inundated Paris the whole of the afternoon to this artistic occasion. An unhealthy curiosity guided us to the premises where the horror museum, calling itself the Exhibition of Impressionists, is having its display. It is well known that the aim of the impressionists is to make an impression. On this point the painters, who are dedicated to this lofty idea, are hazardous as well as non-artistic, are easily attaining the results they pursue; they do make an impression, but perhaps not the one intended. Seen in its entirety the exhibition of the Impressionists resembles a number of freshly painted canvases upon which has been spilled a stream of pistachio, vanilla or redcurrant icecream.'

To coincide with the exhibition, the journal which had been envisaged when the co-operative society was first formed in 1873 appeared for the first time. It was called *l'Impressionniste: Journal d'Art*, and it was edited by Georges Rivière, who wrote most of the articles himself. It appeared weekly during the month of April, from the 6th to the 27th, and then ceased to exist. It was intended to counter and to answer some of the hostile criticism which the three Impressionist exhibitions had received, and it was lavish and fulsome in its praise.

Rivière wrote: 'What enchantment, what remarkable works, what masterpieces, even, are accumulated in the salons at the Rue Le Peletier. At no other time has an exhibition its equal been offered to the public . . .' The artists involved might be excused for welcoming wholehearted, if partisan, praise, for they were accustomed to being reviled in the most excessive terms. As Duret commented: 'The majority of the visitors were of the opinion that the exhibiting artists were perhaps not devoid of talent and they might have executed good pictures if they had been willing to paint like the rest of the world, but that above all they were trying to create a rumpus to stir up the crowd.'

The struggle for recognition, 1878–1879

PISSARRO was beginning to believe that his work would never achieve recognition. 1877 was another severe financial crisis point, and Julie continued to condemn his way of life and the fact that it did not provide adequately for them. His children were showing signs of talent in drawing; one of their enterprises was a book of sketches of everyday incidents, an illustrated journal of life in the Pissarro household, which included drawings of Julie in a violent rage attacking Pissarro with her fists. He always attempted to circumvent her accusations, and retreated wherever possible.

Pissarro was not the only member of the Impressionist group who was in financial straits. Shortly before their exhibition opened, Degas wrote to Faure, one of the most enthusiastic collectors of the Impressionists' work: 'Your pictures would have been finished a long time ago if I were not forced every day to do something to earn money. You cannot imagine the burdens of all kinds which overwhelm me.' Renoir wrote to the publisher Charpentier:

'May I ask you if it is within possibility nevertheless, the sum of 300 francs before the end of the month . . . Now, my dear friend, have the amiability to thank Mme Charpentier warmly on behalf of her most devoted artist and I shall never forget that if one day I cross the tape that it is to her that I owe, for by myself I am certainly not capable of it . . .'

A year later, Monet was to write to Charpentier in his turn:

'I am literally penniless here, obliged to petition people, almost to beg for my keep, not having a penny to buy canvas and paints . . . I have called on you this morning in the hope of arranging a small deal, no matter how small, so as not to go home with no money. I was unable to see you and greatly regret it. I will send you a painting I think you will like. I ask you 150 francs for it, or, if that price seems too high, 100 francs . . . If the picture is not what you want, I will change it for another when I come back . . .'

The Impressionists were reduced to hawking their work around to all possible buyers, desperate for sales at any price. Renoir was to recall coming to a house one day, a painting under his arm, only to be told: 'You are too late. Pissarro has just left, and I have taken a painting of his. A human consideration: he has such a large family. Poor chap!' Renoir was understandably annoyed by this. He told Murer the story that night at dinner in Murer's flat, which he and Pissarro had decorated, demanding, 'What, because I am a bachelor and have no children, am I to die of starvation? I'm in just as tight a corner as Pissarro, yet when they talk of me, no one says, "That poor Renoir" '.

Shortly after the close of the third exhibition, on 28 May, Pissarro, Sisley, Renoir and Caillebotte arranged to hold an auction of 45 paintings at the Hôtel Drouot, although the auction held there two years before had been so damaging. The expert was a former associate of Durand-Ruel's, Legrand, who had recently opened a business of his own at 22 *bis* Rue Laffitte. As before, the public came to jeer, and the painters received little support. The total amount received for the pictures was 7,610 francs. Pissarro had 13 paintings in the sale, and he received amounts ranging from 50 to 260 francs for them.

Even those prices were better than the amounts he received from those dealers whom he could induce to handle his work. Petit and Latouche paid him only 50 francs for the pictures they occasionally took. Eugène Murer, supposedly a friend, amassed a substantial collection at similar prices, paying 50 francs for all canvases up to size 20, that is, approximately 2'5" by 2'0", and 150 francs for portraits.

A few weeks before the opening of the Impressionist exhibition, Piette held a one-man show in Paris. He wrote bitterly to Pissarro in Pontoise:

'The gentlemen of our association have not appeared (except for Cézanne and Guillaumin). If you had been here I am sure you would have shown up. Why? Because independent even of your friendship, a feeling of solidarity would have prompted you to do so. Since we wish to fight against a common enemy, we should enter into a sincere pact. You are doing this, while Renoir and Monet only see in the annual association . . . a means to use the others as the rungs of a stepladder. Their talent, which obviously is very great, has turned them into egotists . . . And on Monday we shall go to *our* Salon; since we are paying for it, this word can well be used. I rather fear that it will be difficult to obtain anything but dark corners, and that all the good walls will be taken over by Renoir and Monet . . . In my opinion, the places of honour should go to capital works by Renoir, Monet, Pissarro, but I do not think

that all the choice spots should be occupied by Renoir and Monet; they should also hang some of their own paintings in the darker rooms. In this fashion there would be well-lit spaces for everybody . . . But it won't be easy to make them admit this.'

Piette's letter is an indication of the split which existed in the ranks of the Impressionists. Monet and Renoir were opposed in some respects to Pissarro, Cézanne, Guillaumin and Piette, and the group exhibitions were already doomed to failure because of this. They continued to be held only because the participants recognized the need to present a unified and strong front to the public and critics. Pissarro was distressed about the difficulties in organization and hanging which the 1877 show revealed, but he was adamant that the exhibitions should continue. He did not consider the possibility of submitting his work again to the *salon*, and he did not agree with Manet that the *salon* was the only real field of battle. He was convinced that it was only by showing its independence from the *salon* that the new art would make its mark.

During 1877 Piette died at his Paris home in Montmartre. His death was a blow to Pissarro. Piette had been a close friend for many years, and he had sustained Pissarro both financially and psychologically over difficult times. He had always been willing to assist Pissarro as best he could, often by accommodating the family willingly on his farm. Pissarro had enjoyed Piette's company, and Piette had been receptive to his ideas, although he did not accept all Pissarro's social and political views. Pissarro admired his work in gouache and used to tell friends, 'If you want good advice, buy Piette.'

Cézanne came to Pontoise to visit Pissarro in the summer of 1877, and the two men resumed their shared painting expeditions in the region with keen enjoyment. Pissarro was strongly affected by Cézanne's work, and he produced some of his most Cézannesque paintings at this time, paintings which resemble the work Cézanne had done on a visit in 1874.

Pissarro's scant confidence in his own work, and his open-mindedness and ability to perceive the essential qualities of the work of others made him susceptible to many influences. In his relationship with Cézanne, and with Armand Guillaumin, the mutual interchange of ideas and the close contact they shared at times led to an acknowledgement of the similarity of some of their pictures. Guillaumin was to say, 'Certainly, Pissarro, Cézanne and I had similar ideas at a certain time, but the ideas and the opinions, like all things, changed . . .' Pissarro was sometimes accused of plagiarism, and Gauguin was later to defend him against these accusations, saying with uncharacteristic generosity:

'If we observe the totality of Pissarro's work, we find there, despite fluctuations, not only an extreme artistic will, never belied, but also an essentially intuitive, pure-bred art . . . He looked at everybody, you say! Why not? Everyone looked at him, too, but denied him. He was one of my masters and I do not deny him.'

Pissarro met Paul Gauguin when he was still employed as a stockbroker. Emile Schuffenecker, Gauguin's friend and colleague, to whom he referred disparagingly as *le pauvre Schuff*, introduced the two men in 1877 or 1878. Pissarro was flattered by Gauguin's interest in his own work and in the art of the other Impressionists, and he enjoyed discussing painting with him, explaining the concepts which formed the basis of his approach. Gauguin already knew some of Pissarro's work from the group exhibitions, and from his study of the paintings in the collection of his guardian, Gustave Arosa, and Arosa's brother, Achille. Gustave Arosa owned three of Pissarro's pictures, and Achille Arosa owned five.

Pissarro introduced Gauguin to Guillaumin and to other members of the group, and they met frequently. Gauguin had begun painting himself several years before, and had exhibited a painting at the *salon* of 1876, but he was an amateur painter, finding time to paint only on weekends and in the evenings. Pissarro was able to assist him with simple technical problems, and to advise him on stylistic matters. His instruction was designed to encourage Gauguin to formulate his own approach, and he was never patronizing or contemptuous of Gauguin's fumbling efforts to master the craft of painting. Pissarro also recognized Gauguin's usefulness to the Impressionists as a collector and patron at a time when such men were desperately needed. Gauguin was reasonably well off, and interested in collecting the work of his new-found friends. Their friendly attitude to him was not entirely due to this, but they were prepared to devote more time and patience to him than they might have lavished on an amateur artist who had no intention of buying their pictures.

Much of Pissarro's time during these years was devoted to finding buyers, to ensure that his family would be provided for during the winter months, when sales invariably dwindled to nothing. Eugène Murer offered to help Pissarro and Sisley by organizing a lottery, with a painting as the first prize. The interest which this project generated was so slight that the draw had to be postponed from the original date set, Monday 5 November 1877, to the following day when nobody arrived for the draw on the allotted day. Murer invited Dr Gachet to be present for the event, but it was a disappointing spectacle. The winner, a young girl from the neighbourhood of Murer's shop, was completely

bewildered by her prize, and suggested timidly to Murer that if he had no objection, she would prefer a cream bun to the picture, an arrangement which Murer found quite satisfactory.

In May 1878 Théodore Duret published a book devoted to his friends the Impressionists which he called simply *Impressionist Painters*. Duret was in a good position to know what the aims and intentions of the new school were, for he had followed its struggles through the years, frequently assisting by purchasing canvases or by offering advice and encouragement. His books provided the Impressionists with some cheer at a particularly depressing time, when sales were negligible and the friction between the members of the group was becoming increasingly apparent.

Renoir decided that the time had come to return to the *salon*. His entry, *The Cup of Chocolate*, was accepted by the jury. His decision not to submit work to the *salon* in the previous five years had been made on the grounds of necessity, after repeated refusals. He was never strongly opposed to the *salon* system on principle, as Pissarro was, and he had been the last of the group to abandon the *salon*. He explained his decision in a letter to Durand-Ruel:

'There are in Paris scarcely 15 art lovers capable of liking a painting without Salon approval. There are 80,000 who won't buy an inch of canvas if the painter is not in the Salon . . . I don't want to waste my time in resentment against the Salon; I don't even want to give that impression. I believe one must do the best painting possible. That's all . . . My submitting to the Salon is entirely a business matter . . .'

Durand-Ruel was finding great difficulty in selling his large stock of Impressionist paintings, and in 1878 he turned his attention to the Barbizon school. He held a mammoth exhibition of their work, a commemorative show, for many of the members of the group had died in the past few years, Corot and Millet in 1875, Diaz in 1876, and Daubigny in February 1878. 88 Corots and 30 Courbets were on view among the 300 exhibits, and 32 paintings by Delacroix were included in the exhibition. In addition, Durand-Ruel held a special exhibition of Corot's work in June.

The Impressionists had to sell their own work because of Durand-Ruel's failure to promote it. Pissarro decided that he would move to Paris for a time, and in November he wrote to Duret:

'I am moving next Tuesday to no. 18 rue des Trois Frères, Paris. I shall do everything I possibly can to scrape up a little money, and I shall even try and fix up some business with Martin if an

opportunity should offer. But you can imagine what a bitter pill that will be for me to swallow, after being so greatly disparaged by him, for he openly declared to all and sundry that I was hopelessly out of the running. My customers took it all in. I was even afraid that you would be influenced by him. In any case, if you can, recommend me some new clients. I shall be delighted to carry out their behests, for it is no use counting any further on Martin's friends.'

His new lodgings were not suitable and he wrote again to Duret in a very depressed state, telling him that the rooms were inconvenient not only for himself, but also for any collectors who might wish to review his work. He added:

'I have had recourse to Portier to beat up the neighbourhood. He certainly doesn't put much energy into the business, his coldness of disposition being against that, but all the same I am glad to have found someone willing to undertake the task. So you see business is dreadful. Soon I shall be an old man, my sight will be failing and I shall be no better off than I was twenty years ago.'

In spite of his despondency, on hearing that Guillaumin, equally dispirited, was thinking of giving up painting, he wrote to Murer, 'It seems to me, that if I had to begin over again, I should do precisely the same thing . . .'

He hoped that attempts to sell his work outside France would find a more favourable reception, and he arranged to send several pictures to the United States through the dealer Legrand. The reception they were accorded was worse than that which they were given in France. Public opinion was totally opposed to the work, which was regarded as being completely incomprehensible and incompetent, and it was felt to be 'so bad that it was decided to send back the whole lot, bag and baggage.'

Pissarro exhibited work for the first time in Italy in September 1878. The Italian critic Diego Martelli was impressed with his paintings, and saw in them an affinity to the work of the Italian Macchiaoli group, whom he admired. He defined the objectives of the Macchiaoli as follows:

'To be charmed by a tonality that nature presents, to translate it with colour so that in this translation are reflected all the effects of nature herself and all the sensations which the soul of the artist has experienced.'

Martelli persuaded Pissarro to send two pictures to an exhibition of the *Promotrice Fiorentina* in Florence. Pissarro submitted two recent works, *Landscape, outskirts of Pontoise* of 1877, and *In the vegetable garden* of 1878.

He wrote to Murer, 'I have sent two canvases to Italy. Will the Italians react as the Parisians and the Americans did?' He found that they did, and his work was slated by the critics. Martelli bought the two pictures himself, and on his death in 1896, they were bequeathed to the *Galleria d'Arte Moderna* in Florence.

Pissarro had not been optimistic about the chances of success in Italy, but he was disappointed by this further setback in a year of difficulties and struggle. He complained to Murer of the difficulty of achieving anything, while the need to eat remained. An article in *La France* at this time praising work of Henner and Vollon, *salon* painters who had adopted certain impressionist techniques, evoked a resigned response from him, for he had abandoned hope of recognition from the critics of most of the newspapers and journals, and pinned his hopes on those collectors who were interested in Impressionism.

He found that watercolours, being smaller and cheaper than oil paintings, provided him with a small but consistent income, and dealers like Martin and Portier who were loath to accept oil paintings were willing to handle watercolours. Duret suggested to him that etchings might prove popular in London, where there appeared to be a demand for graphic work, but Pissarro did not have the confidence to branch out in this direction at this time. He wrote to Duret:

'I shall never venture to believe that such formless attempts at etching as mine could find sale in London. I have had neither time nor means to pursue my attempts: I should have required two or three years of real hard work. The necessity of selling impels me to the water-colour, so etchings are set aside for the time being.'

His need to provide for his family was increased when, after a difficult pregnancy, Julie gave birth to another son on 21 September 1878. He was named Ludovic Rodolphe after Piette. Julie was even more despondent than Pissarro himself, watching with growing foreboding as Lucien showed a developing talent for painting and drawing. She attempted with all the means at her command to dissuade Lucien, now 15, from following in his father's path, pointing to Pissarro's financial failure and lamenting Lucien's lack of interest in a business career.

She urged Pissarro to take Lucien out of school, saying that he was now old enough to start earning and ought to be trained to follow some useful occupation. Pissarro's brother Alfred, with whom he had little contact, for he considered him to be too bourgeois, supported Julie. He said that it was important for Lucien to learn a trade that would enable him to support himself and perhaps to aid his family.

Pissarro was opposed to this plan, and was anxious for Lucien to

remain at school for as long as possible, but Julie and Alfred continued to press for Lucien's removal from school, and as so often happened in family matters, Pissarro was finally worn down by their persistence, and had to agree that it would be beneficial to the family finances to have one less child to provide for.

Lucien moved to Paris, and on 10 June 1879 wrote to his mother that he had arrived 'safe and sound.' He stayed with his grandmother in the rue Paradis Poissonière. Rachel was cared for by her granddaughter Amélie, the youngest of the five children of Emma and Phineas Isaacson. Amélie worked as a milliner in Paris.

Lucien was found of Amélie, and glad to have her company, but he did not enjoy life with his grandmother, and he found his uncle Alfred's lectures on the desirability of achieving success in the commercial world tedious. His work, which was wrapping and stringing parcels, was quite without interest, and he made so many mistakes that his employer finally wrote to Pissarro, 'Your son is a good lad, but he has no head for business and I doubt if he ever will have.' This did not surprise Pissarro, and he was delighted to welcome Lucien home. Julie was forced for the moment to abandon her plan to see him settled in business. She began to realize that her efforts to turn Lucien from painting would yield as little result as the attempts her husband's parents had made to convince him of the folly of the course he was following.

CHAPTER 8

The 4th and 5th Impressionist Exhibitions, 1879–1880

THE FOURTH group exhibition opened at 28 Avenue de l'Opéra in April 1879. Renoir, Sisley and Cézanne did not participate, and the show was described as an exhibition of 'Independent Artists' to try and avoid the emotional connotations which attached to the word 'Impressionist'.

Cézanne wrote to Pissarro at the beginning of the month to explain his decision not to exhibit:

'I think that in the middle of the difficulties raised by my submission to the Salon, it would be fitting for me not to take part in the Exhibition of Impressionists. From another point, I would avoid the fuss created by the moving of my canvases. After all, I leave Paris in a few days . . .'

Sisley told Duret his reasons for leaving the group in a letter of 14 April:

'I have become tired of vegetating, and the time is ripe for me to make my decision. It is true that our exhibitions have been useful in making our names known, but I think it is time to come out of hiding. We are still a long way from the position where it should be possible to ignore the prestige attached to official exhibitions. So I have decided to send some paintings to the Salon. If I am accepted, which is perhaps possible this year, I think I may get somewhere, and so I am appealing to all my friends who are interested.'

His plan did not succeed, for the jury rejected his submission. Totally penniless, he was evicted from his lodgings and had to appeal to Charpentier to assist him in renting another flat.

Renoir decided to submit to the *salon* again, and both his entries were accepted. One was a portrait of the actress Jeanne Samary, the other a portrait of Mme Charpentier and her children, for which Charpentier had paid 1,000 francs the year before.

Pissarro and Gustave Caillebotte were largely responsible for the organization of the exhibition. They worked with energy and

enthusiasm to collect paintings, and to hang the work so that the absence of three members of the original group would not make the display seem inadequate. Pissarro showed 37 paintings, seven of which belonged to Caillebotte, and Caillebotte himself had 25 paintings on view.

On the opening day, 10 April, Caillebotte wrote to Monet, who had remained at Vétheuil, that receipts for the first day's sales totalled 400 francs, 50 francs more than the first day's receipts at the previous exhibition. He was optimistic about the possibility of success. Caillebotte and Degas had disagreed sharply several times over the organization of the show. Caillebotte found Degas crusty and difficult to please, and he told Monet of the problems he had encountered. 'Don't think, for instance,' he wrote, 'that Degas sent his 27 or 30 pictures. This morning there were only eight canvases by him. He is very trying but we have to admit that he has great talent.'

Huysmans compared the exhibition to the entries at the *salon* in his review of the *salon*, which opened on 17 May:

> 'But more interesting are those spoil-sports, so much in disgrace and so frowned upon - the Independents. I do not at all deny that there are among them people who do not know their job properly, but take a man of great talent, M. Degas, take even his pupil Miss Mary Cassatt and see if the paintings of these artists are not more interesting, more unusual, more refined than all these small fumbling unknowns who cover the walls in the immense hall of the Exhibition . . .'

Pissarro, Degas and Mary Cassatt exhibited fans at this exhibition. Degas was attracted to the idea of decorating fans because of his love of Japanese art, while Pissarro, who was always intrigued by the challenge of different technical problems, enjoyed overcoming the compositional difficulties posed by the format. A practical consideration was also a reason for producing the fans; like the watercolours, the fans were more easily sold than oil paintings. Pissarro's fans were not Japanese in character. He admired the art of Japan, and he was to write to Lucien after visiting an exhibition of Japanese art at Georges Petit's gallery a few years later; 'I have observed in the art of this extraordinary people . . . a calm, a grandeur, an extraordinary unity, a rather muted éclat which is nevertheless striking; it is surprising in its sobriety, and what taste!' But Japanese art did not affect the appearance of his paintings, as it did that of many of his colleagues, Degas and Monet among them.

Pissarro found that experimenting with different techniques overcame the dissatisfaction he felt with his pictures. He believed that a

sound knowledge of his craft was of vital importance to the artist, and he attached a great importance to *métier*, which he knew thoroughly, working constantly to perfect techniques, never content with what he had already achieved.

Perhaps with Duret's words about the suitability of etchings for the London art public in mind, he began to make etchings. He had experimented with the medium before many years earlier, and again in 1874, when Dr Gachet had persuaded him to try his hand. These etchings were simple, and he had not been interested enough to continue making them. Now he became absorbed in producing complicated and elaborate examples, combining different processes, and enjoying the discovery of the potential of the medium and the possibility of new approaches.

He worked in close association with Degas and Mary Cassatt, and the three evolved the idea of producing a publication containing a number of graphics. They decided on a title, *Le Jour et la Nuit*, and held frequent meetings to discuss their contributions and how they could make the project a reality.

Degas discussed the venture with Caillebotte shortly before the exhibition of the Independent Artists ended, in the hope that Caillebotte would give it financial support. Caillebotte recognized the possibilities which such a publication could offer, and in spite of his earlier irritation at Degas's unco-operative behaviour, he agreed to assist. Degas wrote to Félix Bracquemond: 'I spoke to Caillebotte about the journal . . . He is willing to guarantee for us. Come and talk it over with me. No time to lose!' Bracquemond was a talented graphic artist, and Degas hoped that he would contribute to the journal.

When Pissarro was in Paris, he and Degas worked together. Occasionally they consulted Bracquemond for technical advice, but they derived great pleasure from ignoring his advice or from pursuing exactly the opposite course to that which he suggested. They were attempting to find personal solutions to the problem of etching, and as they had moved far beyond the limits of accepted painting practice, so in their graphic work they were eager to break 'rules' and to free themselves from constraints.

When Pissarro returned to Pontoise, he continued to produce etchings, although the facilities which were available to him were limited. Degas told Bracquemond on 13 May, 'Pissarro has just sent, via the Pontoise carrier, some attempts at soft-ground etchings . . . Pissarro is delightful in his enthusiasm and faith.' He wrote to Pissarro:

'I compliment you on your enthusiasm. I hurried to Mlle Cassatt with your parcel. She congratulates you as I do on this matter. Here

are the proofs . . . The plate is not smooth enough. I feel sure you have not the same facilities at Pontoise as at the rue de la Huchette. In spite of that you must have something a bit more polished . . . Try something a little larger with a better plate . . . So do also try something a little more finished. It would be delightful to see the cabbages very well defined. Remember that you must make your debut with one or two very beautiful plates of your own work.'

In another letter, Degas wrote:

'Mlle Cassatt is trying her hand at engravings, they are charming. Try to come back soon . . . I am beginning to advertise the journal on various sides. With our deliveries of proofs *avant la lettre* we shall cover our expenses. That is what several collectors of engravings have told us.'

The publication never appeared in spite of the energy and determination shown by Pissarro, Degas and Mary Cassatt. At the last moment the financial support promised by Caillebotte and by the stockbroker Ernest May was withdrawn, and without their backing the project collapsed.

Mary Cassatt was very attached to Pissarro. She liked his gentle manner and his humility, and she admired his ability to teach without being insistent or overbearing. She said of him: 'He was such a teacher that he could have taught stones to draw correctly.' She attempted to help him by praising his work to her American friends, and encouraging them to purchase his pictures. On one occasion she wrote to him asking him whether he would be willing to give three American girls lessons, and he replied that while he would be delighted to do so, he felt that he could make no charge for such lessons.

Two years after their collaboration on the *Jour et nuit* project, Pissarro and Miss Cassatt were virtual neighbours at Pontoise, and they sometimes went out together *sur le motif*. Miss Cassatt was content to watch Pissarro at work and to enjoy their discussions on these expeditions, for she was not a landscapist.

Paul Gauguin had been admitted to the 1879 group exhibition, where he had shown a piece of sculpture. His inclusion had been a gesture of goodwill and of thanks, for he was spending a sizable proportion of his substantial income on amassing a collection of work by Pissarro, Monet, Guillaumin, Cézanne, Renoir, Sisley and Manet, and his support was sorely needed.

Pissarro invited him to spend some time at Pontoise during the summer. Gauguin accompanied him on his daily painting excursions as Cézanne had done earlier in the decade. Unlike Cézanne, Gauguin

was still a novice in many respects, and Pissarro showed him how to prepare his own canvases. Pissarro's dogged, unremitting working pattern was a revelation to Gauguin, as it had been to Cézanne, and on this visit he began to sense something of Pissarro's attitude to nature. He saw that he had much to learn from Pissarro's tenacity, and that his mild manner hid great determination and courage. On his return to Paris, Gauguin wrote excitedly to Pissarro to tell him that he had purchased 80 francs worth of paints at Tanguy's and had prepared the canvases for some new paintings, putting Pissarro's instruction into practice.

Pissarro was uneasy with Gauguin, wary of his arrogance and his selfishness, although he tried to ignore these traits. He was fond of Mette, Gauguin's Danish wife. He grew to know Gauguin well as they worked in each other's company. Gauguin responded to Pissarro's warmth and kindness, and to his concern for his fellow men. They were to sum up their assessments of each other in the twin portrait they did, in which Gauguin represented Pissarro as a gentle, benevolent figure, while Pissarro drew Gauguin with harsh lines, showing him as brutal to the point of violence.

In 1880 the arrangement of a group exhibition proved to be even more difficult than it was in the previous year. The disagreements between Degas and Caillebotte were more marked, and their antagonism threatened the organization of the show. Degas grumbled to Bracquemond:

> 'There was a great fight with Caillebotte about whether or not to publish names. I had to give in to him and allow them to appear. When will there be an end to the idea of putting us forward as stars? Every good reason and good taste are powerless against the inertia of the others and Caillebotte's pigheadedness.'

Pissarro was completely averse to the idea of being promoted 'as a star', but he shared Caillebotte's belief that it was desirable to name the participants, since the group was very different from that which had exhibited in 1874. The feeling of unity, born of the necessity to present a solid front against the attacks of the critics and of the public, had vanished over the years, and wide divergences in the attitudes of the painters who had constituted the original group were now apparent.

Monet was disheartened by the previous year's exhibition, and he decided to follow Renoir's example and return to the *salon*. He believed that there was no possibility of public recognition without official acceptance. He considered his decision agonisingly, for he continued to believe that the system which the *salon* represented was unjust and stifling. Pissarro was tolerant of Monet's attitude, although he

regretted his action, but Degas was violently contemptuous of it, and refused to accept any justification for it.

Neither Renoir nor Sisley were represented at the group exhibition, both having chosen to submit to the *salon*. Gauguin was included in the participants, and Huysmans remarked that his painting was a dilution of the still hesitant works of Pissarro. A newcomer to the ranks was Jean François Raffaëlli.

The exhibition opened on 1 April for the entire month in premises at 10 rue des Pyramides. Pissarro showed 10 paintings, a fan, and several etchings, including those which had been intended for *Le Jour et la Nuit*. Degas showed only seven paintings, some drawings and a few etchings. At the last moment he withdrew the statuette *Petite Danseuse de quatorze ans* which he had intended to include. The exhibition attracted little attention, and the reviews were indifferent rather than hostile. Most of the participants shared the apathy of the public and the critics, for the group shows had become a burden to organize, and no longer seemed to fulfil their purpose.

One of the most interested visitors to the show was a young man who attempted to sketch one of Degas's works. He was observed, and confronted by an angry Gauguin, who said, 'One does not make copies *here* Monsieur,' and forcibly ejected him. He was Paul Signac, 17 years old and still a student at the Collège Rollin.

To Pissarro and to Caillebotte, the existence of an alternative to the *salon* continued to be an issue of importance. Caillebotte discussed it at length with Pissarro:

'What is to become of our exhibitions? This is my well-considered opinion: we ought to continue, and continue only in an artistic direction, the sole direction - in the final sense - that is of interest to us all. I ask, therefore, that a show should be composed of all those who have contributed real interest to the subject, that is, you, Monet, Renoir, Sisley, Mme Morisot, Mlle Cassatt, Cézanne, Guillaumin; if you wish, Gauguin, perhaps Cordey, and myself. That's all, since Degas refuses to show on such a basis. I would rather like to know wherein the public is interested in our individual disputes. It's very naive of us to squabble over these things. Degas introduced disunity into our midst . . . That . . . he talks with infinite wit and good sense about painting, no one doubts (and isn't that the outstanding part of his reputation?). But it is true that the real arguments of a painter are his paintings and that even if he were a thousand times right in his talk, he would still be much more right on the basis of his work . . . If there is anyone in the world who has the right not to forgive Renoir, Monet, Sisley and Cézanne,

it is you, because you have experienced the same practical demands as they and you haven't weakened. But you are in truth much less complicated and more just than Degas . . . I ask you: isn't it our duty to support each other and to forgive each other's weaknesses rather than to tear ourselves down? . . . I shall sum up: do you want an exclusively artistic exhibition? I don't know what we shall do in a year. Let us first see what we'll do in two months. If Degas wants to take part, let him, but without the crowd he drags along . . .'

Pissarro was not eager to argue with Degas, who had been generous with advice and assistance in the past few years. He felt that it was most important that some form of group exhibition, free of the requirements for admission which applied to the *salon* should continue to exist, but he believed that a certain amount of latitude could be permitted with regard to who was admitted to the shows. He would have been delighted to see more of the original group continuing to participate, but he was prepared to recognize the talent of newcomers.

He did not share Caillebotte's vehement dislike of Raffaëlli. He appreciated that Raffaëlli's interest in suburban landscapes was an extension of the Impressionists' recognition of their urban surroundings as suitable subject matter for art, and he recalled how, less than ten years before, paintings showing the stations, factories, and houses in and around Paris had been derided. Félix Fénéon was to say that Raffaëlli had 'invented the suburban landscape'. He captured the dreariness and repetitiveness of this landscape in a manner which would have been inconceivable without the example of the Impressionists. Pissarro was on friendly terms with Raffaëlli and shared many political views with him, but nothing he could say would persuade Caillebotte of the value of Raffaëlli's work, or of the work of some of the other young painters who sought admission to the group exhibitions.

The 6th and 7th Impressionist Exhibitions: The crisis of Impressionism, 1881–1883

THE SIXTH Exhibition opened at 35 Boulevard des Capucines on 2 April 1881, and was on view until the beginning of May. Caillebotte chose not to exhibit, and Degas submitted only seven paintings and the *Petite Danseuse de quatorze ans*, a wax statuette wearing a real *tutu*. Pissarro contributed the largest number of works of any exhibitor, being represented by 27 paintings and gouaches. Guillaumin showed 16 paintings and pastels, and Gauguin exhibited eight paintings, a wood carving and a medallion.

Pissarro was grieved at the depths of the split in the ranks of the Independents which this show glaringly revealed. Different factions warred with each other rather than with official art, and all his efforts to avert such a situation seemed to be in vain. The criticism of the exhibition was as ill-informed as in the past, and Albert Wolff, always vituperative in his comments, wrote: 'Renoir or Claude Monet, Sisley, Caillebotte, or Pissarro, it's all the same thing; what is particularly strange about these Independents is that they are just as prone to routine as are the painters who do not belong to their brotherhood. Who has seen one picture by an Independent has seen the works of all of them . . .' He wrote of Degas: 'Here is M. Degas, nearly fifty years old and his work still consists, as it did thirty years ago, of interesting experiments. He is the standard-bearer of the Independents. He is their leader. He is adulated at the Café de la Nouvelle-Athènes. And thus M. Degas will reign, to the end of his career, over a small circle. Later, in a better life, he will hover over the constantly-replenished group as a kind of Eternal Father, the God of Failures! Frankly, he might have aspired to better things! Ah well!'

Pissarro had long realized that any attempts to persuade Cézanne to show with the Independents would be fruitless. They continued to be close friends, and in 1881 Cézanne visited Pissarro at Pontoise. In the company of Pissarro and his family, he was able to relax, and was not faced with the ordeal of seeing new faces. He had withdrawn more and more from the Independents' circle for his painting was diverging increasingly from theirs, and on his infrequent visits to Paris he found

the meetings at the Café de la Nouvelle-Athènes a strain. The conventions of Parisian society did not interest him, and he went to the *salon* of Mme Charpentier, the meeting place of the Parisian *avant-garde* only once, in the company of Zola.

When he did visit the Café de la Nouvelle-Athènes, he was inclined to make a point of arriving in shabby, dirty working clothes, and deliberately appearing as uncouth as possible. The novelist Duranty regarded these actions as being 'dangerous demonstrations', and from these infrequent appearances grew the legends which surrounded him. George Moore was to write of him in his *Reminiscences*:

> 'I do not remember ever to have seen Cézanne at the Nouvelle-Athènes; he was too rough, too savage a creature, and appeared in Paris only rarely. We used to hear about him - he used to be met on the outskirts of Paris wandering about the hillsides in jack-boots . . . It would be untrue to say that he had no talent, but whereas the intention of Manet and of Monet and of Degas was always to paint, the intention of Cézanne was, I am afraid, never very clear to himself. His work may be described as the anarchy of painting, as art in delirium.'

At Pontoise Cézanne was not required to conform to the delicate manners of society, and in Pissarro he had a friend who understood his difficult temperament better than anyone else, and who was sensitive to the vagaries of his moods. Cézanne took lodgings at 31 Quai du Pothuis, and he remained in Pontoise from early in May until late in October. He and Pissarro saw each other frequently.

Cézanne worked a little but, as he told Emile Zola, without much vigour. He found his stay in Pontoise restful and enjoyable, with the exception of his encounters with Pissarro's protégé Paul Gauguin, who was also staying in Pontoise for part of this summer, working at Pissarro's side.

Gauguin admired Cézanne's work, but he completely lacked Pissarro's patience and tact in dealing with Cézanne's often strange behaviour. Pissarro attempted to maintain a friendly atmosphere, but without success. Cézanne took a violent dislike to the confident, brash Gauguin, and nothing Pissarro said in his defence would convince Cézanne that Gauguin or his work had any merit. Their meetings were tense, and Cézanne's dislike of Gauguin increased when Gauguin, on his return to Paris, wrote facetiously to Pissarro, mocking Cézanne's intensity in striving for a means of realizing his 'sensations' on his canvas; 'Has M. Cézanne found the exact *formula* for a work acceptable to everyone? If he discovers the prescription for compressing the intense expression of all his sensations into a single and unique

procedure, try to make him talk in his sleep by giving him one of those mysterious homeopathic drugs and come immediately to Paris to share it with us.'

Taking this in the spirit in which it was undoubtedly intended, Pissarro mentioned Gauguin's remarks to Cézanne, and Cézanne 's hostility to Gauguin intensified. Monet used to warn people never to mention Gauguin to Cézanne, because the mere name was enough to make him fly into a rage and threaten to wring Gauguin's neck. He never forgave Gauguin or became reconciled to his work, and years after this incident he was to tell Emile Bernard: 'He never understood me. I have never wanted to achieve, nor will ever approve of, lack of modelling and gradation. It's nonsense! Gauguin's not a painter. He produces nothing but Chinese images!'

For his part, Gauguin agreed with Pissarro that Cézanne was a remarkable painter, and worthy of the most intensive study. He bought several pictures by Cézanne, which he valued highly, and he studied them carefully, with distinct effects on his own approach to painting. Pissarro continued to study Cézanne's methods and approach with great interest, while recognizing that their work had taken different directions. Although Cézanne found himself at odds with the approach of the Impressionists, he copied a gouache of Pissarro's, *Woman Sewing*, in a small drawing as a mark of his personal regard and respect for Pissarro.

During Cézanne's stay in Pontoise, the Pissarro family was again enlarged, this time by the birth of a girl, named Jeanne Marguerite Eva, but nicknamed Cocotte, on 27 August. They were delighted by this, but as before, the new addition to the family roused Julie's anger at her almost grown-up son who contributed nothing to the family coffers. She insisted that Lucien find some form of employment, and again found an ally in Alfred Pissarro, who agreed that the boy should be settled in a trade or business. Pissarro was able to prevail against the opposition of Julie and Alfred, and Lucien remained at home, where he helped his father with the preparation of exhibitions, looked after negotiations and business, supervised the framing and hanging of his father's paintings, and worked with energy and determination at his own paintings and drawings.

His assistance was greatly needed. for the organization of the seventh group exhibition provided more headaches for Pissarro than any previous one had done. In spite of his refusal to show the previous year, Caillebotte was still a believer in the principles underlying the independent exhibitions. He decided to see whether it would be possible to organize a show in which Degas was represented, but which excluded Degas's friends, Raffaëlli in particular. He approached

some of the artists with this plan in mind, and found that they were very stubborn. He reported to Pissarro: 'Degas won't give up Raffaëlli for the simple reason that he is asked to do so, and he'll do it all the less the more he is asked to do so.'

Pissarro told Gauguin the results of Caillebotte's attempts at negotiation, to which Gauguin responded:

'If I am to examine your position objectively, I must admit right away that in the ten years since you have taken on these exhibitions, the number of Impressionists has risen, their talent has increased, and their influence too. But on the other hand, as far as Degas is concerned, and it is his doing alone, the trend is going consistently downhill; each year another Impressionist leaves us and makes way for nonentities and schoolboys. Another year or two and you will all alone among the worst kind of cheap *poseurs*. All your efforts will be brought to nothing and Durand-Ruel will be ruined into the bargain.

With the best will in the world, I cannot see my way to continuing to act the clown for M. Raffaëlli and company. Therefore I must ask you to accept my resignation. From today I shall stay on my own . . . I believe that Guillaumin intends to do the same, but I do not wish to influence his decision in any way.'

Pissarro was disappointed by Gauguin's attitude, and he decided to look elsewhere for support. He approached Edouard Manet, although Manet had always maintained that the *salon* was 'the real field of battle', and had never exhibited with the Impressionists. Manet wrote to his sister-in-law, Berthe Morisot: 'I have just had a visit from that terrible Pissarro, who told me about your coming exhibition. These gentlemen don't appear to get on together . . . Gauguin acts the dictator. Sisley whom I also saw wants to know what Monet is going to do; as for Renoir, he has not yet returned to Paris.'

Manet was gravely ill, tormented by pains in his legs, walking with great difficulty with the aid of a stick, and he was alarmed by the lack of effect of the treatments he tried. For the first time in his life he was exempt from the necessity of submitting his work to the *salon* jury for approval, since his two submissions at the *salon* of the previous year, a portrait of Henri Rochefort and a portrait of Pertuiset, the Lion Hunter, had resulted in the award of a second medal.

These factors influenced his decision not to embark on a new course, but to submit to the *salon* in the usual way. His two entries were a portrait of Jeanne de Marsy, subtitled *Spring*, and the *Bar at the Folies-Bergère*. His decision was not made lightly, and his brother Eugène was to say later that he bitterly regretted not having taken part

in the Independents exhibition, and that had hesitated a great deal over making his choice.

Pissarro was desperate. He concluded that it would be possible to have an exhibition only by handing over the organization to Durand-Ruel. Durand in his turn found that he encountered much resentment, half-expressed grudges, and downright bad temper from the artists, but he persevered with the arrangements because a severe slump in the French economy made it vital for him to hold a successful show.

When he invited Monet to participate, Monet was at first extremely reluctant, but he finally conceded that he would be prepared to exhibit, and even to separate himself from Caillebotte if Pissarro would be prepared to renounce his 'protégés' - Guillaumin, Gauguin, and Vignon. Pissarro wrote to Monet in February 1882:

'I confess that I do not understand anything any more. For two or three weeks now I have been making great efforts - in conjunction with our friend Caillebotte - to arrive at an understanding in order to reassemble our group as homogeneously as possible. Obviously an error must have slipped into the letter which M. Durand-Ruel wrote you, for you may well imagine that we have never separated Caillebotte from our group. Since yesterday I have been anxiously awaiting your reply so as to rush to him and start the job together. This, by the way, had been agreed upon long ago with Caillebotte, who is on our side. His only condition is that we should have you with us. We barely have time left. Please reply immediately if you are joining us . . . For Durand as well as for us the exhibition is a necessity. Personally I should be disconsolate not to satisfy him. We owe him so much that we can't refuse him this satisfaction. Sisley absolutely agrees with me; we are getting on famously . . .'

Monet finally agreed to exhibit on condition that Renoir also participated. When he was approached by Charles Angrand, who said that he wished to join the Impressionist group, Monet told him that the group was breaking up and that the members would head in different directions to find exhibitions.

Renoir was at L'Estaque with Cézanne. He was recuperating from a bout of pneumonia. He was in the process of reconsidering his attitude to painting, and he felt very little inclined to exhibit, particularly since he objected strongly to Pissarro's political views and felt that any association with him would bring the entire group into disrepute. He recognized that he had a debt to Durand-Ruel, and he finally authorized Durand to show his paintings, with the proviso that the catalogue made it clear that the paintings were on view by courtesy of Durand, and not of Renoir himself.

The exhibition opened in the same month as the *salon*, March, at 251 rue St-Honoré. With the exception of Degas, all the major Impressionists were represented. After it became clear that Raffaëlli would not be included in the exhibition, Guillaumin and Gauguin changed their minds about participating, and the third of Pissarro's 'protégés', Victor Vignon, also showed. Caillebotte sent 17 paintings to the exhibition. Pissarro showed 36 works, oils, gouaches, and one distemper, *La Moisson*.

He was delighted that the exhibition had come to fruition. It provided an opportunity to assess the changes and the development which had taken place in the work of the major Impressionists since their first exhibition eight years earlier. He realized that the difficulties which had arisen in the arrangement of the exhibition, and the hostility which existed between various members of the original group made it unlikely that a representative exhibition of this kind would be held again, and that this seventh group show represented a culmination and a summing-up of the movement. It came at a time when all the members of the original group were questioning the bases of their art, wondering whether they had exhausted the potential of the course they had chosen, and what their future direction should be.

Renoir had travelled to Italy, and in his study of Italian art had discovered a new interest in classicism, and in the use of line, which had played almost no part in Impressionism. These interests were reinforced by his close contact with Cézanne. He was later to tell Ambroise Vollard that at about this time 'a sort of break appeared in my work. I had pushed "impressionism" as far as possible, and I came to the conclusion that I could neither paint, nor draw. In fact I had got into a blind alley.' In condemning the approach he had used in his impressionist works, he said: ' . . . out of doors there is more variety of lighting than in the studio, where it is always the same: but that is just the point; out of doors the light takes charge of you; there is no time to attend to composition, and besides, out of doors you can't see what you are doing.'

After the death of his wife Camille two years earlier, Monet felt that he had reached the end of a phase in his work. He began to move around restlessly, looking for new *motifs* such as the cliffs of the Normandy coast, the first time he had painted the sea in almost ten years, and the river Seine at Poissy. He was becoming more and more interested in light and colour, extending his researches into domains which had not seemed possible in the early years of Impressionism.

Pissarro was becoming increasingly interested in theory and technique. Like Renoir, he wished to provide a more substantial background for his approach. He was attempting through research, particularly

into colour theory, to combat the dissatisfaction he felt with the progress of his work. Although his paintings did not not please him, he felt slightly more secure financially than in the past. Shortly before the exhibition opened, he wrote to Duret: 'I am not, as the Romantics say, rolling in money. I am enjoying the fruits of a modest but steady sale. My only fear is a relapse into the old conditions.'

He told Duret on 12 March: 'I am . . . very happy with the arrangements of our exhibition . . . To have reunited . . . Monet, Renoir, Sisley, Mme Morizot [*sic*], Caillebotte, is altogether astonishing.' He wrote to Monet that he was delighted that so comprehensive an exhibition had been assembled, and said that he felt it was absurd for the group to disband after all they had gone through, when the show indicated that they still shared an approach to art, in spite of their individual differences.

Duret agreed with Pissarro that the exhibition was the best the group had ever had, and Eugène Manet, describing the effect of the show to his wife Berthe Morisot, who was travelling in Italy, shared this view. He praised Pissarro's submissions, writing: ' . . . Pissarro is . . . uneven, but he has two or three figures of peasant women in landscapes that are far superior to those of Millet in colour and drawing.' Even the irascible Albert Wolff was better pleased with the exhibition than with previous group shows, and Durand-Ruel was well satisfied with the results of his efforts.

Pissarro began to travel more than he had done in the past, like Monet searching for new *motifs*, and savouring the greater freedom which more regular sales afforded him. He travelled in the Aube and Côte-d'Or regions, to Troyes and to Châtillon-sur-Seine, but returned to Pontoise without having done much painting. He always found that it was necessary for him to remain at a place for some time before he was able to render it on his canvas.

In the autumn he went with the family to visit Piette's widow on the farm at Montfoucault. He announced his departure to Duret on 28 September, saying that he hoped to find the peasants at his disposal, since he was becoming increasingly interested in figure studies. In these studies the figure dominated the canvas, in contrast to the small figures which he had included in his landscapes in earlier years. This was the first time he had visited Montfoucault since Piette's death. He found the surroundings and the friendly welcome of Mme Piette a stimulus to work, and completed several pictures.

He and Julie decided that the house in Pontoise was too cold and damp for them to spend another winter in it. The family moved to the Quai du Pothuis, where Cézanne had lodged, and then to the village of Osny, about two miles from Pontoise. Years before, Cézanne had

wondered whether the climate of Pontoise did not adversely affect the health of the children, and now Pissarro was forced to agree, although he still enjoyed painting in Pontoise and found its position in relation to Paris convenient.

He was afflicted by eye trouble in this year. He feared recurrently that he would lose his sight, and for a time an ulcer affected his left eye so badly that he wondered whether he would be able to paint again. Slowly the ulcer healed, but the condition was to return again. Ironically enough, it was at this time that the critics began to accuse the Impressionists of suffering from some form of eye disease. In the following year Pissarro was to write to Lucien: 'If, in London, they reproach us for our lack of finish, here they reproach us with having eye disease, *the disease of the painters who see blue*. Even Huysmans, in his book [*L'Art Moderne*] deplores this affliction of the visual organs.'

The rapidly declining economic situation in France affected all the painters, and by the end of the year Pissarro's financial position was critical once more. In December he had to write to Durand-Ruel: 'I would be most obliged if you did not forget to send me a little money next week, I have promised 600 francs to my wife and I would be most embarassed at not being able to keep my promise.' Durand replied: 'I am sorry not to be able to give you the money you ask for at the moment, but nothing is coming in and I am absolutely broke.'

The precariousness of the situation provided Julie with an opportunity to insist that Lucien should leave home and make a financial contribution. Alfred Pissarro pointed out that if Lucien went to London and learned English, he would be virtually assured of a position in Paris on his return. Pissarro agreed, partly because he was worn down by Julie's relentless campaigning, and partly because he thought it desirable that Lucien should have a chance to develop on his own, at a remove from the strong influence which he exerted over his son's work.

Early in 1883 Lucien left for London, where he lodged in Holloway with his uncle, Phineas Isaacson, and his cousins Rudolphe, Alfred, Alice and Esther. He enjoyed the company of his cousins, but he found that his uncle was a strange and difficult man, given to fits of violent rage. He soon learned to keep out of Phineas's way on such occasions. He was busily occupied, exploring London and arranging employment. He was taken on in the offices of Stanley, Lucas, Webber and Company, music publishers, in New Bond Street. He was not paid a salary, but was given tickets to concerts and recitals, and he wrote enthusiastically to his father about what he had seen and heard.

Julie was hopeful that away from his father, Lucien would develop an interest in the world of commerce and forsake the idea of becoming

an artist. But Pissarro ensured in his stream of letters to his son that he did not abandon his study of art, and his letters contain many injunctions to Lucien to draw continually, and to observe carefully and correctly. Lucien found his new situation pleasant, but in spite of his good intentions he had difficulty in finding enough time to draw and paint. As soon as the weather improved sufficiently to make it possible for him to work out of doors, he built himself an easel and gave up his job, spending his days painting on Hampstead Heath, visiting the exhibitions, and copying in the British Museum.

The financial position of the family had worsened to the extent that Pissarro was once again compelled to spend days on end in Paris, hawking his pictures from one small dealer to another in the hope of bringing in sufficient to keep his large family fed and clothed. He told Durand-Ruel in desperation that cost what it might to his reputation, he was forced to sell for whatever prices he could obtain. Durand-Ruel's own position was precarious, and he was not able to be of assistance.

In an attempt to revive his failing fortunes, Durand-Ruel decided to organize a series of one-man shows in 1883. In February he showed work by Boudin, in March by Monet, in April by Renoir, and in May he arranged an exhibition of Pissarro's work. This was to be followed by an exhibition of work by Sisley in June. In April, he held a small exhibition of Impressionist paintings at Dowdeswell and Dowdeswell in London, in the hope that the British public would be more interested in buying than the French were. Lucien reported to his father:

> 'There is not a single paper that does not express its opinion of your exhibition. Most of them dislike your painting and use the eternal argument, it's unfinished. But the papers who specialize in art are most encouraging. I met M. Duret at the exhibition, he is quite happy about the London exhibition. People talk about it, they come, they laugh, and that's something. There are lots of people there every time I go. Next year I think it will be imperative to have a well-organized exhibition, that is to say a large, well-decorated room, and the pictures sensibly hung.'

Pissarro went to Paris to attend the opening of Monet's exhibition, and he was full of praise. He told Lucien: 'Monet has opened his show first - a great artistic success, very well organized, not too many canvases, forty at most, and well spaced. It is a well deserved success, for Monet has shown some marvellous things. We shall see if the public will acclaim the show; if not, it will not be because he lacks talent.'

He enjoyed seeing the exhibition, and having the opportunity to speak to Monet, but otherwise the visit to Paris was not a success, and he returned to Osny ' . . . without a penny, for Durand was only able to give me the sum I sent you.' as he told Lucien. Monet was convinced that the bad times would soon pass, but Pissarro was dispirited. He found Julie's constant haranguing hard to bear, and he dreaded reporting his lack of success after visits to Paris.

Over the next few months, he went to Paris frequently, attempting to find buyers or to conclude sales already tentatively made, and his pessimism did not lift. He wrote to Lucien that Monet's show did not attract visitors, and the newspapers were devoting their space to the exhibitions of official art. He did not believe that individual exhibitions were a good idea, being firmly committed to the concept of group shows, but he continued to prepare for his own exhibition in May.

He was continually under pressure from Julie, who was annoyed at his frequent absences, and he found his essential visits to Paris totally disruptive of his routine. It was a punishment for him to have to interrupt his work in order to attend to business matters in Paris, for, as he was to tell Octave Mirbeau: 'Work is a marvellous regulator of moral and physical health; for me all sorrows, all bitterness and griefs are forgotten, and even cease to exist, in the joy of work.'

He was in Paris for the opening of Renoir's exhibition, and dined with Monet, Renoir, Dr de Bellio and Duret. Duret had recently returned from London, and he was able to give Pissarro good news about Lucien's progress and evident happiness in England.

As the time for his exhibition drew near, he was overcome with fears about the value of his work. 'I am ready for the Durand-Ruel show', he wrote, 'and I am discontented . . . I shall follow the example of Monet and Renoir who did not show more than 50 well-chosen canvases, which thus were well spaced out . . . My doubts increase as the moment nears.' His exhibition opened on the same day as the *salon*, but in spite of this there were many visitors, and all his friends complimented him on his work. He was not reassured by their praise, for he felt that the show was weak and lacked impact.

He was distressed by Manet's death on 30 April, ten days after the amputation of his left leg. Although they had not been close friends, Pissarro had always respected him and admired his work. He attended the funeral on 3 May. The pallbearers were Zola, Duret, Fantin-Latour, Alfred Stevens, Monet and Antonin Proust. Proust, the Minister of Fine Arts, delivered a moving address at the graveside, praising a man perpetually in search of a new effort.

Household matters took up much of Pissarro's time. He was instructed by Julie to find a maid while he was in Paris, and he duly

returned to Osny with a new servant. Since the house at Osny was inadequate for the family's requirements, he consulted his friends for advice about an alternative place to live, one which would provide him with interesting *motifs*, and the family with suitable accommodation. He discussed their suggestions with Julie on his return, and then buried himself in painting for a few days while she went to Paris to see the exhibition, thankful for a chance to absorb himself in work without the tension of having to prepare for an exhibition, and without interruptions. He did not even read the critics' comments on his show, since these invariably annoyed him.

When the exhibition ended, Pissarro spent some time looking for a house. He apologized to Monet for not having replied to a letter, saying that he was forced to search for an unfindable house. He went to Meaux, which Sisley had told him was beautiful. He reported on his visit to Lucien:

'The town itself, at first glance, has little character: the market is frightful, an immense modern shed, built like a railway station, less interesting than the Halles in Paris, whose proportions give it character . . . The cathedral is superb. Some parts of the outskirts are attractive, with very interesting views of the cathedral, but in regard to types I fear it doesn't come up to Pontoise . . . As for houses, I found only two, and neither any good . . . I went to Ecouen, Villiers-le-Bel, it doesn't suit me. We did consider Versailles, but I am much afraid of that false capital.'

He abandoned the search as hopeless after a time, and returned to Osny to continue with his painting.

The economic situation in France was worsening, and he told Monet:

'As to giving you news of our relations with Durand-Ruel, I can only make guesses. Besides, the trouble we have in seeing any money come in is enough to show that the situation is difficult; we all suffer from it . . . I know that sales are at a standstill, in London and in Paris. My show did nothing as far as receipts are concerned . . . Durand-Ruel is really very active and anxious to push us at any cost . . . I certainly hear other dealers, brokers, and art-speculators saying: "He will only last another week", but that kind of talk has been going on for several months. Let's hope that it's only a bad crossing . . .'

Lucien returned home during the summer, and his brothers and sisters enjoyed his tales about life in London and the strange ways there. He assisted his father again, and at the end of the summer, they went to Rouen together. Lucien stayed there for only a few days before

returning to London, but Pissarro remained in Rouen until the end of November. He welcomed the change, and found Rouen beautiful, with an abundance of *motifs*.

He stayed at Eugène Murer's hotel, the Hôtel du Dauphin et d'Espagne, on the Place de la République facing the Pont Corneille and the Ile Lacroix, and he worked steadily. He painted the Cours-la-Reine, the public promenade flanked by rows of elm trees on the side of the Seine, and the view of the mountains from it; the Côte Ste. Catherine, the route to the north at the foot of the mountains, with the river Aubette running alongside it; the bridges, especially the Pont Corneille, or Pont de Pierre, over the Ile Lacroix; the harbour; and the cathedral. He found the variety and diversity of subject matter stimulating and rewarding. Lucien sent him a copy he had made of Turner's drawings of the Cours-la-Reine motif, and he wrote: 'It is strange that Turner chose just this motif. That's the way it is in Rouen, you are always struck by the same places. Yesterday I made a drawing of the rue de la Grosse Horloge. I had scarcely finished it when I saw a lithograph of the same street done in 1829 or 1830 by Bonington.'

Gauguin gave up his career as a stockbroker at this time, as a consequence of the economic crisis as well as of his desire to devote himself to painting. Pissarro pointed out to him that the cost of living was lower in Rouen than in Paris, and that the abundance of subjects for painting made it most attractive. Gauguin took his advice, and brought Mette and his children to Rouen. He rented a house at 5 Impasse Malerne, and Pissarro and he worked together.

But, in spite of his tolerance, Pissarro was finding Gauguin increasingly difficult to relate to. Their views were diametrically opposed on many subjects, and Pissarro found Gauguin's constant preoccupation with money hard to stomach. He wrote; 'He is terribly commercially minded. I dare not tell him how wrong this is, and how little it helps him. His requirements are very great, and it is true his family is accustomed to living luxuriously, just the same his attitude can only hurt him. Not that I think we ought not to sell, but I regard it as a waste of time to think only of selling, one forgets one's art and exaggerates one's value.'

They disagreed strongly on political questions. Pissarro told Lucien: 'That devil Gauguin has praised the politics of the minister [Jules Ferry] to me. I listened to him for a long time . . . I listened calmly because I am not of the party. But at the end, I began to understand that poor Gauguin does not always see fairly - He is always on the side of the wicked!'

Julie joined Pissarro in Rouen for a few days, and she liked the town so much that she wanted to move there. Pissarro was not in favour of

this and Julie was convinced that this was due to Gauguin, for Gauguin feared that he would not sell his work in Rouen if Pissarro lived there too. Julie was angry about this, and wrote to Lucien, 'What is Gauguin to us that we have to stay away from Rouen because he is there?'

Monet visited Pissarro in October, accompanied by his brother and his son, and by Durand-Ruel and his son. They spent a day together at Deville and Canteleu, a village near Deville from which there was a splendid view of Rouen. Pissarro contemplated returning there to paint, for he found the landscape most attractive, but the visit was never made. Durand-Ruel admired the work he was doing, and he was encouraged by his praise to resume work with renewed enthusiasm.

He summed up the results of his stay in Rouen to Lucien, writing:

'I have just concluded my series of paintings. I look at them often. I who made them often find them horrible. I understand them only at rare moments, when I have forgotten all about them, on days when I feel kindly disposed and indulgent to the poor maker. Sometimes I am horribly afraid to turn round canvases which I have piled against the wall; I am constantly afraid of finding monsters where I believed there were precious gems! . . . However, at times I come across works of mine which are soundly done and really in my style, and at such moments I find great solace. But no more of that. Painting, art in general, enchants me. It is my life. What else matters? When you put all your soul into a work, all that is noble in you, you cannot fail to find a kindred soul who understands you, and you do not need a host of such spirits. Is not that all an artist should wish for?'

Eragny; Divisionism; the 8th Exhibition, 1884–1886

JULIE was pregnant again, and her temper was more uncertain than ever. Furiously, she accused Pissarro of encouraging Lucien to think only about art instead of settling down to a career in commerce. Lucien had told his parents that the prospect of commerce bored him, and he hoped to succeed by selling his drawings to newspapers.

The need for more spacious accommodation was becoming pressing, and Pissarro resumed his search for a suitable place. He went to L'Isle-Adam, which he did not like at all, describing it as 'a vast plain with little slopes in distance, long, long streets, sad, sad walls, stupid, stupid bourgeois houses.' But there was a large house for sale at a reasonable price, and he considered buying it. It was next to a cemetery, but in compensation it had a big garden, suitable, he said, for cricket, a game of which he was very fond.

Before making a decision, he went to Gisors, about 34 miles from Pontoise, which he found most attractive. 'We didn't look the place over when we were there together,' he told Lucien, 'we didn't see the whole section of the public park, the superb forests with extraordinary irregular terrain, the ruins of the castle of *La Reine Blanche*. The park with great trees and towers covered with vegetation, and a view of the church spires in the distance, is superb. Old streets, three little streams, filled with picturesque motifs; and the countryside is superb, too. I hastily made some watercolours. I promised myself that I would go there to paint, for I haven't found a satisfactory house.'

Finally, just as he thought he might be compelled to take the house at L'Isle-Adam, Pissarro found a house at Eragny-sur-Epte, close to Gisors. He was delighted with it, and wrote to Lucien in March 1884: 'The house is wonderful and not too dear: a thousand francs with garden and fields. It is about two hours from Paris.' Lucien returned from London to assist with the move from Osny to Eragny, and he also liked the house.

It had a huge garden, partly cultivated and filled with all kinds of flowers and many old apple trees, and for the rest left wild, making a 'kind of Garden of Eden, full of mystery, which invited one to run

99

wild, or to throw oneself down in the midst of wild grasses.' A field which was the continuation of the garden separated it from the river Epte, which winds through the valley of Eragny. The surrounding countryside was beautiful, the hills covered with chestnut trees. The village of Eragny was tiny, with about 600 inhabitants, and the river separated it from the even smaller village of Bazincourt.

The whole family were thrilled with their new surroundings. Pissarro had many new *motifs* to study, and he was able to set up a comfortable studio in which to work. Julie had plenty of space in the house, and found that the garden provided an abundance of vegetables and fruit. The property had a backyard which pleased her, with a rabbit run containing rabbits in excellent condition, as well as a hen-house and a pigeon cot. The younger children found the garden ideally suited to their games and escapades. The last addition to the family, Paul Emile, was born at the new house on 22 August 1884.

Lucien decided that he would prefer not to return to London, and he found work in the printing section of the art dealer Manzi's business in Paris. Julie was forced to acknowledge that in spite of all her attempts at dissuasion, her eldest son had not lost interest in art. Pissarro was pleased by Lucien's decision, which he felt was a mature one, made after careful consideration of the alternatives open to him. Lucien found a small flat in Paris, and divided his time between Paris and Eragny. The close relationship between father and son flourished as they worked together and avidly discussed literature and politics. While he was in Paris, Lucien attended to many of his father's business matters, leaving Pissarro free to paint without the interruptions which had burdened him in the past few years. He urged Lucien to consider how he would sign his name, suggesting that it might be to Lucien's advantage to use Julie's maiden name, Vellay, rather than Pissarro. This would avoid the stigma still attached to Pissarro's paintings, and would enable Lucien to stand independently, without being bracketed with Pissarro. Lucien used the name Vellay a few times, but finally decided on a monogram, 'LP', which he was to use throughout his career.

The prices Pissarro could ask for his work had improved, and he could expect to obtain about 900 francs for an oil, 200 francs for a watercolour, 150 francs for a pastel, and 100 francs for a fan. He still experienced great difficulty in finding buyers, and his financial situation remained critical. Frequently he had to beg Durand-Ruel to come to his assistance. Soon after the move to Eragny, he wrote to Monet from Paris:

'At long last I have been able to make a few pence, enough to last me three or four days at Eragny. I am completely broke and I can

see that I will have to sell at any cost, as I receive letter upon letter from my wife, revealing all her misery. Sell! Easier said than done. To whom? . . This is driving me mad!'

Lucien met several young painters in Paris whose ideas interested him. He and his father discussed his new acquaintances and their views on art. Pissarro expounded his view that Lucien was mistaken in always seeking the new, for the new, he believed, was not to be found in subject matter, but in the manner of expression. Lucien explained that it was in this sense that his friends' work was new, for they were experimenting with colour theory and were slowly evolving a method of application of pigment which would enable them to manifest these theories on their canvases.

The painters whom he had met were Georges Seurat and Paul Signac. He had been introduced to them by Armand Guillaumin, who had been the only member of the original Impressionist group to exhibit at the *Société des Artistes Indépendants* show in 1884, at which Seurat and Signac showed their work. Seurat had exhibited *Une Baignade, Asnières*, which was rejected by the *salon* jury earlier in the year.

Pissarro met Signac in 1885 at Guillaumin's studio. 55 years old, white bearded, and looking, as his niece Esther Isaacson said, 'like Father Christmas', Pissarro made a strong impression on the young Signac. He was awed at first at the prospect of meeting a painter whose work he had admired for several years, and then encouraged and elated by Pissarro's kindness and his intense interest in the researches of Signac and his colleagues. Seeing that Pissarro's interest was sincere, Signac made a point of introducing his friends and associates of the *Indépendants* to Pissarro. In October 1885, Pissarro met Georges Seurat, recently returned to Paris after spending the summer in Normandy.

Seurat, all agreed, was 'not an easy man to know'. He was to be described by Jules Christophe in *Les Hommes d'Aujourd'hui* as 'a tall young fellow, timid as could be, but with an energy no less extreme than his shyness; the beard of an Apostle and a girlish sweetness of manner; a voice deep, quick to win others to his point of view; one of those peaceable but immensely obstinate people. whom you expect to be frightened of everything and whom, in reality, nothing can deter.'

Seurat had admired Pissarro's paintings at the 1882 Impressionist exhibition, and subsequently at Durand-Ruel's and other dealers. He was pleased to meet Pissarro, and found a willing audience in the older man when he outlined this theories of colour.

Pissarro had considerable knowledge of colour theory, but he lacked

Seurat's grasp of scientific subtleties. Seurat persuaded him to attend one or two of the lectures on colour theory given by Charles Henry. Henry, a mathematician, inventor and physiologist, expounded at length on the aesthetic and scientific bases of the use of colour, covering a blackboard with abstruse equations and formulae as he talked. Pissarro did not share Seurat's fascination with Henry's lectures, which he found almost incomprehensible, and he stopped attending them. Seurat was able to clarify Henry's often murky dissertations on the nature of light in such a way that Pissarro and his other associates could understand and share the fervour which these theories inspired in him.

Seurat was working on his huge painting *Un Dimanche d'Eté à l'Ile de la Grande Jatte*. He was gradually being drawn into the milieu of the leading *avant-garde* literary figures of the day, men like Zola's friend Paul Alexis, Gustave Kahn, Emile Verhaeren, and Félix Fénéon. He sought a theoretical and philosophical basis for his work, which these writers saw as akin to their own. Gustave Kahn said that Seurat's approach to painting and the approach of the Symbolists in literature had in common the philosophical principle, purely idealist, which made them deny any reality to matter and admitted the existence of the world only as representation. The goal of their art, Kahn said, was to rebel against the Impressionists' 'nature seen through a temperament', as Zola had described it, and instead of making the objective world subjective through interpretation, to reverse the process and make visible the subjective. Fénéon, who had been attracted to Seurat's pictures at the 1884 *Indépendants* exhibition, agreed with Gustave Kahn. He said that for Seurat and his colleagues objective reality was a simple motif for the creation of a superior and sublime reality in which their personality was transfused. Seurat himself wished to establish a link between his work, with its contemporary subject matter, and the art of the past; he strove for a sense of permanence in his pictures, of static and hieratic dignity, even where the subject depicted was ephemeral or transient by nature.

Pissarro found that Signac was more approachable than Seurat, and that, flattered by Pissarro's interest, he was willing to explain the intricacies of the method of a painting which he and Seurat were developing. Reversing the role which he had so frequently played, Pissarro now became the student of Signac and of Seurat, seeking to understand their approach and evolving a way of utilizing it himself.

For some years he had been seeking a path which would lead him out of the impasse which Impressionism had become for him. Before his meeting with Signac and Seurat, he had already been considering the potential of a more systematic use of colour than he had used in

102

the early days of Impressionism. He had begun to juxtapose areas of complementary colours, in addition to individual brushstrokes of complementary colours, and he had been using smaller brushstrokes than in the past. Now, to further his understanding of Seurat's divisionist technique, he would go to Signac's studio and enquire into every aspect of the approach. He watched Signac at work, not too proud to learn from the younger man, and on his return to Eragny he experimented with the possibilities of the method for his own work. Signac recognized that Pissarro had already arrived at a point closely akin to that of himself and Seurat before meeting them, and he acknowledged that it required great courage on Pissarro's part to ally himself with them. He wrote to Pissarro: 'How much misery and trouble your courageous conduct will bring you! For us, the young, it is a great good fortune and a truly great support to be able to battle under your command.'

Pissarro realized that for him to change his approach at this stage was to court disaster in financial terms. But he felt that he could not continue to produce work which he no longer regarded as being of value. He espoused Seurat's and Signac's method because he saw in it a potential solution to the pictorial problems he had been wrestling with. He acknowledged that although he had already moved close to the position taken by Seurat before their meeting, Seurat's coolly analytical mind had enabled him to define this approach far more clearly than he himself had found possible.

Julie protested angrily at his decision, fearing the consequences for the already struggling family. When Pissarro had once again to resort to making the rounds of the dealers, hoping for sales, she pressed home her point that he was ruining them, leading them to starvation, and what was worse, doing so deliberately. Pissarro protested to Lucien: 'Your mother believes that business deals can be carried off in style, but does she think I enjoy running in the rain and mud, from morning to night, without a penny in my pocket, often economizing on bus fare when I am weak with fatigue, counting every penny for lunch or dinner? . . .' Lucien urged his mother to understand Pissarro's point of view, reminding her that a '. . . discouraged man is incapable of working, and above all of working well, and that it was therefore necessary to have all possible spiritual stability in order to produce good paintings.'

By the end of 1885, Pissarro was working in the divisionist manner evolved by Seurat, using the dot. A small picture painted in this way was displayed at the dealer Clauzet's early in the new year. It was the first divisionist painting to be exhibited, for Seurat did not show his canvases in the new manner until later that year.

Fired by enthusiasm for the approach, which he felt would have much to offer the other Impressionists, Pissarro began to explain and expound on its benefits to his friends whenever he met them, at the Café de la Nouvelle-Athènes, or at the dinners at which they usually met once a month. Monet listened patiently for a time, and then, infuriated by talk of 'scientific' impressionism, became angry and threatened to have no more to do with Pissarro if he continued to harp on this theme. Renoir was light-hearted in his dismissal of divisionism, and regularly saluted Pissarro with the words, 'bon jour, Seurat'. He refused to listen to Pissarro's explanations of the rationale underlying divisionism, and Pissarro was surprised to find that he based his aversion to divisionism's theories on complete ignorance of them. Renoir had a distaste for theories of any kind. He was to explain this to Ambroise Vollard: 'There is something in painting which cannot be explained, which is the essential. You approach nature with theories, nature knocks them to the ground . . . The truth is that in painting, as in the other arts, there is not a single method, no matter how unimportant, which can be put into a formula.'

Pissarro felt that it was important that a group show including the work of the divisionists be organized. The Impressionists had not held a group exhibition for four years, and Pissarro's suggestion was met with antagonism and derision. Sustained by his belief in the merit of divisionism, he persisted with the idea.

He discussed his plan with Mary Cassatt at the end of 1885, and decided that an excellent nucleus for a show would be Degas, Caillebotte, Guillaumin, Berthe Morisot, Miss Cassatt, and himself, with Seurat, Signac, and perhaps two or three others who were associated with Seurat. His plan was to unite the two generations in a common exhibition, but the only connecting link between Degas and his circle, Monet, Renoir, and Seurat and his supporters was the circumstance that they had all been accepted to some extent by Durand-Ruel. Pissarro stressed *l'élément Durand* as the fundamental idea in his negotiations. But, as he told Eugène Manet: 'The difficulty is coming to an agreement.'

Pissarro wanted Monet and Renoir to participate, but he realized that this would pose particular difficulties. Monet had become less and less confident in Durand-Ruel, and he had concluded an agreement with Durand's rival, Georges Petit, in which he bound himself not to take part in any Impressionist group shows. He showed 13 paintings at Petit's fifth *Exposition Internationale de la Peinture*, held from May to July, and they were favourably received by critics and collectors.

Degas had been hostile to Monet since Monet had returned to the *salon*, but Pissarro knew that his participation was essential for the

financing of the show. He was forced to allow the initiative to pass to Eugène Manet and Berthe Morisot, leaving the organization of the exhibition in their hands. This meant that he encountered fierce opposition to the participation of Seurat and Signac. Even after the framework of the exhibition had been decided, their inclusion was a sore point.

A few days before the exhibition was due to open, Pissarro spent an evening at a gathering of his Impressionist colleagues in Paris. where Eugène Manet questioned the merit of Seurat's work. Pissarro defended Seurat hotly, and later told Lucien about the incident:

'Yesterday I had a violent run-in with M. Eugène Manet on the subject of Seurat and Signac. The latter was present, as was Guillaumin. You may be sure I rated Manet roundly. - Which will not please Renoir. - But anyhow, this is the point, I explained to M. Manet, who probably didn't understand anything I said, that Seurat has something new to contribute which these gentlemen, despite their talent, are unable to appreciate, that I am personally convinced of the progressive character of his art and certain that in time it will yield extraordinary results . . .'

When Pissarro did not encounter hostility, he met with cynicism, as in the case of Degas. He told Degas that Seurat's painting was very interesting, and Degas drawled, 'I would have noted that myself, Pissarro, except that the painting is so big!' Pissarro was exasperated, and commented to Lucien: 'Very well, if Degas sees nothing in it, so much the worse for him. This simply means that there is something precious which escapes him.'

It was finally agreed that the divisionists, or Neo-Impressionists, would exhibit their work in a separate room from the remainder of the participants in the eighth group exhibition. The public would be permitted to see their work as a collective manifestation, a new movement which had grown out of Impressionism, but was clearly distinct from it.

Caillebotte decided not to submit work to the exhibition out of loyalty to Monet, who was bound by his agreement with Georges Petit. Hostility to Pissarro, Signac and Seurat was not the motive for his decision, for he was on cordial terms with all three men. A keen yachtsman, he had taught Signac to navigate his yacht, and together they had sailed down the Seine to visit Seurat at the Ile de la Grande Jatte while he was working on his large canvas.

Renoir chose not to exhibit, but to ally himself with Monet, and to show at Petit's exhibition, and Sisley also elected not to send any pictures to the exhibition. Gauguin agreed to take part, and he

introduced his friend Emile Schuffenecker, whom Pissarro would have preferred to exclude, for his work was amateurish and lacking in character. Eugène Manet and Berthe Morisot agreed to his participation in spite of Pissarro's opposition. Pissarro was obliged to accept that his original conception of the scope of the exhibition would have to be abandoned, and that the exhibition would only be held if a series of compromises were thrashed out.

Degas told Félix Bracquemond: 'We are opening on the 15th [May]. Everything is being done at once! . . . Monet, Renoir, Caillebotte and Sisley have not answered the call . . . The premises are not as large as they should be, but are admirably situated . . . The Jablochkof Company is proposing to install electric light for us.'

The exhibition which was called simply the Eighth Exhibition of Paintings, opened on 15 May 1886 at 1 rue Laffitte, in the second-floor rooms of the famous restaurant, the Maison Dorée. Pissarro was represented by nine oils, three watercolours, one of them a fan, six pastel studies of peasant women, and five etchings. The room in which he, Lucien, Signac and Seurat showed their work was dominated by Seurat's *Grande Jatte* picture, in addition to which Seurat showed another eight paintings. The *Grande Jatte* was seen as a manifesto of divisionism by the critics. Pissarro was content that this should be so, and he was careful to acknowledge that Seurat was the originator of the new method, for Seurat was prickly about this and quick to take offence.

Much of the criticism levelled at the Neo-Impressionists was derogatory. George Moore's lack of comprehension was characteristic:

'How well I remember being attracted towards an end of the room, which was filled with a series of most singular pictures. There must have been at least ten pictures of yachts in full sail. They were all drawn in profile, they were all painted in the very clearest tints, white skies and white sails hardly relieved or explained with shadow, and executed in a series of minute touches, like mosaic. Ten pictures of yachts all in profile, all in full sail, all unrelieved by any attempt at atmospheric effect, all painted in a series of little dots! Great as was my wonderment, it was tenfold increased on discovering that only five of these pictures were painted by the new man, Seurat, whose name was unknown to me; the other five were painted by my old friend Pissaro (*sic*). My first thought was for the printer; my second for some *fumisterie* on the part of the hanging committee, the intention of which escaped me. The pictures were hung low, so I went down on my knees and examined the dotting in the pictures signed Seurat and the dotting in those that were signed

Pissaro. After a strict examination I was able to detect some difference, and I began to recognise the well-known touch even through this most wild and most wonderful transformation. Yes, owing to a long and intimate acquaintance with Pissaro and his work, I could distinguish between him and Seurat, but to the ordinary visitor, their pictures were identical.'

This confusion was offset to some extent by the elegant pen of Félix Fénéon, who had shown himself from the first to be sympathetic and comprehending of the aims of the Neo-Impressionists. In *La Vogue* of 13 June he wrote:

'From the beginning, the Impressionist painters were impelled by their regard for the truth to limit themselves to the interpretation of modern life directly observed and landscape directly painted. They saw objects as interdependent, each participating, where light was concerned, in the practices of their neighbours, where traditional painting had considered them each on its own and had lit them with a light that was meagre and artificial . . .

The Impressionists practised . . . the decomposition of colour; but they practised it in an arbitrary fashion; sometimes the full brush would move across the canvas and leave behind it the sensation of red; sometimes a glowing passage was cross-hatched with green. MM Georges Seurat, Camille and Lucien Pissarro, Dubois-Pillet and Signac are painters who, on the contrary, practise divisionism consciously and scientifically. This procedure developed in 1884, 1885 and 1886. If, in M. Seurat's *Grande Jatte* you take a small patch of uniform tone, you will find that it is made up of a whirling host of tiny dots, and that these dots spell out the constituent elements of the tone. Take the shaded grass: most of the brushstrokes give the local value of the grass; others, orange in tone, are scattered here and there to stand for the almost imperceptible action of the sun; other dots, purple in colour, introduce the complementary of green; where a patch of grass lies nearer to the sunshine, a cyanine blue comes into action, grows thicker and thicker as we approach the line of demarcation, and dies away on the far side of it. When we come to the grass that is actually in the sun, two elements only are concerned: green, and the sunbeam's orange . . . All this is a matter, as will be all too clear, of clumsy indications, when one tries to put it into words; but when you see it on the canvas the delicacy and complexity of the gauging involved are immediately clear . . .
Georges Seurat is the first man to present a complete and systematic paradigm of this new way of painting. Wherever you choose to examine it, his enormous painting, the *Grande Jatte*, will unroll

before you like some patient, monotonous, myriad-speckled tapestry. This is a kind of painting in which cheating is impossible and "stylish handling" quite pointless. There is no room in it for the bravura piece. The hand may go numb, but the eye must remain agile, learned and perspicacious . . .'

In spite of Fénéon's efforts, the exhibition was not a success. Pissarro wrote wearily to Lucien, who had returned to Eragny, 'The exhibition goes very slowly, there are no visitors.' At its conclusion, he found himself in as precarious a position financially as ever, while the split in the ranks of the Impressionists was now complete. On the one hand were the Neo-Impressionists, on the other the group Pissarro now referred to as the 'Romantics'. Gauguin went his own way, and seldom had anything good to say about his former mentor. In 1892 he was to write to Mette from Tahiti: 'You see what happened to Pissarro, owing to his always wanting to be in the vanguard, abreast of everything; he has lost every atom of personality and his whole work lacks unity. He has always followed the movement from Courbet and Millet up to these petty chemical persons who pile up little dots.'

Durand-Ruel decided to take a collection of pictures to the United States in 1886, in the hope that they would be favourably received. Three years earlier he had sent some Impressionist paintings to the United States, where they had formed part of the French Government's section of the International Exhibition for Art and Industry held in Boston in September 1883. Pissarro had been warned by some Americans, friends of Miss Cassatt's, that the exhibition would be mediocre and would have no effect, but Durand-Ruel had seen it as an opportunity to 'revolutionize the new world simultaneously with the old,' as Pissarro put it. He had been represented by six paintings at the Boston show, but as he had feared, the exhibition had made little impact, and the contribution of the Impressionists had either been ignored, or regarded as the work of sick or mad men.

In 1885 Durand-Ruel was approached by a representative of the American Art Association, James F. Sutton, who invited him to arrange an exhibition of paintings under the sponsorship of the Art Association. The American Art Association had been founded by Sutton and Thomas I. Kirby eight years earlier, mainly to promote American painters. Sutton described the organization as a non-profitmaking, educational institution, and he was therefore able to have the paintings which Durand-Ruel shipped across the Atlantic released by the customs without the payment of any duty.

Durand-Ruel sent a large selection of pictures, 300 in all, valued at £81,799. The exhibition opened in New York a month before the Eighth

Exhibition, on 10 April. The quality of the work shown was high, and Duret provided a perceptive introduction to the catalogue. Pissarro was represented by 39 canvases, Monet by 40, Renoir by 35, and Sisley by 15. Seurat, Caillebotte, Degas, Guillaumin, Morisot, and Edouard Manet had paintings on view, and Durand-Ruel had taken the precaution of including in the collection the work of other artists who were not associated with Impressionism, such as John Lewis Brown and Alfred Roll, in order to temper the likely effect of Impressionist painting on a public wholly unaccustomed to it.

Comments in the press tended to the opinion that the collection was 'monumental humbuggery'. The *Commercial Advertiser* headlined its story, 'Gallery of Coloured Nightmares', and described the exhibition as a collection of monstrosities that would not be tolerated in a well-regulated barber-shop. The *Times* wrote: 'The 300 oil and pastel pictures by the Impressionists of Paris belong to the category of Art for Art's sake, which arouses more mirth than a desire to possess it . . . Coming suddenly upon the crude colours and disdain of drawing, which are the traits positive and negative in the works of Renoir and Pissarro, one is likely to catch one's breath with surprise. Is this Art?'

The exhibition was transferred to the National Academy of Design on 23rd Street, and shown there from 25 May until, as the opposition grumbled, 'the last possible customer had been worked.' A new catalogue was printed, and 21 further works, many of them loans from private collectors, were included. When Durand-Ruel left the country at the end of the summer, he had sold 15 pictures for about £17,000 to five American collectors, William Loring Andrews, William H. Fuller, Cyrus J. Lawrence, A.W. Kingman, and H.O. Havemeyer. He was satisfied with the results of his venture, which he referred to as 'a success so well begun', and he had high hopes of the American market. But, as Pissarro said, hopes alone were not enough.

Pissarro discussed Durand-Ruel's American expedition with him at some length, and he reported to Lucien:

'What he said seems reasonable enough: there are two opposite versions of what befell in America, both equally exaggerated: he did not make a fortune with miraculous luck nor did he engage in sharp practice and have to decamp. He is very glad that he went to America himself and he has great hopes of possible developments there. All this is quite vague, but proves, at any rate, that everything is not lost. If we are not saved by Durand, someone will take us up, since our work is sure to sell in the end. For the present, I am trying to find some means of support until my paintings sell.'

Pissarro also discussed Durand's New York exhibition with Legrand, and Legrand revealed that he had been approached with an offer to arrange an exhibition of Impressionist work in America. This offer had been made by Knoedler's in New York. Pissarro felt that unless Durand was careful he would lose the game, since there was clearly considerable interest in the future potential of Impressionist pictures in the United States.

Durand set to work soon after his return organizing another exhibition for the following year in New York. This was finally held in May 1887, but possibly through the intervention of Knoedler, letters to the press and petitions to the Secretary of the Treasury urged that Sutton's 'educational' institution was an art business, and not entitled to exemptions from tax or duty. Durand-Ruel was allowed to bring his paintings into the United States on condition that none were sold; and although there were more visitors than there had been the previous year, neither Pissarro nor any of the other artists represented benefited financially. Durand-Ruel decided that the time was ripe to establish himself in the United States on a more permanent and satisfactory basis than had been provided by his association with Sutton. He opened a branch of his gallery at 297 Fifth Avenue, and he and his sons Georges and Joseph travelled back and forth between Paris and New York, promoting the work of the Impressionists.

Pissarro was anxious for Durand-Ruel to promote the work of the Neo-Impressionists as well as that of the 'romantic' Impressionists. He wrote to him from Eragny in November 1886, explaining that their purpose was 'to seek a modern synthesis by methods based on science . . . to substitute optical mixture for the mixture of pigments, which means to decompose tones into their constituent elements, because optical mixture stirs up luminosities more intense than those created by mixed pigments.'

'As far as execution is concerned', he told Durand, 'we regard it as of little importance; art, as we see it, does not reside in the execution; originality depends only on the character of the drawing and the vision peculiar to each artist.'

He stressed that it was Seurat, 'an artist of great merit', who was the first to conceive the idea and to apply the scientific theory after having made thorough studies, and that he had merely followed Seurat's lead.

Pissarro found himself in the position of spokesman for the Neo-Impressionists, a position into which he was forced by Seurat's reluctance to discuss his theories. In September 1886, Fénéon enlisted his aid with an article on divisionism he was preparing for the Belgian journal *L'Art Moderne*. He sent a draft of the article to Pissarro, who felt that the technique of divisionism was not very well explained. He

revised certain sections of the article, although, as he told Lucien, he would have preferred Fénéon to contact Seurat himself for assistance. Since Seurat maintained a close silence about this theories and techniques, Pissarro thought that it was essential that one of the group discuss the basis of Neo-Impressionism in order to make its intentions clear to the public and the critics. The other members of the group were happy to have him speak on their behalf.

Signac was far more co-operative than Seurat, and both Pissarro and Lucien were soon on extremely friendly terms with him. After the group show, Signac worked for some time at Petit Andelys on the river Seine, and Lucien joined him there. Lucien found the country beautiful, with steep chalk hills and cliffs, and the river winding through the landscape. He wrote to his father that Signac hoped that he would make use of his (Signac's) Paris studio during their absence. When Signac returned to Paris, he presented Pissarro with one of the canvases he had painted at Petit Andelys. It was *Les Andelys, les bains*, and he inscribed it *'A mon bien cher maître C. Pissarro'*.

The *Société des Artistes Indépendants* held their second exhibition in Paris in August 1886. Pissarro did not exhibit, since he felt that this was a venue for the younger painters. He had advised Lucien some time before the exhibition to participate in it, and Lucien showed some watercolour studies of Eragny. Seurat, Signac, Gauguin and Guillaumin participated in the exhibition, and among Signac's submissions was the study of Les Andelys on loan from Pissarro.

Among the increasing ranks of painters who were following the approach of the Neo-Impressionists, men like Albert Dubois-Pillet and Maximilian Luce, whose work was on view at the *Indépendants*, Pissarro noticed the work of a very different painter, Henri 'le Douanier' Rousseau. A friend pointed out Rousseau's work to him, and instead of joining the chorus who laughed at it, Pissarro admired the pictures for the exactness of values and the richness of the colours, in spite of the naiveté of the drawing. Gustave Kahn thought that it was wholly understandable that Pissarro, despite his concern with the exacting technique of neo-impressionism, should be seduced by a painter in whom emotion was of greater importance than technique.

Rousseau found it something undreamed of that the man who was regarded by his associates as the god of the 'heretical' Impressionists should be interested in his paintings. It was a matter of great importance to Pissarro to retain an open mind when he saw new work. He always attempted to assess it on its merits, and was careful not to fall into the same trap as the critics whose mirth he had so often provoked, that of ridiculing the new because it was unfamiliar and strange.

He participated in an exhibition held at Nantes in October, showing in the company of Seurat, Signac, Guillaumin, and Dubois-Pillet. It had been found that exhibitions at provincial centres sometimes elicited a more favourable response than exhibitions in Paris. Several members of the original Impressionist group had begun exhibiting their work outside Paris, in the hope of attracting new buyers who had not been affected by the venom of the Parisian critics. Monet had tried this approach, and had exhibited in Grenoble in August.

Additional new horizons were opened when, at the end of 1886, Octave Maus wrote to Pissarro from Brussels, inviting him to exhibit with *Les Vingt* in February of the following year. *Les Vingt*'s aim was to introduce *avant-garde* art to the Belgian public, and Maus also invited Seurat, Signac, Berthe Morisot, Raffaëlli, and Auguste Rodin to participate in the exhibition.

Pissarro decided to send three paintings to Brussels, *The Walnut Tree*, *The Meadow and the Church at Eragny*, and *The Railway Line at Dieppe*. Only two works were hung, *The Walnut Tree* and *The Railway Line*. Both these pictures belonged to Durand-Ruel, and they were priced by him at 200 francs and 600 francs respectively. Signac went to Brussels to see the exhibition. He reported to Pissarro: ''Your canvases look very well, but unfortunately their small number and small size has isolated them a little too much. They disappear, lost among the large paintings which surround them. However, the effect produced has been a great one. The divisionist execution intrigues the people and obliges them to think; they realize that there must be something to it.'

The critical reception accorded the work in Brussels was very much what Pissarro had become resigned to. One critic wrote: 'Les XX have invited, following their pattern, both Belgian artists and foreigners, practical jokers like Seurat and Pissarro. These innovators are not taken seriously by any artist, and do not deserve to be.'

CHAPTER 11

New friends, old problems, 1886–1888

PISSARRO'S paintings in the new manner proved to be almost impossible to sell. Buyers who had started to approach his earlier work cautiously, at last beginning to understand it, were alarmed and confused by the new pictures. Durand-Ruel refused to handle Pissarro's divisionist work, and throughout the winter of 1886 he was plagued by financial problems.

He spent much of his time in Paris during the winter, attempting to interest collectors in his work, and caring for his mother, who was extremely ill. He told Lucien, who was at Eragny, that Rachel's condition had alarmed the family, but that the crisis seemed to have passed. Soon after, he returned to Eragny. He found that Julie had been obliged to pay their last *sous* to the local carpenter, Crépin, and she was very anxious about their position. On his return to Paris in January, he said that the situation was such that he found himself literally enchained, and only the sale of a small canvas in the new manner to Seurat's mother alleviated the pressure. He was touched when Albert Dubois-Pillet offered to lend him 50 francs, for Dubois-Pillet himself was not well off.

He developed a fever which forced him to remain indoors for a few days, and added to his feeling of being fettered and hampered at every turn. He was impatient and irritable, disheartened by everything except the results he was obtaining with the divisionist approach. He found the fans he had recently completed to be clearer, better designed and better drawn than those which he had executed previously. He retained his belief that the new manner would be favourably received if he and his friends had the patience and resolution to endure the present crisis.

Patience, however, was a quality which Julie did not possess in abundance. She was convinced that Pissarro had deliberately set out to ruin the family by his actions. While he was in Paris, she wrote to him complaining of all the domestic difficulties. the continual trouble with the maid, her lack of money, and many other grievances. Pissarro attempted to deal with these complaints as calmly as possible,

sometimes asking Lucien to intervene, since Lucien was frequently able to placate his mother and to stem the flow of recrimination and dissatisfaction, if only for a short time. Pissarro told Lucien that he regretted that Julie had had trouble with the maid, but that this was not the time to lose one's head. He said that he was enormously concerned about the rent and other expenses, and was splitting his head to find a way out, but he refused to adopt the solution which Julie suggested. This was to hold an auction sale of his pictures. Pissarro remembered too clearly the disastrous results of the auctions held in the 1870s, and felt that such a sale would prejudice his future and would compromise his fellow divisionists.

Julie decided to take drastic action. She wrote to Lucien in April 1887:

'I wanted to get Georges to Paris, and so his trunk was packed, but your father grumbled so much that he did not go. Your poor father is really an innocent; he doesn't understand the difficulties of living. He knows that I owe 3,000 francs and he sends 300 and tells me to wait! Always the same tune. I don't mind waiting, but meanwhile one must eat. I have no money and nobody will give me credit. What are we to do? We are eight at home to be fed every day. When dinner time comes I cannot say to them 'wait'. This stupid word your father repeats and repeats. I have tried all ways to manage. I am at the end of my tether. I give up. Your father has no more courage either. I had decided to send the three boys to Paris and then to take the two little ones for a walk by the river. You can imagine the rest. Everyone would have thought it an accident. But when I was ready to go, I could not. Why am I such a coward at the last moment? But I feared to cause grief, and I was afraid of your remorse. Your dear father wrote me a letter which is a masterpiece of selfishness. The poor dear man says he has reached the top of his profession, and doesn't want to prejudice his reputation by having a sale.'

Lucien was terribly distressed by this letter, and he told his father of Julie's plan, begging him to consider her extreme agitation. But Pissarro, who thought continually of his family's welfare and of how he could alleviate their plight, and who was as unhappy as Julie at their critical position, was adamant in his refusal to have an auction sale. Auctions were a threat, since not only did the artist himself not benefit from any increase in the value of the paintings, but he frequently lost, since low auction prices often necessitated lowering the price of current work. He was convinced that the success he attained would be the greater for having taken so long to arrive.

He decided to exhibit his work at Georges Petit's *Exposition Internationale*, which opened in May, as a concession to the need to sell his work. Duret urged him to do so, saying that he should regard it as a purely commercial venture, since it was a 'most stupid milieu'. He made this decision reluctantly, and he was not satisfied with the hanging of his pictures. He told Lucien:

'I had all I could stand from that confounded exhibition which smells to heaven of bourgeois values. But just the same I wanted the experience of seeing my pictures hanging with those of the leaders and followers of triumphant Impressionism. Evidently, for the test to be decisive, I would have needed at least 15 canvases to be in harmony with the other exhibitors, and also my works should not have been scattered about as they were.

The Monets, Renoirs, Sisleys, Cazins, Raffaëllis, Whistlers, were shown in groups. Just the same it is clear, it is very evident that we have more luminosity and more design; still a bit too much stiffness; badly framed, and the tapestries are in contradiction to our harmonies. I am not too dissatisfied; what enraged me, though, was the offhand way I was treated. M. Petit, to please a foreign painter who was blinded by my luminosity, withdrew my *Plain of Eragny*, withdrew it altogether and hung in its place a dark Monet. I was so angered that I was simply incapable of being polite to my guests. I was furious and complained bitterly; if it had not been for John Lewis Brown I should have made a furore. I reflected that after all it was better to calm down and take it up later. But you cannot conceive to what degree this milieu enslaves one, and how easy it is for the powerful to restrict the liberty of others.'

He added that Dr de Bellio had praised his paintings, and had called him a magician, but he was always suspicious of flattery too easily given, and he doubted de Bellio's sincerity. The exhibition was well-attended by fashionable Paris, and Renoir for one was pleased with the results he attained. He wrote to Durand-Ruel in America that he believed he had made his mark, if on a small scale, in the public's esteem. But Renoir was anxious to satisfy current bourgeois taste, and went to great lengths, including suppressing all details about his personal life, to make himself acceptable to *haut bourgeois* society. Pissarro was repelled by this society, having, as Theo van Gogh was to say, 'the qualities of a rustic character which show immediately that the man is more at ease in wooden shoes than in patent leather boots.'

Julie came to Paris with Georges, for whom Alfred Pissarro had found work with a cabinet maker. Alfred was moved by her tale of suffering, and gave her 100 francs, not as a gift, but in payment for a

drawing. She went to see the exhibition at Petit's, without warning Pissarro that she was coming. He accompanied her around the gallery, pointing out the merits of the work, and the effect of harmony, simplicity and luminosity which he felt his most recent paintings had achieved, an effect which he considered to be heightened by the contrast to the work surrounding it. Julie declared that all the pictures were bad, and Pissarro's 'dots' were the worst of all.

On her return to Eragny, she told Lucien that Durand-Ruel had not sent any money, and that it was imperative for him to find a job to earn a living. 'We cannot help you any more', she wrote, 'Your father is very worried and obliged to do anything to get money. I am sure he won't be able to manage. On top of this my poor mother is dying and asking us to send her a few francs . . . What a struggle life is, my poor Lucien. So much suffering just to feed oneself.' Lucien told his uncle Alfred that he would accept a commercial post only because it was a matter of earning a little money for the moment, but he stressed that he did not want to be a shopkeeper, and that he thought it a short-sighted move, for it meant that he would have to forego his exhibition plans. This would compromise his future, 'For there is a future,' he emphasized to Alfred.

Pissarro found that it was becoming impossible to discuss business or family matters with Julie. 'That is the state I am in, darkness, doubts, quarrels. Your mother accuses me of egoism, indifference, nonchalance. I make heroic efforts to preserve my calm,' he wrote to Lucien.

Julie was not satisfied that her husband's efforts were adequate, and she decided to act independently in an attempt to improve the situation. First she approached Eugène Murer for assistance, but Murer told her that he could not buy any paintings because he was in financial difficulties himself. Then, still convinced that Pissarro should arrange an auction, she determined to enlist the aid of Emile Zola. She went to his house at Médan, only to be refused admittance.

She wrote to Zola:

'You must have been surprised to hear of my visit yesterday, and it was not nice for me to be despised. I went to see you as one goes to an old friend in the hope of a welcome. I called in the place of M. Pissarro who, if he knew of this, would die of shame. I had been walking three kilometres under a blazing sun and with a little girl of six. I was happy to have reached your home at last and hoped for some refreshment. I was told you were not at home. I asked for a glass of water and for the maid to tell you who had called. It seemed that Madame wasn't at home either. I enquired the time of the next

train, it was in three hours, a long time. Could I wait somewhere in the shade? but the maid said she had orders not to let anyone in. You are very rude, I thought; you do not know the rules of hospitality. Surely in such a heat I should have been allowed to rest? At the same moment I saw Madame Zola, who addressed me in such an impertinent manner that I was stunned and began to cry. But Madame Zola said it was my fault for not making myself known, since I had not presented my card! I was going to ask you a great favour as we are in great distress. We are going to have a sale of Camille's pictures, and I beg your influence to have an article published to help our project. Since we have not a penny to pay for such an article, we offer any one of the pictures to be auctioned. My husband does not know of this visit, and do not let him know, for Camille, who is pride itself, would be furious.'

Pissarro heard about the incident, and he was angry, both with Julie for having acted expressly against his wishes, and with Mme Zola, for having so humiliated her. In the past he had visited Médan frequently, but now his relationship with Zola ended. The publication of Zola's novel *L'Oeuvre* in the previous year had already led to a rift in their friendship. Pissarro had been an admirer of Zola's work, reading all his novels, and often commenting on them in his letters, but he felt that *L'Oeuvre* was a betrayal of Zola's comradeship with the artists who constituted the Café Guerbois group in the 1860s. He made no secret of the fact that he disliked the book intensely. His criticisms may have reached Mme Zola's ears, and since it was her favourite among her husband's novels, the book which she regarded as her cross of honour and her reward, which she could not refer to without emotion, this may have been the reason for her rudeness to Julie.

Although Pissarro's financial position suffered from his adoption of divisionism, he enjoyed new contacts with painters, writers and critics whom he had not known previously, some of whom became close friends. Among them was the critic and writer Octave Mirbeau. Mirbeau had contributed a review of the 1886 exhibition to *La France* in which he said, rather hesitantly: 'M. Seurat is certainly very talented and I have not the courage to laugh at his immense and detestable painting, so like an Egyptian fantasy, and which, in spite of its eccentricities and errors, which I hope are sincere, shows signs of a true painter's temperament.' Mirbeau was a man of ready wit, with a biting tongue and pen. He could launch an artist or writer with a few lines published in *Le Gaulois* or *Le Figaro*, and it was he who made the public aware of Maurice Maeterlinck and Knut Hamsun. Equally effectively, he could castigate and scorn, and his influence was so great

that the presence of an article by him was sufficient to boost the circulation of a newspaper or journal by several thousand copies.

Pissarro admired him because he was a fighter, battling against social injustice, deriding the painters of the *salon* and the more conservative critics, lauding the new art. He had a horror of authority, and loathed anyone in uniform, be they policemen, ticket collectors, messengers or servants. His friend Léon Daudet said that in his eyes a landlord was a pervert, a Minister a thief, lawyers and financiers made him sick, and he had sympathy only for children, beggars, dogs, certain painters and sculptors, and very young women. Another friend added: 'That there need be no misery in the world was his fixed belief. That there nevertheless was, was the occasion of his wrath.'

Over the years, Pissarro and Mirbeau became close friends. Pissarro was welcome at Mirbeau's home at Pont-de-l'Arche, where Mme Mirbeau provided a hospitable welcome and superb food. He and Mirbeau shared many political views. Both felt strongly about the iniquities of society, and deplored the tyranny of officialdom, whether in art or in other spheres. They would spend hours engrossed in discussion about the need for change, and ways in which change could be realized.

Very different in character was Albert Dubois-Pillet, 16 years younger than Pissarro, who was an army officer. Despite his resolutely anti-militarist views, Dubois-Pillet's cultivated, friendly manner, and his warmth and sincerity endeared him to Pissarro. Dubois-Pillet was one of the founder members of the *Société des Artistes Indépendants*, and had helped to formulate its statutes. He was firmly convinced of the merits of divisionism, and Pissarro admired his pictures.

In 1888 Dubois-Pillet stayed in Rouen, working on a series of studies of the river Seine and the surrounding hills, and Pissarro may have visited him there for a few days. One of Dubois-Pillet's pictures of Rouen, *Rouen: The Seine and the Cantaleu Hills*, showed his indebtedness to Pissarro in its similarity to Pissarro's painting *River, Early Morning: Ile Lacroix, Rouen*, executed in the same year using the Neo-Impressionist technique, but based on studies he had made during his stay in Rouen five years earlier.

Maximilian Luce was Pissarro's closest friend among his Neo-Impressionist colleagues. Similar in temperament and tastes, the 28 years that separated them in age did not affect their relationship. Luce was a modest, simple man, whose rough manners hid an affectionate and gentle nature. Like Pissarro, he had no time for affectation, and dressed shabbily, usually wearing a shapeless hat. Jules Christophe was to describe him in *Les Hommes d'Aujourd'hui* as being 'of medium height, with a bulging forehead, socratic nose, round skull, chestnut

hair and red beard, warm melancholic gold-flecked eyes and thick twisted lips.' He was highly intelligent, and like Pissarro, he was firmly convinced of the merits of the anarchist views propounded by Kropotkin and Jean Grave. He was not prepared to compromise these views, which he valued more highly than material success. Pissarro and he shared similar opinions on the art of the past, and both men particularly admired Corot and Daumier. Pissarro would often praise the lithographs of Daumier, describing them as 'marvels' from all points of view, and Luce agreed with his judgement.

Luce invited Pissarro to accompany him on a painting expedition to Lagny-sur-Marne in 1888. A group of like-minded painters had formed an artists' colony at Lagny. They included Luce, Cavallo-Peduzzi, Aman-Jean, who had been a friend of Seurat's since their student days at the *Ecole des Beaux-Arts*, Ibels, Louis Hayet, and Charles Jacque. They lived and worked together, spending their evenings discussing their theories and the paintings on which they were engaged in a spirit of friendly rivalry. The group regarded Pissarro with respect and deference, and they welcomed his opinions on their pictures. He was flattered by their attention, and delighted to see the concept of a community of painters, which he had long held dear, put into practice by men sharing many of his views.

This was in contrast to the group which had formed around Gauguin at the same time, in the village of Pont-Aven in Brittany. The schism between the Neo-Impressionists and Gauguin and his associates was deep and bitter, and Gauguin habitually referred to the Neo-Impressionists as 'the *others*'.

Pissarro was regarded as a father figure by many of the younger members of the Neo-Impressionist camp, an image encouraged by his soft-spoken, gentle manner and his interest in the work of his colleagues. Louis Hayet was one of this group. Born in Pontoise, he was a year younger than Lucien, and had been interested in painting since childhood. Once, roaming through the fields near Pontoise, he had come upon Pissarro and Lucien standing at their easels, absorbed in their attempts to render the landscape before them on their canvases, and scarcely aware of the boy's fascination at the picture they themselves presented. Through mutual acquaintances in Pontoise, Hayet was introduced to the Pissarros and he used occasionally to accompany them on painting expeditions. In 1885 he met Pissarro again in Paris, by chance, and they discussed the progress he had made. He met Signac in the same year, and he and Lucien became close friends in 1886, when Hayet was engaged in military service at Versailles.

Hayet was a dreamy youth, whose dreaminess had an unusual

corollary - he was also extremely practical and interested in technical procedures. He advised some of his comrades about various technical procedures in the graphic arts and in painting, and he experimented with painting on cloth and with producing his own encaustic mixtures, rather than using oil paints.

Hayet subsequently was to quarrel with Pissarro *père* and *fils*. The quarrel with Pissarro was the result of a disagreement between Pissarro and Hayet's father, Calixte Hayet, over the purchase of a picture. Hayet and Lucien were later to renew their friendship, and Hayet visited Lucien in London in the 1890s.

Léo Gausson, three years older than Lucien, was another young painter who revered Pissarro and was a frequent guest at Eragny. He was interested in drawing and engraving, and made engravings of the work of the masters he admired, among whom was Millet. Pissarro encouraged him in this, as he urged his own sons to study the art of the past and to learn from it, without losing sight of the necessity to look forward and not always backwards, 'in the dust of the old masters'.

Pissarro's concern with the efforts of other painters and his open-mindedness endeared him to fellow painters of all ages. Georges Lecomte, who was to be his biographer and who met him through Félix Fénéon, recalled:

'Shrewd and fair when judging men and their work, Camille Pissarro - who knew the value of all creative effort - showed extreme kindness towards the younger artists. Always, he was predisposed to attempting to be understanding. He was sensitive to the slightest suggestion, even if only partly indicated. I have visited more than a hundred painting exhibitions in his company . . . Without any lack of sincerity he would dwell upon the good points and thus inspire confidence in the young artists and encourage them in their efforts . . .'

In 1886 Lucien met Vincent Van Gogh. Van Gogh dedicated one of his paintings, *Apples*, to Lucien in exchange for a collection of Lucien's wood engravings. Lucien introduced the strange, intense Dutch painter (whom A.S. Hartrick, a fellow student at Cormon's *atelier* described as 'a rather weedy little man, with pinched features, red hair and beard, and a light blue eye . . . [who had] an extraordinary way of pouring out sentences, if he got started, in Dutch, English and French, then glancing back at you over his shoulder, and hissing through his teeth') to his father. Vincent eagerly showed Pissarro the paintings he had brought with him from Holland, which included the *Potato Eaters*.

Vincent was studying the work of all the Impressionists, particularly

Monet and Guillaumin. He was friendly with Guillaumin, who explained the principles of colour theory on which the Impressionists based their work to him. Pissarro saw talent in Van Gogh's work, as he had in Cézanne's studies 25 years earlier. Although he was sometimes disconcerted by Vincent's burning enthusiasm, he advised and encouraged him, explaining aspects of the Impressionists' ideas, and his reasons for having adopted the more precise and theoretical approach of Neo-Impressionism.

One day he and Lucien met Vincent in the rue Lepic, close to the flat he shared with his brother Theo, as they were returning from a visit to Signac at Asnières. Vincent was also returning from a painting expedition, dressed in a blue workman's smock, and he insisted on showing Pissarro his work then and there, oblivious to the comments and derision of passers-by. Vincent respected and valued Pissarro's judgement, and after he left Paris for Arles in 1888, he would sometimes ask Theo to show various pictures to Pissarro, to ascertain his opinion of them.

Pissarro and Lucien, Guillaumin, Vincent and Theo Van Gogh frequently had discussions about the problems which affected all of them. 'Often these discussions had to do with the problems that are so very near to my brother's heart and mine', Theo wrote. 'That is, the measures to be taken to safeguard the material existence of painters and to safeguard the means of production (paints, canvases) and to safeguard, in their direct interest, their share in the price which, under the circumstances, pictures only bring a long time after they leave the artists' possession.'

Theo was the manager of a branch of the gallery Boussod and Valadon. His concern for the interests of the painters he represented, and his strenuous efforts to protect them encouraged several of the Impressionists to sell their work through him rather than through Durand-Ruel. Monet decided to exhibit with Boussod and Valadon because of his confidence in Theo, and Pissarro sold several paintings through Boussod and Valadon in 1888, although they fetched very low prices. An oil, *Peasant House*, sold for 300 francs, while a watercolour fetched only 60 francs.

Theo's superiors did not always agree with his predelictions, but he gradually established the Montmartre branch of Boussod and Valadon as one of the most adventurous galleries in Paris. Gustave Kahn wrote of him: 'He was pale, blond and so melancholy that he seemed to hold canvases the way beggars hold their wooden bowls. His profound conviction of the value of the new art was stated without vigour and thus without great success. He did not have a barker's gift. But this salesman was an excellent critic and engaged in discussion with

121

painters and writers as the discriminating art lover he was.'

Pissarro's affiliation with the Neo-Impressionists introduced him to a more literary milieu than he had previously frequented, since the symbolist writers and poets regarded Neo-Impressionism as the visual counterpoint to their concerns. Pissarro had always been a voracious reader, and he welcomed the opportunity to discuss literature, particularly with Mirbeau.

Often in the early evening, painters and writers would gather in the offices of the *Revue Indépendante*, where would be found 'the white beard of Pissarro, the silence of Seurat, the absence of Mallarmé occupied with other refinements, and sometimes Raffaëlli . . . Jacques-Emile Blanche introduced a note of fashionable brilliance which was countered by the exuberant Signac . . . Félix Fénéon, like the cold diplomat he was, arrived, looked around and told a story that would have made the Baron d'Ange blush.'

Pissarro was delighted by his new associates' willingness to discuss philosophy and theory. He found that the stimulation of their company, and the technical challenge of the Neo-Impressionist method compensated for the near-disastrous financial problems, and the derision in certain circles which his changed approach had created.

Anarchism and attitudes to art

PISSARRO found a closer accord with his views on art, politics and society among the Neo-Impressionists than among his earlier colleagues. He saw in the work of Seurat and Signac the equivalent in art of an idea he had long cherished, the movement of ideas in the society of the present toward the elaboration of new philosophical and scientific systems destined to become law in the societies of the future.

He was wary of Seurat's affiliations with the *Ecole des Beaux-Arts*, and he wrote to Signac: 'For the future of our art "Impressionism", it is absolutely essential that we remain outside of the influence of Seurat's school. . . . *Seurat is of the Ecole des Beaux-Arts*, he is impregnated with it, therefore take guard, there is a danger . . .' He feared the *Ecole's* attempts to recreate the past, without considering the present or the future. Many years later, Cézanne was to tell his son that Pissarro often expressed his view that the necropoles of art should be burned down. This view was not at variance with his profound interest in history. He was concerned with the art and artists of the past, and studied the works of different ages with diligence and enjoyment, but he stressed that the past had to be harnessed to the present, not emulated for its own sake.

In a discussion with Lucien in 1898, he was to say: 'What good is it to look backwards and never at nature, so beautiful, so luminous and so diverse in character? Always in the dust of the old masters, which one pretends not to notice, on the pretext of venerating them. It seems to me that it is better to follow their example and seek those elements in that which surrounds us, with our proper senses.'

He was to be critical of Lucien's admiration for the work of William Morris and of Charles Ricketts, writing: 'I do not doubt that the books of Morris are as beautiful as the Gothic, but it must be remembered that the Gothic period were the *inventors*. . . . Your friend Ricketts is certainly charming as a man, but from the point of view of *art* he seems to me to be a long way from the goal which is the return to *nature*. And one does not work in this sense except when one observes nature with

our proper modern temperament; it is a different thing to invent or to imitate.'

He found a sterile retreat to the shelter of the past in Gauguin's work, and he commented to Lucien on Gauguin's *Jacob Wrestling with the Angel*: 'I do not reproach Gauguin for having made a vermilion base . . . I reproach him for having lifted from the Japanese and from the Byzantine painters and others, I reproach him for not having applied his synthesis to our modern philosophy which is absolutely social, anti-authoritarian, and anti-mystic. *That* is the serious question. It is a return to the past. Gauguin is not a prophet, he is a wicked man, who has sensed a retreat of the bourgeoisie backwards, as a result of the grand ideas of solidarity which are germinating among the people - an inarticulate idea, but fecund and the only legitimate one!'

In the 1880s Pissarro became increasingly involved in the concepts propounded by anarchist thinkers such as Kropotkin, Jean Grave, and Elisée Reclus.

He read Kropotkin's *Paroles d'un Révolté* as well as numerous articles by him in the anarchist newspapers. He was to send Lucien a copy of *Paroles d'un Révolté* in 1892. Lucien found it very interesting, according in many ways with the concepts which he and his father discussed frequently. Pissarro, in discussing Kropotkin's book with Octave Mirbeau, wrote: 'It must be admitted that, if it is utopian, it is in any case a beautiful dream. And as we have often had the example of utopias becoming realities, nothing prevents us from believing that this will be possible some day, unless man is engulfed and returns to complete barbarism.'

Pissarro was attracted to Kropotkin because of his constructive attitude and gentle manner, which was in contrast to that of other anarchists like Bakunin. When Kropotkin was confronted with two fiery trade unionists during a coalstrike in England in 1893, shouting, 'We must destroy! We must pull down! We must be rid of the tyrants!', his reply was, 'No, we must build. We must build in the hearts of men. We must establish a kingdom of God.'

Pissarro could not entirely agree with Kropotkin's views on art, since he did not consider that art was a luxury, nor did he think that it was necessary to live like a peasant, as Kropotkin suggested, in order to understand or to portray peasant life. He told Mirbeau that while it seemed to him that it was essential to be involved with the subject to depict it well, he questioned whether it was essential to be a peasant, since being an artist gave one the ability to feel and understand, even to understand nature without working on the land.

Grave was to ask Pissarro to design a cover for a reprint of a lecture by Kropotkin, *Modern Times*, in 1897, and he was to execute a

lithograph called *The Labourer*, showing a ploughman using an old-fashioned wheelplough. He did not regard this as an anachronistic image, since to him this form of labour represented a state to be striven for, incorporating his ideas of health, dignity, and honest labour, the antithesis of the degrading and oppressive conditions in which workers in large cities found themselves.

Jean Grave came from a working class family. He was originally apprenticed as a shoemaker, but became a printer and typesetter. His first book, *The Dying Society and Anarchism*, persuasively argued the overthrow of the state, and the authorities jailed him for two years. On his release, he wrote *Society after the Revolution*, which, being Utopian in character, was considered less dangerous. He edited and printed *La Révolte* in a fifth-floor attic in the rue Mouffetard, and his belief in himself as the repository of true anarchist ideals and doctrine won him the nickname of the 'Pope of the rue Mouffetard.' He lived and worked in these offices, surrounded by piles of books, pamphlets and newspapers, dressed in a workman's long black blouse, 'simple, silent, indefatigable', so absorbed in his mission of spreading anarchist belief that 'he seemed like a hermit from the Middle Ages who forgot to die 800 years ago.'

Pissarro was a subscriber to *La Révolte*, and he continued his subscription even when his financial affairs were at their most precarious. He bought copies of whatever anarchist material he could, often sending books and journals to Lucien in London. In 1893 he was to buy two copies of a new edition of Grave's first book, *The Dying Society and Anarchism*, one for himself and one for Lucien. When *La Révolte* was forced to cease publication because of *les lois scélérates* in 1894, he was to subscribe to its successor, *Les Temps Nouveaux*, which made its appearance in the following year. Fellow subscribers among his colleagues were Signac, Luce, and the Belgian painter van Rysselberghe.

La Révolte was written in the language of the educated, without academic affectation, but with appeal only to a limited audience. In February 1889, a new anarchist newspaper appeared, written in the vernacular of the working class. This was *Le Père Peinard*, edited by Emile Pouget.

Pouget had been arrested with Louise Michel in 1883 for leading a march of some 500 unemployed workers. The demonstrators pillaged three baker's shops, shouting, 'Bread, work or lead!', and they distributed their plunder among the marchers. The police attacked the procession, and Pouget fought to give Louise Michel a chance to escape. But she was arrested and accused at the ensuing trial of inciting the looting of the baker's shop. Pouget's case was complicated

because the police found leaflets in his room addressed to 'Soldiers who have decided to aid the Revolution', calling on them to burn their barracks, kill their officers, and join the fight against the police. Pouget had not published these pamphlets, but he was responsible for their distribution. He was sentenced to eight years solitary confinement, and Louise Michel to six years, but public pressure subsequently forced the granting of an amnesty freeing them both. Pissarro regarded Louise Michel as an extraordinary woman, and he had urged Lucien to read her defence in the trial, saying that she conquered ridicule by force of feeling and of humanity.

Pissarro became a member of the *Club de l'Art Social* in 1889. The club was founded by a group of writers who included Cladel, Rosny, Descaves, and Ajalbert, and it met once a week in the evenings in the offices of the *Revue Socialiste*, 8 rue des Martyrs. By the dim light of four candles, the members would huddle around a table and earnestly discuss proposals to revive popular art, and to establish contact between literary, artistic, socialist and anarchist groups. Some of the members pointed out that in Renaissance times artists had been regarded as craftsmen, similar to goldsmiths. Pissarro, with his belief in the importance of understanding one's craft, would stress to his fellow members the desirability of such a situation, if art was to move away from the realm of the mystical and to express the concepts of a new society, free from unclear conceptions. He recognized that his art was out of step with general trends, which tended toward the mystical and the religious, and he believed that it might only be the next generation which would again turn in the direction of the most modern ideas.

The range of opinions held by the members of the club was great; almost all they had in common was a strongly anti-conservative viewpoint. Among their ranks were Maximilian Luce, Auguste Rodin, Grave, Louise Michel, and Amilcare Cipriani. The issue of whether or not violence was an acceptable means to bring about social change divided the members. Whenever this matter was discussed, voices were raised, the atmosphere became charged with tension, and the schism between those members who believed that change was possible without recourse to violence, and those who saw violence as the only option remaining became greater. Largely as a result of these irreconcilable differences, the club remained in existence for only a year.

Pissarro believed that 'artists could work with absolute freedom once rid of the terrible constraints of Messrs. Capitalist collector-speculators, and dealers etc', but his gentle nature could not condone the use of violence in order to bring about the change in society which would

permit such freedom. He thought that by discussion and careful education, the new generation could be taught to accept the anarchists' beliefs, and he never tired of discussing his views with his own children and with his nephews and nieces. He told Lucien in 1883 that he was looking out for one or two of the works of Proudhon which dealt with the question of literature and society to give Alfred Isaacson some idea of the issues involved, although he doubted whether much good would come of this. He sent his niece Alice Proudhon's *De la Justice dans la Révolution* early in the following year, for he shared Proudhon's belief that the 'abstract idea of right' would obviate the need for revolution, and that man could be persuaded to adopt the stateless society through reason.

He and Lucien sent Esther and Alice Isaacson an anthology of 28 lithographs entitled *Les Turpitudes Sociales*, inspired by *La Révolte*, at the end of 1889. The depravities chosen for depiction, Pissarro told Esther, were the most honest of the bourgeois, in view of his nieces' education and sex, and did not include prostitution. The lithographs were concerned with the quest for beauty and what this signified in an age of 'Humbug'. The first illustration showed a philosopher holding a scythe and an hourglass. The scythe mows down the old world, the almost empty hourglass signifies the appearance of the new world. Gustave Eiffel's Tower, constructed for the Universal Exhibition of that year, struggles to reach a rising star, the star of Anarchism. Other scenes included a marriage of convenience; the suicide of a stock-broker; art in the doldrums; a hanged man; and insurrection.

Pissarro fulfilled Kropotkin's injunction to artists to 'show the people the ugliness of contemporary life' in these lithographs, but they were seen only by a handful of people. He intended them to serve a didactic purpose, and he decided that Alice and Esther would be more responsive to the graphic representation of a series of cautionary episodes than they would be to discussion or to the arguments developed in the writings of Proudhon or Kropotkin.

CHAPTER 13

Doubts about divisionism; a measure of success, 1888–1892

SIGNAC wrote in a letter to the *Cri du Peuple* in 1888, addressed to Paul Alexis, of 'those marvellous precursors the Impressionists who suddenly, except for Camille Pissarro, refused to go any further and to admit the progressive element and the solution to the problem for which they were searching for such a long time, and which was provided by a new generation of artists.' This letter created a flurry of resentment on the part of the 'other' Impressionists which Pissarro regretted, although he believed that Signac was correct in his estimation.

In spite of the bad feeling between him and his former colleagues, he exhibited at Durand-Ruel's in the company of Renoir and Sisley in May and June 1888, showing 26 canvases. His work did not sell, a fate to which he was becoming reconciled.

Monet showed 10 Antibes seascapes at Boussod and Valadon in July. He had signed a contract with Theo Van Gogh reserving him the right of first refusal, which meant that if Durand-Ruel wished to acquire new work by him, he would have to negotiate with Boussod and Valadon. The Antibes paintings were the first to be sold on this basis. Vincent Van Gogh wrote to the Australian painter John Russell: 'My brother has an exhibition of 10 new pictures by Claude Monet - his latest works, one for instance a landscape with red sunset and a group of dark fir trees by the seaside. The red sun casts an orange or blood red reflection on the blue green trees and the ground. I wish I could see them.'

Fénéon described the pictures as revealing the artist's 'excessive bravura of execution, fecund powers of improvisation and vulgar brilliance.' Pissarro agreed. He told Lucien: 'I saw the Monets, they are beautiful, but Fénéon is right, while good, they do not respresent a highly developed art. For my part, I subscribe to what I have often heard Degas say, his art is that of a skilful but not profound decorator.'

Pissarro was still adhering closely to the tenets of divisionism at the time of Monet's show. Soon after, he began to express his growing doubts about the laborious technique involved in the production of

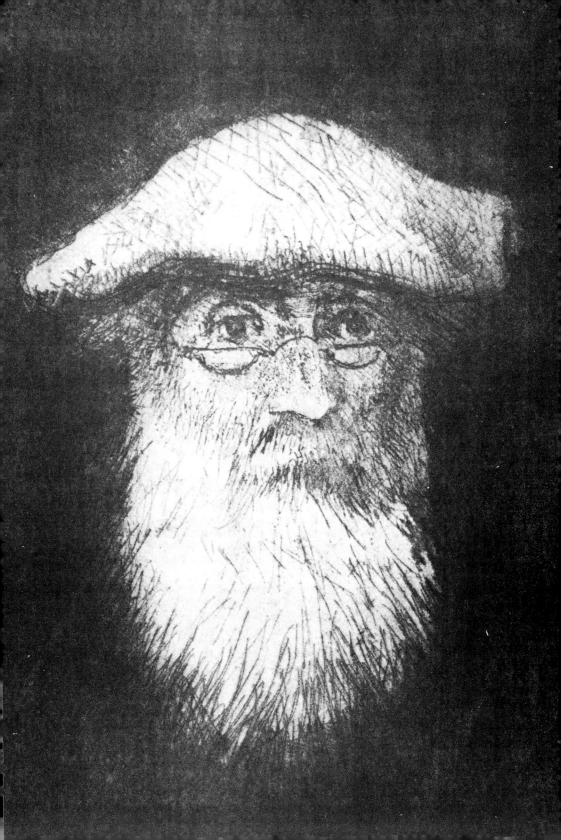

13 *previous page* Self-portrait by Camille Pissarro: etching c.1890. Museum of Fine Arts, Boston

14 *below* Pissarro and Cézanne. Roger-Viollet, Paris

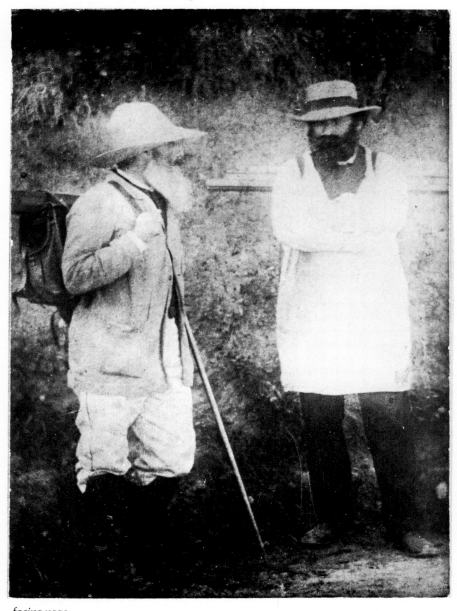

facing page
15 Watercolour of Fritz Melbye by Camille Pissarro. Nationalhistoriske Museum, Frederiksborg, Denmark
16 Aquaforte portrait of Paul Signac by Camille Pissarro. National Gallery of Art, Washington

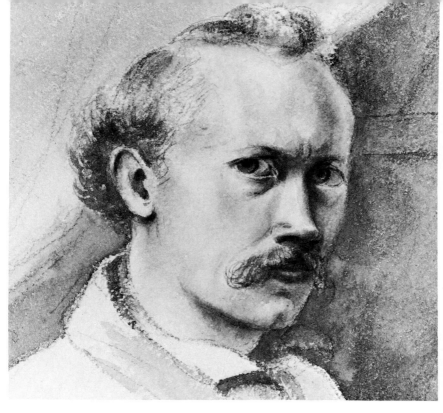

17 Pencil drawing of
Pissarro by Cézanne.
John Rewald, New York

18 Pissarro going off to
paint. Pencil drawing by
Paul Cézanne. Cabinet
des Dessins, Musée du
Louvre, Paris

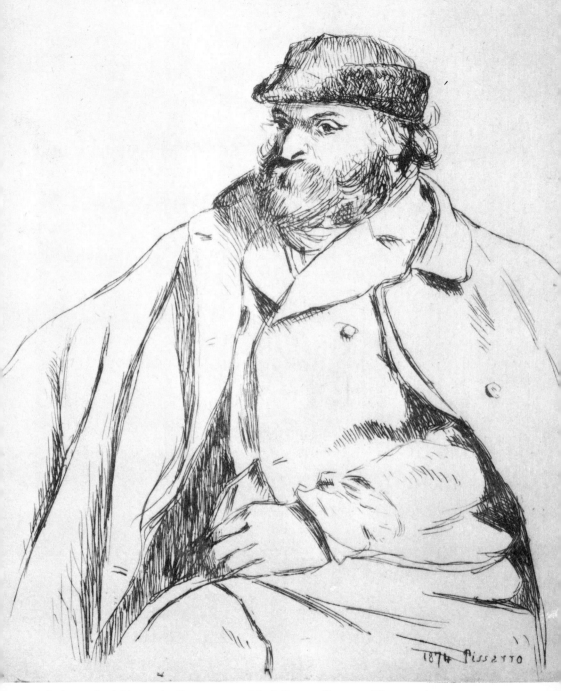

19 Lithograph of Cézanne by Pissarro, 1874. Musée Bonnat, Bayonne; Photographie
Giraudon, Paris

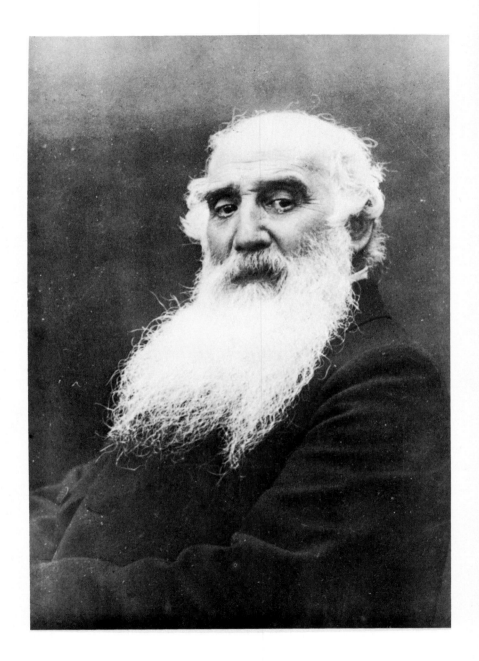

20 Camille Pissarro. Photograph Durand-Ruel, Paris

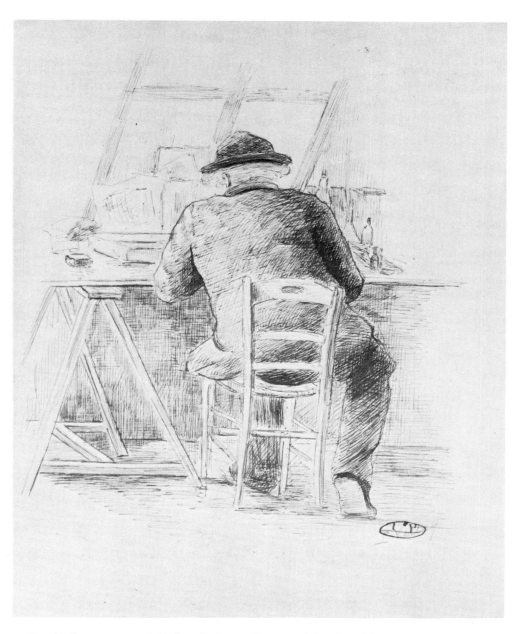

21 Camille Pissarro at work. Etching by Lucien Pissarro. Ashmolean Museum, Oxford

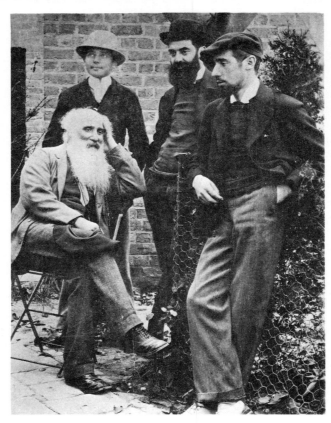

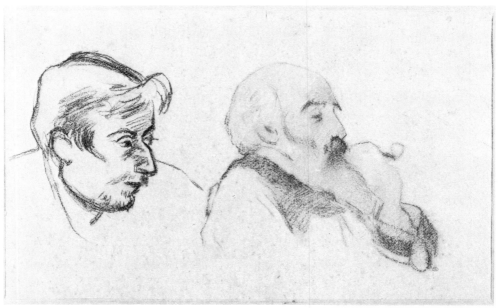

22 Camille Pissarro with Lucien, Rodo and Félix in Belgium. John Rewald, New York

23 Double portrait: Camille Pissarro by Paul Gauguin, Paul Gauguin by Camille Pissarro. Cabinet des Dessins, Musée du Louvre, Paris

divisionist paintings, which still did not attract buyers. He exhibited some recent works on the mezzanine floor of Boussod and Valadon in September, and although Fénéon praised the pictures, Theo was unable to sell anything until the end of November, when the collector Dupuis purchased a divisionist canvas for 400 francs, of which Pissarro's share was 300 francs. In mid-September, he had to implore Theo to assist him with an advance of 1,000 francs to enable him to pay his rent and other expenses.

Fénéon asked Pissarro to advise him on the preparation of an article on *passages* early in the new year, and Pissarro found it difficult to reply to his request. He told Lucien about it, saying that he was looking for some substitute for the dot, but had not yet found the answer to the problem. He was finding that the use of the dot made the execution of the painting too slow, so that it did not follow sensation with enough inevitability. Finally, he told Fénéon at the end of February: 'I am trying at this very moment to master the technique which ties me down and prevents me from reproducing the spontaneity of sensation. It would be better to say nothing about it, I have not yet really settled this question.'

He was aware that his 'defection' would shake the other Neo-Impressionists, for he was their most important convert. He was even used as a measure by painters who disagreed with the Neo-Impressionists, in a negative way. Gauguin, for instance, wrote to Theo Van Gogh in connection with an exhibition at the Café Volpini at which he, Anquetin, Emile Bernard, and other members of the Pont-Aven group showed work: 'Pissarro and some others are displeased by my exhibition, *therefore* in my eyes its good.'

Pissarro had always stressed the importance of a direct and immediate response to nature, and the slow and painstaking technique of divisionism, with its inevitable remove from immediacy, was a serious stumbling block to him. His belief in this method which accorded with scientific developments and which seemed to promise a way of achieving a new art, without the limitations of Impressionism, had been so great that he had been prepared to suppress his concern with spontaneity. Now, he found the method increasingly tedious and unsatisfactory.

Some years later, he was to elaborate on the reasons for his abandonment of divisionism in a letter to Henry van der Velde, in which he said:

'Having tried this theory for four years and having then abandoned it, not without painful and obstinate efforts to regain what I had lost and not to lose what I had learned, I can no longer consider myself

129

one of the neo-impressionists who abandon movement and life for a diametrically opposed aesthetic which, perhaps, is the right thing for the man who has the temperament for it, but not for me, anxious as I am to avoid all narrow and so-called scientific theories. Having found after many attempts (I speak for myself) that it was impossible to be true to my sensations and consequently to render life and movement, impossible to be faithful to the effects, so random and so admirable, of nature, impossible to give an individual character to my drawing, I had to give it up. And none too soon! Fortunately it appears that I was not made for this art which gives me the impression of the monotony of death.'

His dissatisfaction was increased by the physical difficulty he experienced in using the 'dot' technique, for his eye trouble became acute in 1889. He suffered from a condition known as dacryocystitis, an infection of the tearduct. While he was in Paris with Lucien, he experienced considerable pain and inconvenience from an inflammation which enlarged the tearduct, and Lucien wrote to Julie on 26 May that it had been necessary to make an incision in the tearduct to reduce the swelling. The treatment relieved the condition for a time, but it recurred periodically, particularly in changeable weather. It did not affect his vision, but while the eye was inflamed he often had to keep it bandaged to protect it from draughts, and this was a severe impediment.

A few days after the small operation on his eye, Pissarro's mother died, aged 94. When Theo told him this, Vincent Van Gogh wrote from the asylum at St Remy: 'So old Pissarro is cruelly smitten by these two misfortunes at once. As soon as I read that, I thought of asking him if there would be any way of going to stay with him. If you will pay the same as here, he will find it worth his while, for I do not need much - except work. Ask him offhand, and if he does not wish it, I could quite well go to Vignon's . . . It is queer that already, two or three times before, I had had the idea of going to Pissarro's; this time, after your telling me of his recent misfortunes I do not hesitate to ask him.'

Theo replied to Vincent some time later, telling him that he and Tanguy had already discussed the possibility of such an arrangement. He warned Vincent that when Meyer de Haan, Gauguin's friend, had wanted to stay with Pissarro, Pissarro had said that he did not have enough room, and had sought accommodation at the homes of his neighbours, but without success.

The house at Eragny was large, and many of Pissarro's friends did stay there, but Julie had objected to the hunch-backed de Haan, and she now objected even more vigorously to the idea of having Van

Gogh, freshly emerged from an asylum, in the house with the children. She said she did not want a madman in the house, she had been through enough and did not want to start fresh troubles. Pissarro had to tell Theo that the proposed arrangement would not be possible. Theo commented to Vincent: 'I do not think he has any great authority in his own house, where his wife wears the pants.' Pissarro suggested to Theo that it might be possible for Vincent to stay with Dr Gachet in Auvers, but that in the meantime he would look around the country for a boarding house for Vincent. After a few weeks, he wrote that neither he nor Julie had been able to find anything suitable, and that he thought it would be best for Vincent to stay with Dr Gachet.

One of the visitors to Eragny during 1889 was Esther Bensusan, to whom Lucien had been introduced by his cousin Esther Isaacson in London. Lucien had first met her in 1883, when she was 13, and now he saw her again in Paris, on holiday with her parents. He wrote to Pissarro and Julie, telling them of his friendship with Esther, and Pissarro replied: 'We await with some impatience a letter from you telling us some details about the Misses Bensusan [Esther and her sister Ruth] . . . Your mother instructs me to tell you to invite the Misses Bensusan and Amélie [Isaacson] to come and spend Sunday at Eragny.'

The visit was finally arranged for Thursday 22 August. Esther's mother had qualms about allowing her daughters, whose knowledge of French was limited, to travel alone, but she was persuaded to consent. Esther recorded in her diary: 'Went by 6.10 a.m. train to Eragny . . . Spent a most splendid day. M. Pissarro gave me a picture and all were delightful. Went to Gisors and saw towers and church.'

The Pissarro family were delighted with Esther in their turn, and they prepared a book of drawings for her, which was sent to London for her birthday in November. The book was an album of old French songs, handwritten by Lucien, with a frontispiece by Pissarro, watercolours by Rodo and Félix, and page decorations by Lucien. It was inscribed, 'From Eragny artists to Miss E. Bensusan.' Esther wrote to thank them for it, saying: 'I cannot tell you how much I thank you all for the lovely book you sent me for my birthday. I think it is too sweet and kind of you to take so much trouble for me and I wish I could tell you how delighted I am with it. It is so beautifully bound, and it is so splendid to have drawings by all of you under the same cover, for Georges has also illustrated a song called the "Canard Blanc" and drawn some chrysanthemums.'

Pissarro acknowledged Esther's thanks. 'The artists of Eragny are all delighted to hear that you are satisfied with the album', he told her, 'and assure you that if you are pleased to receive it, we are also

pleased, because so few people understand us. So it is a joy to do something for someone who does.'

The 'artists of Eragny' regularly collaborated on a 'house journal', a satirical magazine called *Le Guignol*, which Pissarro and his sons produced once a month. Pissarro designed the cover, contributing a drawing or a lithograph, and each of the sons submitted work. At the end of a year, Lucien would collate the issues, and Georges would bind the volume, sometimes in satin, sometimes in cloth embroidered with a dazzlingly coloured cock.

Georges had been in London since earlier in the year. He was attending the Guild and School of Handicrafts in Whitechapel, which was run by C.R. Ashbee. The Guild was a society of craftsmen, working in close co-operation with each other, and at the same time training apprentices, and Pissarro, who was sympathetic to its aims, was interested to hear Georges' reports of it.

In the spring of 1890 Pissarro went to London for a short time to see Georges, accompanied by Maximilian Luce and by Lucien. He painted a few aspects of London that particularly appealed to him on this visit, the Serpentine, Hyde Park, Kensington Gardens, Charing Cross Bridge, and Hampton Court Green, where he enjoyed watching his favourite English sport, cricket. His oil painting and watercolour of the Thames at Charing Cross, a *motif* he had not previously painted, were an acknowledgement of his interest in Monet's long-intended project, a series of views of the Thames, which he had been considering for the past ten years. Monet loved London in the winter, and believed that 'without the fog London would not be a beautiful city. It is the fog that gives it its magnificient amplitude . . .'. Pissarro disagreed, preferring to visit England during the spring and summer, and to avoid it during the winter months.

Lucien went to London in October 1890 for a few days, to see whether he could sell any of his drawings, and he spent some time with Esther. He told her: 'The time of my stay seemed so very short; we were so occupied that it went quickly. I have such a lot of things to tell and ask you.'

In November he returned to London, and rented a studio in Cornwall Road, where he proposed to give art lessons to young ladies. Esther wished to join his classes, but her father would not allow this.

Lucien was discouraged by the resentment his courtship of Esther aroused, and by the difficulties he experienced in finding pupils or models who appealed to him as much as his sister Cocotte. He wrote to his parents, expressing his disappointment, and Julie became angry and anxious about him.

Pissarro wrote chidingly:

'I am really astonished by your expressions of discouragement. For you to write in this way means many scenes here at home. After I wrote just to warn you, you had to put your foot in it! If you are already discouraged, you will not accomplish anything in London. You must understand once and for all that one must be sure of success to the very end, for without that there is no hope! He who doubts is lost beforehand! How many times have I not told you that where there's a will there's a way; but nothing comes of itself. You've hardly been gone a month, damn it, and it takes a little time to arrange one's affairs. You have good opportunities, you ought to succeed, *besides it is absolutely necessary that you do so.*'

He was particularly annoyed with Lucien because his letter came at a time when Julie was demanding that their third son, Félix, whom they called Titi, find employment. Pissarro took him to Paris, at Julie's insistence, but then sent him back home. He said: 'For, after all, what is the point of putting a boy: Titi or Georges, in a factory, where they will be exploited, where they will learn little or nothing like young Murer [Eugène Murer's son]? It's idiotic! Wouldn't it be better to have them wait for a good opportunity and in the meantime have them work with me? But these false notions [Julie's] prevent me from setting to work with good effect.'

Julie attacked Pissarro for having brought up his sons to do nothing, encouraging them to think of themselves as artists when they should have been learning a trade. Georges had returned home from England, and she felt that neither he nor Félix should be at Eragny, relying on their parents for support. She railed constantly at Pissarro, while he, as was his wont, let the storm pass, knowing it was useless to attempt to argue with her in such a mood.

Pissarro was slowly beginning to achieve a small measure of success. He had exhibited with *Les Vingt* in Brussels in 1889, together with Seurat, Luce, Monet and Gauguin, and his work had been more favourably received than before. The prices he was asking for his pictures had increased appreciably. *La Fenaison*, a painting of 1879, was listed in the catalogue at 1,500 francs, while *Jeune Paysanne faisant au feu (Gelée blanche)* was priced at 2,500 francs. He continued to search for a new approach, one which would enable him to 'combine the purity and simplicity of the dot with the freshness, suppleness, liberty, spontaneity and freedom of sensation postulated by Impressionist art'. It was a difficult problem, and it was to be several years before he felt that he had found a solution to it.

He exhibited 15 paintings and 11 gouaches, one on loan from Clemenceau, at Boussod and Valadon in February 1890. He had

decided to allow Theo Van Gogh rather than Durand-Ruel to handle his work, as Monet had decided earlier. Theo had written to him at length on 17 January:

'We will have to arrange our exhibition most carefully as we ought to sell not only the odd picture, but we must also ensure that it will be on a level that it deserves. I have started by ordering the frames. They will be quite simple in white or grey wood or in oak for *Les Fameuses* and *Les Moutons*. I think, after all, it might not be a bad idea to have a catalogue. Don't you think a preface would be desirable? Kahn, Geffroy or O. Mirbeau could no doubt take care of that. I would like this preface to be a rather comprehensive thing, so, apart from what is to be said of you, the quality of the technique will be insisted upon in such a way as to eliminate the public's ridiculous attitude about this technique. Is the large painting meant for the exhibition as well? It seems to me that we ought to have it towards the end of February to the end of March. How do you feel about that? When are you coming to Paris? It appears to me that we might well be heading for success.'

The introduction to the catalogue was written by Gustave Geffroy, and the gallery contained wood relief carvings and stoneware by Gauguin in addition to Pissarro's pictures. Many visitors came to the gallery, and several pictures were sold. Pissarro was pleased with the results of the exhibition, and wrote to Theo to express his thanks. Theo replied: 'You are really much too kind in the way you express your appreciation of my modest efforts at putting your way of painting across to the public. If I had a say in the matter you would sell much quicker and at quite different prices. I have not given up hope of doing better, and in any case I will always consider it an honour to arrange your exhibition . . . When I see you, you always give me courage to persevere . . .'

Pissarro had become friendly with Theo and his wife Jo. He presented Jo with a fan as a Christmas gift, and he frequently invited Theo and Jo to visit Eragny. Theo told Vincent in April that he intended to spend the Whitsun holidays with the Pissarros. When Vincent left St Remy in May to stay with Dr Gachet in Auvers, Pissarro was concerned about his welfare, and often asked Theo for news about him. Early in July Theo wrote to Pissarro that he had to go to see Monet on 14 July with M. Valadon, and that he would like to invite himself, his brother-in-law, and perhaps Vincent to stay overnight with the Pissarros. Pissarro immediately extended the invitation to include Jo and her son, Vincent.

The health of young Vincent, who was born on 31 January, was

troublesome, and Dr Gachet prescribed ass's milk for him. This made it difficult for Theo and Jo to travel, and Theo regretfully declined Pissarro's invitation, visiting neither Eragny nor Giverny. When Vincent visited his brother and sister-in-law in Paris for a few days, hoping to discuss the question of his allowance and his anxiety about his situation in Auvers, he found them exhausted and still worried about the baby. He returned to Auvers without having broached the subject.

As soon as the baby had recovered, Jo took him to Holland, and on 25 July Theo wrote to her that he had received a letter from Vincent which he found totally incomprehensible. Two days later Vincent went into the fields outside Auvers and shot himself. He died on 29 July with Theo at his side.

Theo wrote to his mother: 'It is impossible to describe his sadness and find consolation. I shall be crushed by my grief for a long time. I shall never forget it. All one can say is that he has now found the rest he longed for . . . Life was too great a burden for him . . . O mother, we were so much alike!'

Vincent was buried in the cemetery at Auvers on 30 July. Lucien attended the funeral, but Pissarro did not travel to Auvers.

Theo was unable to recover from the blow of Vincent's death. In October Jo wrote to Dr Gachet that he was extremely ill at the Maison Dubois, and that she would appreciate it if Gachet could see him. Lucien wrote to Esther: 'You probably remember the young man who showed us some pictures at the Maison Goupil at the time of your journey to Paris. This poor man has just gone mad. It is very sad for all his family and for the all the Impressionist painters for he was more than a dealer to them. Nobody took more to heart their affairs, and at this moment there is not in Paris a man able to replace him.' Pissarro was told at the gallery that Theo had suddenly become violent, and that he, the most gentle of men, had wanted to kill his wife and child. A month later, he was somewhat calmer, and Andries Bonger, Jo's brother, wrote to Pissarro that he and Jo were going to take Theo to Holland. He died there on 25 January 1891.

Pissarro was very distressed at the news. He had liked Theo's quiet manner, and his concern for the artists he represented. Theo's interest had provided a counter-balance to the attitude of many of the other dealers, and Pissarro missed his support and encouragement. After Theo's illness and subsequent death, Boussod and Valadon was managed by a friend of Toulouse-Lautrec's, Maurice Joyant. Pissarro did not feel that he was an adequate replacement for Theo. He told Lucien that Portier had pretensions to taking over Theo's rôle, but he decided that, in spite of his reservations, he could return to

Durand-Ruel, who was finding it easier to sell his old work, but was not eager to buy new pictures from him.

Dubois-Pillet died at the end of 1890, and Pissarro mourned his death, for he had been a kind and valued friend. In March 1891 he was shocked to hear of the death of Seurat after a brief illness. He wrote to Lucien that Seurat had been in bed for three days with a disturbance of the throat, and that 'improperly treated, the illness developed with ruinous speed'. He attended Seurat's funeral on 31 March, grieved at the death of a man whom he believed to be a great painter. He agreed with Lucien that with Seurat's death, 'divisionism is finished'. He said that he thought that it would have consequences which would be of the greatest importance for art, and that 'Seurat really added something'.

Pissarro had exhibited in Brussels with *Les Vingt* in February 1891. The organizer, Octave Maus, had invited Seurat, Sisley, Gauguin and Guillaumin to participate, and he had showed Van Gogh's work. The English painters represented had included Walter Crane and Wilson Steer.

Pissarro was interested to hear of a lecture delivered at the exhibition by Henry van der Velde entitled *Le Paysan en peinture*. Van der Velde had complimented Pissarro, and had contrasted his conception of the peasant in his paintings with more dramatic, picturesque view of Millet. Van der Velde was a close friend of Theo van Rysselberghe, who had been a staunch Neo-Impressionist since travelling from Brussels to Paris to see the Eighth Exhibition of Paintings. He had talked of van der Velde to Pissarro, and had explained his interest in awakening a recognition of the importance of craftsmanship, and of the application of the same design standards in architecture, the arts and the crafts. Van Rysselberghe himself designed furniture and jewellery, and was concerned with graphic design, especially poster design. When Pissarro met van der Velde three years later, he found that many of their ideas were in sympathy. He saw in van der Velde's views an extension of the concepts about art expounded by Kropotkin, that art and life must be integrated, and that the artist could not remain neutral in the struggle for humanity and justice.

Pissarro and Miss Cassatt had a joint exhibition of their etchings at Durand-Ruel's in April 1891, at the same time as the Society of French Painter-Engravers' exhibition. Pissarro was troubled by the inflammation of his eye, and was not able to work. He told Lucien that he was going to see Dr Parenteau when he went to Paris for the exhibition, and that another operation would probably be necessary to alleviate the complaint. He was so pressed for money that he wrote to Monet, who immediately sent him 1,000 francs. This enabled him to pay the rent and make the journey to Paris. To his surprise and pleasure, the

exhibition was a success.

Durand-Ruel organized a large retrospective show of Pissarro's work in the following year. It opened on 23 January and was on view for a month. It consisted of about 50 paintings, dating from 1870 to 1892, and 21 gouaches dating from 1880 to 1890. Georges Lecomte wrote an introduction for the catalogue, and Lucien returned from London to assist with the arrangements. Shortly before the opening, Pissarro told Mirbeau that he was ready in a manner of speaking, since one was never ready. He was not satisfied with his work, and wondered whether the undertaking would be worthwhile, since he had so little luck generally.

Mirbeau wrote a review praising the work highly, and the exhibition was well attended. By 7 February, four pictures had been sold, with a total value of 5,200 francs. Lucien wrote to Julie:

'The exhibition is a success. Mirbeau's article in *Le Figaro* made a noise, and plenty of people came . . . When you come to Paris you will be surrounded with people patting you on the back and wanting to buy the pictures father has given you, but do not. Soon they will be twice the value they are today. At last the time has come when you will be happy and able to buy yourself a beautiful dress. It is time. You have been patient long enough.'

The dealer Bernheim told Pissarro, 'Your moment has come', and so it proved to be. The exhibition marked a turning point in his career, for all the paintings on view were finally sold. At last Pissarro began to achieve some recognition after the long years of struggle, although his financial problems did not disappear entirely. When the exhibition was over, he declared himself very satisfied with the results, and returned to Eragny where he worked steadily.

Pissarro's eyes were causing him trouble, and whenever an abscess formed on the right eye he was obliged to bandage it for a few days. The operation performed by Dr Parenteau in the previous year to open the tearduct and drain the suppurating matter had assisted for a time, but it was a recurring condition, and as a result he was obliged to work more and more in his studio. On his return to Eragny he told Mirbeau that he did not dare go outdoors, for the cold tended to induce the condition, and he frequently painted the view from his window.

He was becoming convinced that work done in the studio was necessary, and that provided one recognized that it had its own limitations and prerequisites, it was desirable.

Monet and Renoir had also reached this conclusion. Monet wrote to Durand-Ruel in 1886 that his Belle-Ile paintings needed to be reworked in the peace of his studio, and Renoir complained that 'out of doors

you can't see what you are doing.'

Pissarro wrote to Lucien: 'I learn with pleasure that you have begun painting in the studio. . . . It is certain that work in the studio is identical from the point of difficulty with work in the outdoors, but it is absolutely different from the point of view of *métier*, methods and results. It does not do to seek from studio work that which is not possible, just as out of doors it doesn't do to seek anything except direct and instantaneous sensations . . .'

He would have agreed with Monet's remark, made many years later: 'One is not an artist, if one does not carry one's picture in one's head before one executes it, and if one is not sure of one's *métier* and composition. Techniques vary, art remains the same . . .'

Lucien and London, 1892

L UCIEN returned to London from Paris at the beginning of April 1892 determined to let nothing stand in the way of his relationship with Esther. Esther's father, Jacob Bensusan, was angry that Lucien continued to see his daughter, for he objected to the fact that Lucien was not Jewish, and found many of his views intolerable.

He believed that a marriage which was not sanctified by a religious ceremony would have little or no chance of success, and he requested Lucien to consider becoming a Jew. Lucien was opposed to this, and Pissarro, born a Jew, objected strongly to Lucien taking such a step. 'I told you in my last letter about my fear of Mr Bensusan insisting on your adopting the Jewish faith to obtain his daughter's hand', he wrote to Lucien on 15 May. 'This is a certainty, so what is to be done, since I cannot imagine that you will accept this stupid and false arrangement . . . It seems impossible to me, he will have to give in. That is not asking too much.'

Lucien found it difficult to make any headway in his discussions with Mr Bensusan. He consented to discuss the question of his becoming a Jew with the Rev John Chapman, but felt that all he could reasonably commit himself to was that any children born of the marriage would be 'fairly instructed in Judaism so that if they wish to become Jews they may do so of their own free will' when they reached the age of 17 or 18. They were to receive no religious instruction of any kind until then. Lucien said that Esther would of course be free to stay at her father's house for the Jewish festivals if she desired to do so.

This did not satisfy Mr Bensusan, and he ordered Lucien to stop seeing Esther. In desperation, Lucien wrote to his father, asking him to come to London to intervene on his behalf with Mr Bensusan. Pissarro agreed to do so, and he decided that this would provide him with an opportunity to paint in London. He proposed to do some 'very free and vigorous things' there. 'And now I would like to ask how much equipment I will have to take with me?' he wrote to Lucien. 'I am not as strong as formerly - when I carried bag and baggage with ease - I am beginning to fret at burdens. Suppose I sent ahead my paints and

canvases of 21" x 18" and 25" x 21"?'

As in 1890, his travelling companion was Luce, and he warned Lucien, 'I must tell you something very sad. Our friend Luce is in great despair. His wife has left him and is not returning to him. The poor boy is out of his mind, and I did not know how to comfort him in his deep grief. I asked him to come to London, so as to get away from his surroundings which always remind him of his wife. Could you find a modest room for him near Leicester Square or in your district?'

Pissarro and Luce left Paris for London on 23 May, and Lucien and Georges met them at 5 o'clock the next morning at Victoria Station. They found lodgings where they could all be together, at 1 Gloucester Terrace, Kew, opposite the green and over a baker's shop. Pissarro was enchanted by the beauty of Kew Gardens, and he was eager to embark on a series of paintings, but Luce remained depressed, and Pissarro found it almost impossible to comfort him.

Esther frequently came to Kew to see Lucien in spite of her father's attempts to force her to discontinue their relationship. Mr Bensusan learned of these visits. He wrote to Lucien on 9 June: 'As against my wish and without my consent you continue to pay your addresses to my daughter and as I learn that she accompanies you to Kew Gardens, I beg to inform you that I consider such conduct most improper and I must prohibit it in future . . .'

He tried every tactic to induce Esther to renounce Lucien. After one terrible scene, he wrote to her:

'My mind is too torn to pieces to talk to you, and besides I have made up my mind not to do so any more after the scene of last night. I think it my duty to tell you so that you may guide yourself in future. Your grandmother was so upset by your obstinancy and the insulting way you spoke to your father than after crying for about an hour she had a heart attack and I thought she would die. Dr Carter told me that she must be careful to guard against anything like that as her heart is very weak. Now bear in mind what you do as I suppose you would scarcely like to have, in spite of your indifference and coldness, her death on your conscience.'

But Esther was determined, and with the encouragement of her friend, Lucien's cousin Esther Isaacson, and in the knowledge of Lucien's love for her, she was able to withstand her father's attacks with great strength. Eventually, her father agreed to see Pissarro, and their discussion was amiable, for Mr Bensusan was reassured by Pissarro's mild manner and distinguished appearance.

He wrote to Pissarro:

'I trust that after a friendly discussion we may arrive at some

amicable arrangement. Each side must show a disposition to yield a little and then perhaps a satisfactory conclusion to this matter may be brought about.'

Since the one point on which Mr Bensusan was insistent, and the point on which Lucien was not prepared to yield, was the question of his acceptance into the Jewish faith, no such conclusion was forthcoming. The brusque tone of Mr Bensusan's next communication to Pissarro and Lucien made this plain: 'Will you kindly come down tomorrow evening and be here if convenient at 8 o'clock . . . I want to have an important interview with both of you . . .'

Pissarro discussed the question of religion with Jacob Bensusan, but, as Lucien reported to his mother, 'He would not budge, he would rather, he said, see his family dead than go against his faith. He said he would never see Esther again if she married me, and would forbid the family to do so. It would kill the grandmother. The comic part is that he declared he would fast on the wedding day and eat no food for 24 hours. However, we don't need his consent. Esther loves me and we shall go ahead with our plans.'

Pissarro was very fond of Esther, and supported Lucien in his determination, but Julie was doubtful about the proposed marriage. She told Lucien: 'This girl is used to comfort that you won't be able to give and is not used to work, do you think she will live in poverty for the love of you? Because you know you must not rely too much on us, we still have the three little ones to bring up. Think well about it and be sure you tell the young girl your situation. I hope you haven't compromised yourself. The laws are very strict on this matter.'

Lucien and Esther were not to be dissuaded, and they made arrangements for their wedding. It took place at the Registry Office in Richmond on 11 August 1892, in the presence of Pissarro, Lucien's friends Ricketts and Shannon, and Mr Bensusan's clerk, Mr F.J. Prescott. Lucien and Esther went to France for their honeymoon, and spent two days at Rouen before walking across the country to Eragny.

Shortly before the marriage took place, Esther wrote charmingly to Julie that she had wanted to tell her many times that she was so happy she was to be her daughter-in-law. 'You were so good to me when we spent that day at Eragny', she said, 'that it seems to me that I have known you for a long time.' She confessed that she did not know much about housekeeping, but hoped that she would learn quickly and that she would be a good companion and wife to Lucien.

Julie did not make Esther's new role easy for her. She grumbled and constantly criticized her untidiness and lack of householding skills. She was hostile partly because of her love for Lucien, and partly because

141

she did not understand Esther's attitudes and resented the easy life which her middle-class background had ensured for her.

Lucien had originally had qualms about marrying Esther lest she think it was for her money. He had written to her: 'At the beginning, Esther, I was always telling myself that you were a rich girl, and that is why I did not dare to speak to you of my love. I was afraid that you would believe it was because of this money that I wanted to marry you . . .' Now he supported her resolutely, and did all he could to make her new life easy and happy. Julie complained to Lucien: 'Your mother doesn't take much place in your life - what a lot of trouble you gave her to bring you up. How are you going to manage if your father does not give you any more? I don't know how you are going to live.'

Julie's carping and her sharp attacks on Esther often reduced her to tears, for it seemed that nothing she could do would please her mother-in-law. Julie had become more and more intractable with the years, to the extent that Lucien was to write to Esther a year later: 'Is it true that the mother will come to Paris? The father won't like it for several reasons 1. it is bad for the children 2. she is so funny that he will not be able to do quietly what he want . . .'

Esther's father did not relent in his attitude to the young couple immediately, although he subsequently became very attached to Lucien. He refused to continue seeing the Isaacson family, and wrote to Esther in October: 'With your marriage all connection with the Isaacson family ceased as far as I am concerned. I cannot receive them again as my guests nor do I intend to receive any of the "Bayswater Clique" who belong to the same school.'

Pissarro himself welcomed Esther wholeheartedly into the family, and she loved him, agreeing with Esther Isaacson that he was 'everything that is good and noble . . . doing away with all the stupid conventionalities which we dull people think *so* important, and leading such a pure, simple and intelligent life.'

Pissarro enjoyed his stay in London, for he arrived there during an exceptionally fine summer, and he was delighted with the *motifs* provided by Kew Gardens. He wrote to Mirbeau: 'I am at Kew taking advantage of an exceptional summer to throw myself bodily into studies in the open air, in the wonderful garden at Kew. Oh, my dear friend, what trees! what lawns! what beautiful, imperceptible undulations of the land! It's a dream!'

He began a dozen small canvases of views of the gardens, but he was hampered by changes in the weather and by the demands made on his time by the necessity for his intervention in Lucien's affairs. He told Durand-Ruel early in July that the time he had was so short, and the work so long, that it made him despair.

On the August Bank Holiday, he found that Kew Green presented a changed appearance which pleased him. It was crowded with families enjoying the summer weather, and omnibuses crammed with laughing, excited holiday makers arrived and departed constantly. He hastily set up his easel and painted the scene from the window of his lodgings.

He had broken away from the rigidity of the divisionist technique completely, and his work was freer and more spontaneous than it had been for some years. He found the dealers more willing to handle his recent work, and Maurice Joyant at Boussod and Valadon wrote to him that he was eager to see the results of his London visit.

Soon after Lucien's and Esther's marriage, he left London and returned to Eragny. He told Lucien that he was delighted to be back with the family and surrounded by his work.

During his absence, Julie had again sought assistance from one of his friends without his knowledge. The house they had been letting at Eragny had been put on the market by its owner, M. Dallemagne, and in May Pissarro had told Lucien:

'Your mother wants me to *borrow* in order to buy it; I am opposed. The moment I am beginning to sell does not seem to me to be the right time to burden ourselves with a debt that will cause me anxiety, and all to the end of remaining in Eragny, which I would like to leave. It is too far from Paris, a badly constructed house which doesn't stand straight, with a garden far too large for your mother to look after, about which she has not failed to complain often enough. No, it doesn't suit me. If we have to move, you can come and help us.'

Julie decided to approach Monet for assistance, and when she told Pissarro that she had spoken to Monet, he felt that it was advisable to accede to her wishes. He wrote to Monet, backing up Julie's request. Monet was selling his work for high prices, and he was happy to help. Lucien went to Giverny for a few days to discuss the details of the loan with Monet, and the purchase of the house was concluded.

In the previous year, Pissarro had confided to Mirbeau that he would be glad to leave Eragny and return to Pontoise, which was so much closer to Paris. Now, he wrote to Mirbeau from London, telling him the details of the negotiations for the house:

'My wife, terrified by the thought of moving, has persuaded me to buy the house, a clause in the contract giving us the first refusal if the owner puts it up for sale. I am borrowing part of the amount from Monet (this is between you and I). At the moment of decision

143

the solicitor's tricks are putting spokes in our wheels, in other words we must either buy for 31,000 francs what could have been had for 15,000, or go elsewhere. Oh, those solicitors! Well, that's what it's like to have such ideas, it does not even appeal to me to become a house owner. Anyway, all for a bit of peace and quiet, but I wonder how I will manage and without a penny . . .'

The purchase of the house, which Pissarro always referred to (in English) as Eragny Castle, effectively prevented him either from moving elsewhere in France, or from returning to London to paint, as he had hoped to do, for he enjoyed the life there, and had found many challenging and attractive *motifs*. Its purchase meant that his financial embarrassment was so great that he had to write to Esther Isaacson, asking her if she could assist with the rent payments for Lucien's studio. Esther Isaacson wrote chidingly to Esther Pissarro:

'Will you give my dear love to your new Papa and tell him not to worry, and I will pay the studio till he finds he can do it. My dear, the poor old man writes me he hasn't a penny, and asks me to do this for him. I am so sorry he is still so embarrassed. My dear little Esther, do do all you can to save and not bring extra expenses on him. Did I not tell you that it was heartless to go and travel at his expense?'

CHAPTER 15

France and Belgium, 1893–1894

SOON after his return to Eragny, Pissarro took up an invitation he had received while he was in London to visit Octave Mirbeau at Les Damps, Pont-de-l'Arche. He told Mirbeau that he looked forward to painting his superb garden, and hoped to do some larger studies than those in the Kew Garden series.

He quickly established a work routine at Les Damps. He would begin painting at dawn, and when the other members of the household arose, they would find him hard at work, having already recorded the effect of sunrise on the garden, which was filled with flowers and shrubs. He painted through the day, only abandoning his easel when it was too dark to see, and then with regret. He followed this pattern except when strong winds kept him indoors, for with his easily aggravated eye condition he did not dare to expose himself to treacherous weather, knowing that the outcome would be an inflammation of the right eye, and several days of having to work with the eye bandaged.

His visit was cut short when Mirbeau received an urgent request from his father to come and see him. He told Pissarro that he was welcome to stay, but Pissarro felt that he could not do so in Mirbeau's absence. He was working on three canvases, and he told Lucien that he would have to complete them in the studio, which he regretted. He wrote to thank Mirbeau, telling him that with the hospitality and the marvellous cooking he had experienced at Les Damps, he had been truly spoiled.

Georges had remained in London, and at this time he startled the family by marrying his cousin, Esther Isaacson, who was 14 years his senior. Julie wrote to Lucien: 'Esther Isaacson doesn't tell me a word about the 100 francs I sent her, but oh, what a shock, she says she is married to Georges. Even Alice, her sister, did not know.' The family had always been fond of Esther, and Lucien was very friendly with her, but they had never anticipated such a step on Georges' part, and they were hurt that he had not told them his plans.

Georges and Esther stayed in London, but they visited France for a

short time early in the following year. Julie feared that Georges might bring Esther to live at Eragny, but Georges would not consider such an arrangement. 'Oh no, she should not be scared like that, the poor woman', he wrote to Lucien, 'I never thought of such a thing. Certainly not. To let my wife be under her petticoats, why, I would never dream of it. Think how rude she has already been to your Esther.'

Soon after came the news that both Esthers were pregnant. Lucien and Esther were staying at Eragny, and Esther was constantly miserable because of Julie's criticism and disapproval. She was anxious to return to England, and in June 1893 they left France. At first they stayed in furnished rooms in Lancaster Road, Westbourne Park, while Lucien looked for suitable accommodation. Finally he found a cottage in Hennell Street, Epping, which pleased him, and he signed a lease for it, although he considered the rental of £21 a year excessive. He called the cottage Eragny House. Georges and Esther moved in with them. Lucien thought the surroundings were beautiful, the forests in particular, but Georges did not agree. This provoked a rubuke from Pissarro, who believed that one could find beauty anywhere if one cared to

Esther, Georges' wife, gave birth to a boy on 31 August 1893 in her father's house at 7 Colville Square, Bayswater. Two days later she died of complications arising from the birth. She was 36 years old. The baby survived, and was named Tommy Clarence.

On 8 October, Lucien's Esther gave birth to a girl, who was called Orovida after an aunt of Esther's. Lucien wrote to Julie that she was a big baby, and that although Esther was disappointed because she had wanted a boy, he felt that the only thing which mattered was that the child should be an artist. Julie was horrified by this expectation for her granddaughter, one which was eventually to be realized.

Georges took his son to Eragny, and Julie reported to Lucien that he was very unhappy and that he made them unhappy as well. He was restless and undecided about his future, and found it difficult to concentrate on his work. In an attempt to encourage him, Pissarro wrote to Octave Maus in Brussels, declining an invitation to exhibit with *La Libre Esthétique*, and using the opportunity to introduce Georges to him: 'May I introduce you to my second son Georges, who will be able to show you a piece of modern design furniture; if possible will you please let me know about this in the near future. I think I may also become a good recruit for the cause you support so valiantly and so victoriously.'

Georges did not complete the furniture in time for the exhibition. Early in January 1894 Pissarro wrote to Maus to explain this to him, and to tell him that Georges would submit some watercolours and engravings instead of the furniture. Georges continued to idle away his

time, and Pissarro became increasingly annoyed with his conduct, and with his expectation that his father would provide for him financially. Lucien visited France, and went to Chaumont with his father. He told Esther that Pissarro had spoken of all his worries about Georges, and was profoundly disgusted with his behaviour. Georges decided that he could not bring up the baby, and he was taken back to London, where his aunts, Esther's sisters Alice and Amélie, assumed responsibility for him.

At the end of 1893, three of Pissarro's sons, Lucien, Georges, and Félix became interested in a new venture, the opening of a gallery to show the work of the Neo-Impressionists at 20 rue Laffitte. Luce, Cross, Petitjean and Charles Angrand were also involved. They painted the façade of the gallery bright blue with red lettering, and intended it to provide a permanent venue for the exhibition of their work. Pissarro himself did not show there, for he had completely dissociated himself from Neo-Impressionism, but he watched the progress of the gallery with interest. Four collective exhibitions were held, followed by joint exhibitions of Luce and Signac, and of Cross and Petitjean. Van Rysselberghe exhibited on his own after this. By 1895, Pissarro was to report to Lucien that although the gallery still existed, it was totally different. It had been leased by a M. Moline, who used it for small exhibitions, but did not show the work of the divisionists.

Pissarro embarked on an ambitious new venture, a series of paintings of Paris. An increase in the sales of his pictures made it possible for him to take a room at the Hôtel Garnier, at 111 rue St Lazare, opposite the Gare St Lazare, whenever he was in Paris. This was convenient, for it was from the Gare St Lazare that he took the train to Eragny. Early in 1893 he had to spend several days in Paris, waiting to discuss his affairs with Durand-Ruel, and he decided that it would be interesting to paint the view of the Place du Havre, directly in front of the station, from his hotel bedroom window. He began four canvases of this subject. He was finding the potential offered by views from a window increasingly fascinating, recognizing the difference which framing the composition in this way made to his approach.

Lucien came to Paris to be with him. He had been told by Dr Parenteau, the homeopathic doctor whom he consulted, that a small operation on his eye was again necessary. He did not have the confidence to remain alone with Félix, whom he had brought to Paris to introduce to the circuit of galleries and dealers. The operation was performed in March, and by mid-April Pissarro was much recovered. He was given new spectacles, and he was delighted to be free of the impediment of the inflammation. He resumed work immediately, with

renewed vigour.

He travelled back and forth between Eragny and Paris frequently, and when in Paris he attended the monthly dinners of the Impressionists at the Café Riche on the Boulevard des Italiens. He took Félix to one of these dinners, but Félix found it 'terribly boring' to listen to the conversation of his elders. Now that Pissarro had broken with the doctrines of divisionism, his relations with his colleagues from the early days of Impressionism were more cordial. He had maintained his friendship with Monet, and admired his recent work greatly. He wrote to compliment him on his *Poplars* series in 1892: 'How beautiful, the three arrangements of poplars in the evening, but that is painting and so decorative . . .'

Monet was engaged on his series of paintings of Rouen Cathedral. 'The more I continue, the more trouble I have in rendering what I perceive', he told Geffroy; 'and I say to myself that he who claims to have finished a canvas is a terrible boaster. To finish means to complete, to perfect, and I labour without advancing: searching, groping, ending up without much of anything, but at the point of being exhausted by it.'

Pissarro saw several of these canvases, and was very impressed by them. In October 1894, before the series was exhibited at Durand-Ruel's, he wrote to Monet that a friend of his, M. Viau, a collector of Impressionist paintings, was very eager to see the *Cathedrals*, and that he too would be delighted to see the most recent ones, which, he said, were surely outstanding to judge from those he had already seen.

He seldom saw Renoir, for Renoir was frequently away from Paris, but their differences of opinion over what Renoir referred to as '*le petit point*' were forgotten, and on the occasions when Pissarro visited Renoir at his home, Renoir's wife Aline was struck by his gentlemanly behaviour. Sisley was working at Moret-sur-Loing, painting a series of studies of the church there. He seldom came to Paris, although he occasionally attended one of the Impressionist dinners.

Of his former Neo-Impressionist colleagues, Pissarro continued to remain on extremely good terms with Maximilian Luce, who was always welcome at Eragny. Signac had initially been bitter about Pissarro's decision to renounce divisionism, and accused him of 'spending half his life slandering us.' Gradually, he recognized that even at the time when Pissarro was most involved with divisionism, his conception was intrinsically different from that of Seurat or Signac. 'He is looking for unity in variety, we, for variety in unity', Signac wrote. When Pissarro was in Paris, Signac visited him regularly. Pissarro and he retained a strong affection for each other, and enjoyed their meetings, at which the conversation was usually about politics

rather than art, for Signac had increasing reservations about the value of Pissarro's work.

The question of political alliance was assuming ever greater significance. The 1890s were marked by a spate of anarchist attacks, and between March 1892 and June 1894 there were 11 dynamite explosions in Paris alone. In 1892 Ravachol blew up the house of the President of the Republic, President Benoît, and the house of the public prosecutor, Bulot. He greeted his death sentence with a shout of *'Vive l'anarchie'*, and went to the guillotine singing an anti-clerical song. A few months later a bomb found in the offices of a mining company in the Avenue de l'Opéra exploded in a police station, to which it had been carried by a police officer, and killed four. The bomb put Paris into a panic. Wild rumours spread about the likely position of the next attack, and a story that the anarchists had mined the churches and poured Prussic acid into the water reservoirs swept through the city.

In December 1893 Auguste Vaillant, recently returned to France from the Argentine, threw a bomb from the gallery into the Chamber of Deputies. No one was killed, but Vaillant received the death sentence, and in spite of public protests, President Sadi Carnot refused to commute his sentence. The socialist Jules Breton was provoked to say that not a single man in France would grieve for Carnot if he were one day himself to be the victim of a bomb. These prophetic words cost Breton two years in prison. Pissarro asked Lucien the day after the incident whether he had read of it in the English newspapers, commenting, 'The deuce! The oppressed revolt!'

Vaillant was executed on 5 February 1894, crying 'Death to bourgeois society! Long live anarchy!' A week later, a bomb was thrown into the Café Terminus at the Gare St Lazare, close to the hotel where Pissarro stayed when he was in Paris. It killed one and wounded 20 others. The man responsible, Emile Henry, stated that it had been his intention to kill 'as many as possible. I counted on 15 dead and 20 wounded'. The police found that he had enough equipment stored in his rooms to make at least 15 bombs. In court, when the judge reproached him with having endangered the lives of the innocent, he replied, 'There are no innocent bourgeois.' Shortly after his arrest three more explosions shook Paris.

In this uncertain situation, Pissarro held an exhibition at Durand-Ruel's. It opened on 3 March, and consisted of 30 oils, 23 watercolours, 14 pastels and 4 gouaches. He was dispirited by the recent deaths of Caillebotte, Dr de Bellio, and *père* Tanguy, and he felt that the entire Impressionist group was nearing death. He did not attend the opening of the exhibition, for he was tired and unwell, but Durand-Ruel came to his hotel in the evening to give him news of its reception. Some of

the watercolours and pastels were sold at the opening, and it cheered Pissarro to hear this.

The exhibition was favourably received. Gustave Geffroy wrote an article praising it highly, and Pissarro's young friend Georges Lecomte wrote him a charming letter expressing his admiration for the work. Mallarmé complimented Pissarro, saying that he was younger than ever. Both Monet and Degas were enthusiastic about the same picture, *Récolte de pommes de terre au soleil couchant*.

Pissarro returned to Eragny, and continued to paint there. He went back to Paris for the last few days of the exhibition, and was heartened to learn that there had been steady sales. The purchase of Eragny Castle meant that he owed almost 20,000 francs, and he was obliged to liquidate this debt as quickly as possible. He found the debt worrying and he was grateful for the improvement of his income, which made its repayment feasible.

He was shocked to hear of the arrest of Félix Fénéon on 26 April. Fénéon was held at Mazas Prison, and he was dismissed from his post at the War Ministry even before formal charges were preferred against him. Pissarro told Lucien: 'Our friend Fénéon has been arrested for belonging to a group of malefactors. - What are we coming to! . . . Isn't this the limit!' He hurried to Paris to find out further details, and sent Lucien several papers which vividly described the anarchist activities of the past few weeks, and included a sympathetic article on Fénéon by Mirbeau.

Pissarro was appalled by the drastic measures which the anarchists were taking, while recognizing that the miseries suffered by much of France's populace demanded strong action. He was torn in two on this issue, his natural disinclination to violence set against his agreement with Fénéon's view that the anarchist attacks had achieved more for the cause than 20 years of brochures by Reclus and Kropotkin. He shared Fénéon's belief that Henry's attack, aimed as it was at the bourgeois, at the voter, rather than at persons holding public office, was the most anarchistic. They felt that the voters were more guilty than the elected, since the latter were forced by the former to perform their function as the people's representatives.

After Vaillant's bomb attack a succession of laws was passed in an attempt to prevent further attacks and to intimidate anarchists and anarchist sympathisers. These laws became known as *les lois scélérates*. The first of the laws made it a crime not merely to incite criminal acts, but even to apologize for them. The second concerned 'associations of malefactors' and defined them by intent rather than by action. The third law, passed in July forbade acts of anarchist propaganda 'by any means whatever'.

The passing of these laws forced both Jean Grave and Emile Pouget to stop the publication of their newspapers, and they were closely watched by the police. Pouget fled to England to avoid arrest, and Pissarro gave him Lucien's London address. Lucien had already contributed several drawings to *Le Père Peinard*, and Pouget welcomed his assistance in producing the miniscule *Père Peinard* brochures he published to keep the spirit of the newspaper alive.

Pissarro was becoming increasingly aware that, with his close associations with the leading members of the anarchist movement, it would be unwise for him to remain in France. He told Lucien on 26 May that he and Félix planned to leave for Belgium, and that he would take advantage of the opportunity to study the collections of the work of the Flemish school. He asked Theo van Rysselberghe to assist the family with the necessary arrangements, and van Rysselberghe replied that he would be happy to do so.

Pissarro did not leave immediately. He delayed his departure from Eragny until 19 June, hoping that a change in the situation might spare him the necessity of the journey. He intended to spend two or three days in Paris with Félix while they waited for Julie to arrive from Eragny, where she was concluding arrangements for leaving the house. Once in Paris, he again postponed his departure, and remained there for several days.

He went to an exhibition of English painting, at which he admired the work of Reynolds and Gainsborough, and the two Turners on view which belonged to Groult. Groult and the dealer Sedelmeyer were bringing Turner's late work to the attention of the French public for the first time. Groult's collection was notorious for containing pictures which he bought in the full knowledge that they were fakes, grudgingly paying 300 francs for them, because he derived malicious enjoyment from seeing connoisseurs praising them for fear of annoying him. The Louvre hung one of his fake Turners for years, in the hope that Groult would bequeath his collection to them. Sedelmeyer showed a Turner at this exhibition which he hoped to sell to the Louvre, but Pissarro was not impressed with it, and said to Lucien that it was 'not beautiful, far from it!'

While Pissarro lingered in Paris, President Carnot was stabbed on 24 June in Lyons by an Italian anarchist called Santo Caserio, on whose dagger were inscribed the words, 'Revenge for Vaillant'. Immediately after this the police began a massive round-up of known anarchists and anarchist sympathisers. Pissarro was finally galvanized into action. He was known to the police, and a dossier on his activities was in their possession. He realized that any further delay in leaving Paris would result in his being held for questioning.

151

He and Julie, with Félix and Jeanne, took the train from Paris on 25 June, and van Rysselberghe met them at the station in Brussels. Van Rysselberghe was anxiously awaiting news of the situation in France. He hesitated to write to his friends there for fear his letters would be intercepted and would cause difficulties for the recipients. He could not obtain French newspapers to learn the details of what had occurred. Finally, news came through Charpentier that Luce had been arrested, and that friends were taking care of his wife, who had returned to him, and their baby. Octave Mirbeau, Gustave Kahn, Bernard Lazare, Paul Adam, and the illustrator Steinlen fled, knowing that they faced certain arrest if they remained in France.

Pissarro realized that he would have to stay away for some time although Julie returned to Eragny with Jeanne early in July. At the end of July, Pissarro reassessed his position, and decided that his own return would be foolish. 'I am afraid I shall be forced to stay abroad for some time', he wrote to Lucien, 'Since the last law passed by the French Chamber it is absolutely impossible for anyone to feel safe. Even a concierge is allowed to open your letters. A mere denunciation can land you across the frontier, or in prison, and you are powerless to defend yourself . . . And since I don't trust certain persons in Eragny, who dislike us, I shall remain abroad.'

He was enjoying his enforced exile, travelling in the company of van Rysselberghe. They went to Antwerp, to Ghent, to Bruges, and then to Knocke-sur-Mer. Van Rysselberghe made every effort to assist Pissarro to find a place which appealed to him, where he could spend some time. He made several small studies of Knocke, and found the countryside attractive, so he decided to stay there, at the Hotel des Bruges.

Rodolphe came in to join him at the beginning of August, and Lucien also paid a short visit. Pissarro met him at the quayside, and Lucien told Esther that he could see his father's white beard from the ship, with Félix and Rodo standing beside him. Georges visited Belgium in September, and he and van Rysselberghe became friendly.

Pissarro was introduced to several painters and designers, among them Henry van der Velde, who came to visit him in Brussels a few days after his arrival in Belgium. Van der Velde was particularly interested in Pissarro's divisionist work, which he had seen at the exhibitions of *Les Vingt*, and since he himself was working in this manner, he was curious to hear why Pissarro had abandoned it. He was anxious to know Pissarro's attitude to the integration of architecture, arts and crafts, about which he felt strongly. Pissarro was attracted to this concept, which his sons, Georges and Lucien in particular, were deeply involved with, and he and van der Velde

discussed it at length. Pissarro stressed that he thought the approach advocated by van der Velde might lead to sterile imitation of the work of the past. To prove that their ideas were innovative, and not derivative, van der Velde and van Rysselberghe took Pissarro to see the house which van Rysselberghe had designed for himself, and which was being built at the that time, at 83 rue de Livourne, Brussels.

Pissarro saw Elisée Reclus frequently. Reclus's nephew Paul was among those who had been arrested in Paris. Pissarro and Reclus discussed the recent events in France at length, wondering what the future held. On 30 July they went on an excursion to the Zeeland area of Holland, accompanied by Félix and by Theo van Rysselberghe. They spent two days there. Pissarro was captivated by the beauty of the landscape, with its grey colouring and its primitive atmosphere and style, and he enjoyed seeing the women in their traditional costumes. From Zeeland the party made its way to Westcapelle, the extreme tip of the Island of Walcheren, which evoked memories of the luxuriance and fertility of St Thomas for Pissarro. He saw many scenes he would have liked to paint, among them the butter market at Middelburg. The journey was a welcome break from the tension he had been experiencing as he tried to assess the political climate in France, and, hampered by a lack of information, to make a decision on his future.

Soon after his return from Holland to Belgium, the trial of those who had been seized in the police raids following Emile Henry's and Caserio's attacks began. They included Fénéon and Luce. The trial became known as the 'Trial of the Thirty'. The prosecution attempted to prove that a conspiracy had existed between the anarchist theorists and the terrorists. Among the defendants were three burglars, led by a Mexican named Ortiz, who handed part of their profits to the anarchist cause. The trial was intended to show that men like Reclus, Grave and Pouget were the accomplices of criminals.

Fénéon conducted his defence in a manner which made a mockery of the prosecution's questions, answering with impeccable dignity and style. He was asked: 'Detonators were found in your office. Where did they come from?' and replied: 'My father picked them up in the street'. The prosecution probed: 'How do you explain detonators being found in the street?' Fénéon answered: 'The police magistrate asked me why I had not thrown them out of the window instead of taking them to the Ministry. You see, one may find detonators in the street.' When asked whether he recognized a flask of mercury found in his office, he acknowledged that it was similar. The prosecutor said: 'Emile Henry, in prison, recognized this flask as having belonged to him.' Fénéon responded: 'If a barrel of mercury had been shown Emile Henry, he would immediately have recognized it. He was not free of a certain

bragging spirit.' When the presiding judge said : 'You were seen talking with an anarchist behind a lamp post', Fénéon enquired: 'Can you tell me, Your Honour, where is behind a lamp post?'

The prosecution's case was so shaky that the defendants were given little opportunity to speak, and after only a week of hearings, the jury ruled that all the accused, with the exception of Ortiz and his two companions, be acquitted. Pissarro was relieved to hear the verdict, and he was particularly pleased to learn of Luce's release. While he was in prison Luce had prepared 10 lithographs depicting life in the cells, which were subsequently published in an album, *Mazas*, with a text by Jules Vallès.

Despite the result of the trial, Pissarro thought that it would be unwise for him to return to France. He was working steadily in Belgium, and was fairly satisfied with the results. He contemplated remaining there permanently, for he found life in Belgium congenial, and although it was as difficult to sell his work as it was in France, he felt that the friendship of van Rysselberghe and Reclus was worth a great deal. Julie wrote to him that the former owner of their house at Eragny wished to re-buy the property, and he asked her to consider this offer carefully, for he had always thought that the purchase of Eragny Castle was a mistake.

He also considered whether it might be possible for the family to move to England, where they could all be together, or, since Julie disliked England so intensely, whether they might move back to Pontoise, while he retained a small studio on the outskirts of London. He enjoyed working in London, and he hoped that he might find a more tolerant political climate in England than existed in France. But Julie was determined. Complain as she might about Eragny, about the size of the house and garden and the burden that this placed on her, it was security to her, and she would not consider moving, especially not to England.

Pissarro viewed the situation in France with disquiet, for it presented a grim picture in many ways. Durand-Ruel was experiencing renewed difficulty in selling Pissarro's work, and his attitude was unco-operative. Several letters to him were unanswered, and Pissarro felt that he could not depend on his support. The *lois scélérates* were still in force, and a wave of anti-Semitism of virulent proportions was sweeping France. In 1891 a group of deputies of the French Chamber had gone as far as to introduce a proposal for the expulsion of Jews from France, although this proposal had been thrown out without receiving a hearing. The following year a daily newspaper, *Libre Parole*, was founded under the direction of the arch-anti-Semite Edouard Drumont. Drumont had published a vicious attack on the Jews in a

book called *La France Juive* six years earlier.

Pissarro had totally renounced any affiliation with Judaism, and had not brought his children up in the Jewish faith. He disagreed strongly with the tenets of orthodox religion. Nonetheless, he was always identified as a Jew by others. Renoir referred to him as 'the Jew Pissarro', Gauguin described him by saying that he was a Jew, and many of his friends and colleagues said that he looked like an Old Testament prophet, with his long white beard and dark eyes. He had described himself as a Hebrew, in contrast to Millet, whom he said was biblical.

As the intensity of the anti-Semitic mood in France grew, he was forced to recognize that being a Jew played a role in his social thinking. His friends Gustave Kahn and Bernard Lazare reached the same conclusion. Some of the anti-Semitism they encountered was socialist in inspiration, identifying Jews like the Rothschilds with the backbone of capitalism. Gustave Kahn pointed out that many of the leading revolutionaries were themselves Jews, and yet they delivered the first attacks on the golden calves of their fathers.

Pissarro agreed with Gustave Kahn that religious notions tended only to obscure the struggle, whether these notions were Jewish or Christian. The struggle was to free oneself from the enslavement of systems which hampered the ideal, the 'free man', creative and removed from crippling laws and social conventions. Religion, in his view, was one of these constraints. He believed, as he had told Lucien when Jacob Bensusan urged Lucien to convert to Judaism, that it was a retrogressive step to accept the rules and laws of religion, and that such a step served only to inhibit the possibility of change and development. In addition to these objections he knew from his childhood experience in St Thomas how the rigid application of religious laws could blight a family and cause their ostracization from a community. However, as the Jews, who constituted a small minority group in France, became subjected to increasing attack and abuse, he decided that it was necessary to acknowledge the fact that by birth and upbringing, he was a Jew. He remained as implacably opposed to the practice of orthodox religion as ever.

For all his misgivings, he decided to return to Eragny, since Julie had made it clear that she would not move elsewhere. He left Belgium at the end of September. Rodo returned to Eragny with him, but Félix and Georges remained in Belgium. They spent some time with van Rysselberghe at Hemixem near Antwerp, and later moved to Brussels.

Early in the following year, van Rysselberghe and his wife came to Paris for an exhibition of van Rysselberghe's work, and Pissarro was able to reciprocate the hospitality they had shown him in Belgium. Van

Rysselberghe and his wife spent two days at Eragny, and during this time he and Pissarro discussed the use of the divisionist technique at length. Pissarro strove to convince his friend that the use of this method could lead only to cold, unanimated results, which did not do justice to his talent for painting and drawing.

His concern with explaining his distaste for the dot continued into the next year, when he clarified his position to van der Velde. He was opposed to the stultifying effect of divisionism's narrow theoretical approach, and believed that it made the rendering of life and movement impossible. In his talks with van Rysselberghe, he attempted to persuade him that the most important thing was to attain a feeling of harmony in one's painting.

Signac had commented on this quality in Pissarro's work a few months earlier, on seeing a pre-divisionist picture of his at Durand-Ruel's:

'There is an early Pissarro (1880) - a peasant woman cutting grass - which is a marvel of unity. From top to bottom of this painting, it is the same tone, either blue or green almost all of the same value, and despite this, the air circulates in it, the planes outline themselves, everything takes its place without clashing, without harshness, without breaking the general harmony . . .'

CHAPTER 16

Guide and mentor: the 1890s

PISSARRO had assumed a position of great importance among the younger painters in Paris by the mid-1890s. This was due to his personality, for his painting was contrary to the excursions into symbolism and decorative painting which were practised by the *avant-garde* young artists of the day. It was an age which looked to older painters for guidance, and even Gauguin was described by Seguin as having a 'paternal image'.

Pissarro was always known for his patience with and understanding of younger artists. He had, as Thadée Natanson, editor of *Revue Blanche*, pointed out, the qualities which enabled him to discern a future swan among a flock of fledglings, imagination, courage, and a particular gift of divination. His enthusiasm was clear, and he was seldom mistaken. He was fair-minded and kind, and ' . . . for those who knew him in the '90s he was something like God himself, he was an idol, perhaps with warts which made him even more human. In a pair of very dark eyes, gleaming with shrewdness and cunning, there was also great kindness, and the same applied to the tone of voice which could be animated but was never agitated. Those who shout make the wise suspicious and it is they after all who must be convinced. But the means of convincing is often a quiet articulate voice . . . We did not love *père* Pissarro, we adored him.'

Georges Lecomte saw Pissarro frequently in the 1890s. His admiration for Pissarro grew as their friendship developed. They met in the afternoon, when Pissarro had finished painting for the day and Lecomte would accompany him as he strolled along the *quais* and visited the art dealers. He was always curious to see the latest work of his own contemporaries and of younger artists, and would often be approached by these painters at the galleries, timid but eager to learn whether their work met with his favour, or to request his advice with the problems they were encountering. Pissarro was never impatient at such requests, and would give a carefully considered opinion. Sometimes he was able to discern the direction suggested by a picture more clearly than its author, and he would perceive merit in work that

had many flaws without seeming insincere.

After making the round of the galleries, he liked to visit the bookshops, browsing tranquilly over the contents of books on philosophy, art and sociology. Lecomte was to recall that he had been surprised by Pissarro's taste in literature when they first met. In view of the simple and rustic life Pissarro led, he had thought that Pissarro would love books about nature, but he found instead that Pissarro was concerned with the discussion of ideas, with the criticism of present social organizations and with the presentation of plans for future societies.

In the early evening, seated in a café, he usually attracted a group of young disciples around him, and he never tired of pointing out to them why the work at the *salon* was poor, and what they should strive for in their own art. He was adamant that it was not advisable for other painters to follow too closely in his footsteps, since this would lead to that sterile emulation of the past which he held in such scorn.

He replied to a young artist who wrote to him at this time:

'You ask me in your letter to kindly give you my permission to work under my direction. Your frank letter demands a frank reply.
I do not think that it is profitable for a young painter to follow exclusively the direction of one master. You have, you say, profited from a study of my works, it seems to me that you would be well advised to follow others also, so that you do not develop a personal manner which would be harmful to you.
I explain my manner of seeing to all those who request my assistance, but . . . art cannot be taught. The best method is to follow the lessons of different painters of value.
I have told you how I think, in the hope that this will assist you, for the rest you should study Corot, Millet, Delacroix, Daumier, Courbet, etc, etc, without being solely under their influence.'

He believed above all that to paint well it was necessary to paint a great deal. He was impatient with painters who told him that they were not working because they were waiting for inspiration. Georges behaved in this way, and Pissarro told Lucien that he was very changeable, easy to discourage, and he would veer from doing no work at all to making prodigious efforts. Pissarro failed to convince Georges that the only way to attract inspiration, and above all, 'sensation', was to work daily and regularly, as he himself did.

One of the painters who approached Pissarro in this decade was Henri Matisse. Matisse had begun painting relatively late; he was 26 years old when he enrolled in the *atelier* of Gustave Moreau. In 1897 he had a picture accepted at the *Salon de la Nationale*. It was called *The*

Dinner Table, and it showed the influence of Impressionism on his approach.

During a visit to Belle-Ile in the previous year, Matisse met John Russell. Russell was interested in his work, and he promised to aid him by introducing him to some of the artists he knew. He was friendly with several of the Impressionists, particularly Monet and Sisley. With Russell's sponsorship, Matisse paid several visits to Pissarro, and found him most encouraging. Pissarro saw promise in *The Dinner Table*, but he remarked to Matisse that one did not produce the effect of light by using white.

On one of his visits, Matisse asked Pissarro: 'What is an Impressionist?' Pissarro replied: 'He is a painter who never paints the same picture twice over; all his pictures are different.' 'For example?' Matisse probed. 'Sisley', was Pissarro's reply. 'Cézanne is not an Impressionist. He is a classical artist because whether he painted women bathing, Mont Ste-Victoire or similar subjects, he painted the same picture all his life long.'

Matisse told Pissarro in 1898 that he intended to go to London for his honeymoon. Pissarro urged him to look at the Turners, in order to see how the effect of light could be created by using many multi-coloured strokes, set close to each other, so that they fused from a distance. Moreau, Matisse's teacher, also encouraged him to look at Turner. Matisse saw that Turner's work, which created form by means of colour, was related to the work of Pissarro and of Monet, but he was not much impressed.

Pissarro did not forget his own contemporaries while he encouraged and aided his younger associates. He met a flamboyant new figure in the Paris art world in 1894, Ambroise Vollard, who had opened a gallery at 39 rue Laffitte. Like Pissarro, Vollard came from the West Indies, although his accent was that of a native of Auvergne. His manner was deceptively indolent, and Renoir was to say that he had 'the weary look of a Carthaginian general'. Still a novice to the art world, he was an astute business man and a gambler. Renoir told his son that 'with paintings this young man was as stealthy as a hunting-dog on the scent of game.' When Pissarro mentioned Paul Cézanne to him, he was interested, and asked Pissarro for more information. Pissarro, who never tired of discussing the merits of Cézanne's work, was happy to oblige. He told Vollard that Cézanne was living virtually as a recluse at Aix-en-Provence, and that he did not submit his work for exhibition in Paris, but that it was time his pictures were shown.

When he had first met Seurat and Signac, Pissarro had told them about Cézanne, and had taken them to *père* Tanguy to see his

collection. Signac had bought a landscape by Cézanne from Tanguy at Pissarro's suggestion. Both he and Seurat had been affected by Pissarro's belief that it was desirable that a large exhibition of Cézanne's work be organized. The idea had not materialized because of the difficulties the Neo-Impressionists encountered in arranging their own exhibitions, and because of their precarious financial position.

Pissarro had long regarded Cézanne as 'one of the most astounding and curious temperaments of our time . . . who has had a very great influence on modern art'. He told Vollard with infectious enthusiasm about the importance of Cézanne's work at Tanguy's, and had toyed with the idea of an exhibition, without pursuing the idea seriously. Now, he threw himself into the organization of a show with great energy, stimulated by the challenge that collecting sufficient paintings for a large-scale show represented. At first Pissarro proposed that the exhibition consist of his own collection of Cézanne's work, which was very precious to him, and to which he had clung tenaciously through the years, augmented by the paintings in a few other Paris collections. As plans for an exhibition progressed, he became unwilling to part with his pictures for the show, and Vollard decided to find Cézanne in order to obtain a collection directly from him.

Pissarro and Cézanne no longer saw each other regularly. Cézanne's behaviour had become increasingly strange over the years, and he was suspicious even of Pissarro. He visited Monet at Giverny in 1894, and Monet invited Mirbeau, Geffroy, Clemenceau and Rodin to meet him. He welcomed Cézanne by saying, 'At last we are here all together and are happy to seize this occasion to tell you how fond we are of you and how much we admire your art.' Cézanne looked around, blurted: 'You, too, are making fun of me!' and fled. He left Giverny so suddenly that he abandoned several canvases at the inn, which Monet retrieved and forwarded to him at Aix.

Pissarro met Cézanne at Monet's exhibition at Durand-Ruel's in 1895. Cézanne had returned to Paris to paint Geffroy's portrait. Pissarro had an amiable discussion with him about Monet's paintings, which both agreed were remarkable. Pissarro told Lucien that Cézanne had been in complete agreement with his view that the *Cathedrals* were the work of a well-balanced but impulsive painter who pursued intangible nuances of effects realized by no other painter.

He was hurt to hear that Cézanne had criticized him to Geffroy, describing him as an old fool. Cézanne also berated him to their mutual friend Oller, saying 'Pissarro is an old fool, Monet is a cunning fellow, they have nothing in them . . . I am the only one with temperament, I am the only one who can paint a red!' He realized that

Cézanne was mentally disturbed when he insulted his friends this way, and wrote sadly to Lucien, 'Is it not sad and a pity that a man endowed with such a beautiful temperament should have so little balance?' He excused Cézanne, but avoided seeing him. Cézanne made it plain that he wished to be left alone. He sometimes signalled to his former colleagues when he saw them in the street in Paris that he wanted them to cross the road, and not to speak to him.

Vollard had some difficulty in finding Cézanne. After several abortive attempts, he located Paul Cézanne *fils* at 2 rue des Lions-Saint-Paul, and discussed his proposed exhibition with him. Cézanne *fils* promised to write to his father that day, and Vollard finally obtained over 150 canvases from him.

The exhibition opened at Vollard's gallery in November 1895. Pissarro was excited and moved by it, the first large exhibition of Cézanne's work to be held in Paris. He wrote to Esther: 'At Vollard's there is a very complete exhibition of Cézanne. Still lifes of a surprising perfection, unfinished things that are really extraordinary in their savagery and character.' He spent hours at the exhibition, and returned to it again and again, his resentment at Cézanne's rudeness completely forgotten in the joy he felt at seeing his pictures. He told Lucien:

> 'I think . . . that at the Cézanne exhibition there are some exquisite things, still lifes of irreproachable achievement, *others very worked* and yet left in the lurch, still more beautiful than the others, the landscapes, the nudes, the unfinished heads and yet truly imposing and so painterly, so pliant. Why? The sensation is there . . . My enthusiasm is not that of St John beside that of Renoir. Degas himself submits to the arm of this kind of refined savage, Monet, everyone . . . Are we in error? I do not think so . . . As Renoir has said to me very fairly, there is an analogy with the things of Pompeii, so rough and so admirable . . . Nothing of the Academy Julian! Degas and Monet have bought some stunning things, and I have made an exchange of some admirable small Bathers and a portrait of Cézanne for a poor sketch of Louveciennes.'

He was upset by the critics' comments which implied that he had always been under Cézanne's influence, or that Cézanne had been influenced by Guillaumin. He felt that Cézanne had been influenced by him at Pontoise, and he by Cézanne, and he was struck by the resemblance which some of the landscapes of Auvers and Pontoise bore to his own work of that time. He had not seen these paintings for more than 20 years, and had forgotten what they looked like. The similarity was scarcely surprising, he commented to Lucien, since they

had been together all the time, and yet each had kept the only thing which counted, his 'sensation'.

Pissarro urged his young friends to see the exhibition, and often went round the gallery with one or more of these painters, pointing out works which particularly appealed to him, explaining aspects of the paintings, and telling them of the companionship which he and Cézanne had shared. Not all the visitors shared his view that the show displayed the best of Cézanne. Hippolyte Petitjean wrote to Lucien: 'I went to see the Cézanne exhibition the same day I received your letter, I met your father in the area and we went to see it together. I do not know if I am wrong but I have seen nothing there which is as good as the canvases belonging to your father. My visit to the exhibition confirmed the opinion that I had formed of Cézanne. I found there qualities of the first order, but in embryo . . .'

Pissarro saw the exhibition as the justification of his belief in Cézanne's talent, first formulated when he saw him at the *Académie Suisse* 34 years earlier. His delight was contagious. He respected Cézanne's wish for privacy, but when one of his friends, M. Félicien Champsaur, author of *Les Hommes d'Aujourd'hui*, told him that he was going to Aix, Pissarro urged him to visit Cézanne and to express his good wishes. Cézanne received his visitor cordially, and Champsaur expressed his admiration for his paintings. Cézanne was delighted and urged him to take the still lifes he had praised. Champsaur was dismayed, for he had no wish to be burdened with the pictures for the remainder of his journey, having praised Cézanne only out of politeness. However, he took the canvases, for he did not want to offend Cézanne, or to wound Pissarro's feelings.

Cézanne was loath to see his old friends, and Renoir, who had been very friendly with him in the 1880s, once went to Aix with a young painter and left without calling on Cézanne, for fear of his reaction. Monet spent a gay and convivial evening with Cézanne in Paris, only to receive a note the following day which read: 'I was very glad to see you again, but it is better that this meeting be the last of our life.' Pissarro accepted the view of Dr Aguiard that Cézanne was ill, and not responsible for his behaviour.

In later years, Cézanne was generous in his acknowledgement of Pissarro. He referred to Pissarro in his talks and letters to Emile Bernard as the 'humble and colossal' Pissarro. In 1902 he said to Jules Borély: 'As for old Pissarro, he was a father to me, a man to consult and something like the good Lord.'

CHAPTER 17

Rouen, Paris and London: 1895–1897

THE HOUSE at Eragny oppressed Pissarro, and he enjoyed having visitors. Luce and his wife spent some time there in the summer of 1895. Their child had recently died, and Mme Luce was very depressed when she arrived. By the time she and Luce left at the end of September, she was more relaxed, and Luce had managed to complete a considerable number of pictures.

Lucien and Esther and Orovida spent the summer in France, and they were at Eragny for much of the time. Orovida was almost two years old, but she did not walk properly, and the family were concerned about this. Julie continually criticized Esther and her handling of the baby, although Lucien had reproached her for her attitude to Esther the previous year. He told Julie: 'You seem still to have animosity against poor Esther who, however, does her best to keep the house tidy and look after the baby. You speak about her cooking. She does cook and well. She has no time for drawing.' Esther was untidy, and often mislaid things, and this annoyed Julie and provoked a stream of complaints.

Pissarro enjoyed having Lucien and Esther at Eragny, in spite of the friction between Julie and Esther. When they left early in September to return to London, he wrote: 'The house seems quite different since your departure; there is nothing like a small baby to give it life . . .'

A month later, he told Lucien:

'Despite a great sweep of work, I am very bored at Eragny . . . Is it anxiety about money, the feeling of winter approaching, weariness with the same old motifs, or lack of data for the figure paintings I am doing in the studio? It is partly due to all these things, but what hurts me most is seeing little by little, the breakup of the family. Cocotte is gone, soon it will be Rodo. Can you see us two old people alone in this great house all the winter? It is not gay . . . They say it makes one work. I don't agree. Although I don't like anyone pestering me when I am working, isolation doesn't give one an eagerness to paint.'

Cocotte had been enrolled at a school at the beginning of October, although she had not wanted to leave home and had cried bitterly. She soon made friends at the school, and settled there. Pissarro felt that the school was much the same as many others, perhaps a little better, because there were several English students, and there was no religious instruction. He took Cocotte to various exhibitions and galleries in Paris, to the Louvre several times, to an exhibition at the Trocadéro celebrating a century of lithography, and to other exhibitions which he thought she would enjoy, in an attempt, little by little, to open her eyes.

Pissarro decided to go to Rouen early in 1896 because of his dissatisfaction with Eragny. On his arrival on 20 January he took a room at the Hôtel de Paris, on the Quai de Paris, which had fine views of the harbour. He saw Monet's brother Alfred regularly, and he was introduced to a wealthy local resident. Félix-François Depeaux, a friend of Mirbeau's and a collector of Impressionist paintings.

Depeaux offered Pissarro the use of his property, which commanded splendid views of Rouen, but he declined because his eyes were troubling him again, and he felt that it would be detrimental to his health to work out of doors. It was difficult for him to accept that he could no longer go out to the *motif* in all weathers as he had done in earlier years, but he was resigned to it. The regulated viewpoint he achieved by looking out of a window suited his present purpose, for he proposed to paint a series of pictures of the harbour.

He began work immediately, and reported to Lucien on 6 February that he had eight paintings in progress, and was eagerly awaiting snow. In all, he painted 12 views of the harbour at different times of day and in varied weather conditions. On this visit he was attracted by the bridges which spanned the Seine, more than 300 yards wide at Rouen. He painted several views of the Pont Boïeldieu, an iron bridge which had been erected subsequent to his first visit to Rouen. One of the pictures of the bridge was purchased from Durand-Ruel by a Rouen collector, M.E. Decap, who was Depeaux's brother-in-law. He wrote to Pissarro some months later to point out that one of the piers of the bridge was out of alignment in the painting, *Le Pont Boïeldieu à Rouen, Soleil Couchant*. The picture is now in the Birmingham City Museum, and it appears that Pissarro did not accede to M. Decap's wish to have this defect corrected, for the pier is still crooked.

He enjoyed wandering through the streets of Rouen. He sketched some of its buildings and the narrow lanes of the old city, and he visited the library. He found the fine collection of illuminated manuscripts in the library beautiful, and told Lucien of his pleasure at examining them.

He saw Depeaux occasionally, either at his hotel, or at Depeaux's home at Mesnil-Esnard, on the outskirts of Rouen. Depeaux had gathered a *coterie* of painters around him, and he aided and encouraged them, bought their work, and arranged exhibitions for them. It was through his intervention that Monet had been provided with the room from which he painted his series of views of the Cathedral. Sisley had spent the summer at Rouen two years previously, and he had been Depeaux's guest for some time.

Pissarro was irritated by Depeaux's patronising attitude, and he found the conventions of his *haut bourgeois* style of life irksome. Depeaux bought his *Toits du vieux Rouen*, but at the end of March Pissarro wrote with annoyance to Lucien: 'I am packing my canvases at the moment without having seen my *amateur* Depeaux. I do not understand that gentleman. He told me he wished to see my pictures in his frames, in order to judge them better, he promised me the frames which are in his dining room; agreed, a meeting fixed for the next day . . . I wait like an idiot . . . nobody. Two days pass, the framer of these parts comes to me with the frames, I expect my strange *amateur* at any time, he gives me a time, I wait again. So I pack, it is *fumisterie*.'

Charles Angrand, whom Pissarro knew from his Neo-Impressionist days, lived in Rouen, and there was a group of young painters there who called themselves the Rouen school. Among them was Joseph Delattre, an admirer of the Impressionists, who had painted a number of views of the Paris boulevards at night some years earlier. They were a small group, who bravely asserted their independence from official art, and they were honoured when Pissarro climbed the five narrow flights of stairs which led to Delattre's studio to visit them and to encourage them in their efforts. There was a view from the studio across the rooftops and chimney pots to the towers of the Cathedral. Pissarro was so attracted by this view that he found a room in the Hôtel de Paris, tiny and without heating, from which he had a similar view. Here he painted *Toits du vieux Rouen*, the painting which Depeaux first bought and then failed to collect, having decided that it was too expensive.

Durand-Ruel held an exhibition of the recent work in April. Pissarro had not intended to show *Toits due vieux Rouen*, for he feared that to do so would be interpreted as an attempt to compete with Monet's *Cathedrals*. Arsène Alexandre, who wrote the introduction to the catalogue, insisted that he show it, and he finally agreed, since his painting was very different from Monet's series.

'You will remember that the Cathedrals of Monet were all done with veiled effects which gave a certain mysterious charm to the edifice', he

told Lucien. 'My *Toits du vieux Rouen* with the Cathedral in the background was done in grey weather and is clearly outlined against the sky; I like it well enough, it pleased me to see the cathedral firm, grey and clear on a uniform sky in wet weather. Well then, Depeaux doesn't care for the sky! I think I shall keep the picture for us.'

The cathedral at Rouen had attracted many painters' attention. Among them had been Turner, who in about 1830 made a watercolour study of the façade. The viewpoint Monet had selected for his series was similar to that chosen by Turner, but Pissarro's picture was concerned with setting the cathedral in relation to its surroundings, and did not resemble Turner's study or Monet's paintings.

Pissarro's friends and associates were complimentary about the exhibition of Rouen paintings, and he was pleased by their praise, which relieved his mood of irritation. But his irritability soon returned, and he was easily annoyed and quick to find fault with those around him, and with the work of other painters. He described the paintings which Signac showed at the *Indépendants* as 'abominable', above all the portrait of his wife which he told Lucien was terrible from all points of view. Cross's work at the *Indépendants* pleased him as little. His uncharacteristic bad temper was occasioned by his concern about his health, and by the tension and strain of his relationship with Julie.

He wrote to Julie frequently while he was in Rouen, but she seldom replied, and when she did, her tone was reproachful. The political situation was worrying him, and his friend Pouget had once again been arrested. Pouget wrote to him from prison, and Julie forwarded the letter to him in Rouen, appending a note condemning Pissarro for being moved by Pouget's misfortunes. She resented the assistance Pissarro gave Pouget and Grave, sending them small sums of money whenever he was able to, and she thought that it was irresponsible of him to help others when they still owed money and could not be sure of their own financial stability. Her constant chiding masked her real concern. She wrote to Lucien, telling him of her anxiety about Pissarro's health while he was in Rouen, without her to care for him.

Pissarro saw Julie very little during this year, for in the summer she went to London to visit Lucien and Esther, taking Rodo and Paul Emile with her. They spent a few days in a rented flat, and then moved in with Lucien and Esther. Julie's opinion of her daughter-in-law's housekeeping was as low as ever. She said that Esther was a spendthrift, and Esther, who made great efforts to please her, was hurt and upset. Lucien's health was poor; he was suffering attacks of giddiness, and he was angry that his mother saw fit to complain. He told Pissarro that they had spent more than usual in an effort to make Julie welcome and that her abuse of Esther was unfair, since Esther did

what she could to help and assisted with massaging patients in a nearby doctor's to earn extra money. Julie revisited some of the places such as the Crystal Palace she remembered from the family's stay in London in 1870. She enjoyed Kew Gardens, for she loved plants and flowers, and she was amazed at the profusion of flowers in the gardens.

On her return, Pissarro found himself in a position he disliked intensely, in the centre of a conflict which had arisen between Julie and Lucien because of Julie's antagonism to Esther. Lucien wanted to move to a larger house, and he asked his father to send him 300 francs to assist with removal expenses. Julie first said that they should send the money, but then changed her mind, and insisted that Lucien and Esther must fend for themselves, and should not have the money. Pissarro wrote resignedly to Lucien: 'I try to reconcile everybody, but I don't succeed very well. All I can say at the moment is that you can be sure I will help you if conditions are not too bad . . . So, for my part, I will do my utmost to send you the three hundred francs without speaking about it.'

Pissarro found that his customary enthusiasm for his work deserted him during the summer, for Eragny and the *motifs* it afforded did not satisfy him any longer. He thought of several places which might appeal to him, and projected a visit to Canteleu, near Rouen, and a journey with Rodo along the Seine, from Rouen to Caudébec. Lucien came to France for a short visit in June, and they went together by boat from Paris to Rouen, which brought back happy memories of his honeymoon for Lucien.

Early in September Pissarro returned to Rouen. He stayed at the Hôtel d'Angleterre, on the Cours Boïeldieu, although he found the hotel rather expensive. From his room he had a new view of the town and the river. He took some time to accustom himself to the change in his surroundings, but by the beginning of October he was able to report to Lucien that he was working *'comme un nègre'* on 10 canvases. All four walls of his room had canvases propped up against them, large and small studies of the river and the bridges, so that he could work on the canvas appropriate to the weather and the time of day. A visitor, Pascal Forthuny, was impressed by the intentness with which Pissarro studied his subject, and he himself was enraptured by the beauty of the scene, which he said equalled that of Venice, with 'marvels' to be seen and painted to left and to right.

He was forced to leave Rouen on 12 November by a recurrence of the inflammation of his eye. He travelled to Paris to see Dr Parenteau, who cauterized the abscess which had formed on the right eye. Pissarro was pleased with the results of the stay in Rouen. He had completed 15

pictures, and found them bolder than those he had executed on his previous visit. He considered that they captured something of the movement, the life, and the atmosphere of the harbour.

He spent December at Eragny, and then returned to Paris, for he had in mind a new series and was eager to experiment with the opportunities which this idea presented. He stayed at the Hôtel Garnier, and worked on a series of snow scenes, looking out of his bedroom window along the rue St Lazare and the rue d'Amsterdam. They were small paintings, but they prompted him to contemplate a series of views of the boulevards, on a bigger scale.

This would be a stimulating challenge, he decided, and it would be interesting to master the difficulties it posed. He had felt the need to set himself new problems to overcome during the past few years, within the limitations of his far from robust health and the need to protect his eyes from changes in the weather. His intention in the *Boulevards* series was to capture the densely interwoven fabric of Parisian life which they presented, with crowds of people promenading, shopping, queueing for horse-driven omnibuses.

He booked a room for himself at the Grand Hôtel de Russie, 1 rue Drouot, on the corner of the Boulevard des Italiens, which commanded a view of the Boulevard Montmartre 'almost to the Porte St-Denis, at any rate to the Boulevard Bonne-Nouvelle', and began work on the series on 10 February 1897. For several years he had been interested in recording how the familiar static elements of a scene were changed by the presence of a crowd. When he had visited Lucien in London in 1892 he had found the spectacle of Kew Green on a Bank Holiday exciting to paint, and at Rouen the bustling acitivity of the harbour had fascinated him. Now, at his hotel room window, he prepared to paint the boulevard during the festival of Mardi Gras.

When he returned to Eragny in April he found that the change of *motif* had reawakened his responsiveness to the beauty of the countryside. He set to work without delay, recording the profusion of blossoms and the new growth of spring. He was anticipating with pleasure a visit from Lucien and Esther in the summer, and was feeling more tranquil than he had for some time, when suddenly there was bad news from London.

Lucien and Esther had moved to a new house at 62 Bath Road, Bedford Park. It was larger and more suitable for their requirements than their previous accommodation had been. Their pleasure at the move was marred by Lucien's ill-health. One evening in May he went into London to dine with Charles Ricketts, and on his return, he was so tired that he decided to spend the next day in bed. In the afternoon Esther was dismayed to find him crumpled in a chair. She wrote to

Pissarro that he had suffered a stroke, and could not use his left arm at all, nor open his right eye.

Pissarro hurriedly made arrangements to leave for England. He travelled straight to Dieppe from Eragny, without going to Paris, and wrote to Durand-Ruel: 'I had to drop everything at Eragny, studies of spring begun, to rush over to my son Lucien, very gravely ill. Please send me 1,000 francs, because in my haste, I did not have the time to pass through Paris . . .'

Shortly before he arrived, Lucien suffered a second stroke, and Esther was relieved to see her father-in-law, who made every effort to assist and reassure her. He looked after Orovida, calmed Esther, and encouraged Lucien's progress back to health. He spent two months in England, but managed to paint very little because of his preoccupation with Lucien's condition.

By mid-June Lucien was gradually recovering, and he found time to begin some studies. He told Durand-Ruel: '. . . I am hard at work and the sun is really so rare here that I dare not leave my neighbourhood, which is so far from the centre . . .' He painted the view from the back of the house, which looked across a railway line to a cricket field. Two of his pictures were of cricket matches, for the game continued to intrigue him. While he was in England, the Diamond Jubilee of Queen Victoria's accession to the throne was celebrated. Although he was not able to travel to the West End to observe the festivities, he painted the celebrations at Bedford Park, relishing once again the opportunity to catch the excitement of an urban event, the illuminations and the vivid colours of flags and bunting, on his canvas.

Georges and Félix were also in England. They were living together in Kew, and Pissarro was happy to see them again. They had spent a short time earlier in the year at Saint Sebastian, but had returned to England with some relief, and they were both working conscientiously. Pissarro was disturbed to find that Félix was not well. He was extremely pale, coughed frequently, and tired easily.

When Lucien was a little stronger it was decided that he and Esther would accompany Pissarro to Eragny, where he could convalesce. Lucien was still very frail, and quickly exhausted, but at Eragny he slowly recovered. But further bad news was in store for the Pissarros, for Félix's condition was diagnosed as tuberculosis. Julie hastened to London to care for him, while Pissarro remained in France, spending most of his time at Eragny with Lucien and Esther.

Julie stayed at Lucien's and Esther's house, and immediately after her arrival she wrote a furious letter, accusing Esther of deliberate rudeness, for she had arrived to find the house locked. Esther protested that Julie had known that the keys were being kept by

friends, the McGregors, and that she would never have behaved so vindictively. But Julie continued to grumble, complaining of Esther's bad housekeeping and extravagant ways. Esther was in despair at having to bear this attack in addition to her anxiety about Lucien and Félix. She wrote to Pissarro, who was in Paris for a few days: 'Georges and the mother hate me. I should not mind very much on their account, but as I like you *very* much, I dislike the idea that you doubt me . . .'

Lucien was well enough to return home by the end of October. Pissarro suggested that it would be a good idea if he gradually began working again, for he was convinced that this was the best way for Lucien to restore his interest in life and his strength. Julie was back at Eragny, but she continued to write letters berating Esther for her inefficiency and improvidence. Lucien was still weak and easily depressed. He wrote to Pissarro: 'I am really better now, but unfortunately not well enough to be able to get such letters as the mother writes to me. It is Esther she is against, but she doesn't understand it upsets me as well.'

Esther had employed a maid, so that she would be able to spend time caring for Lucien. She was hurt to receive a letter from Pissarro in which he too took her to task, saying:

'In your letter you tell me that you have only 70 francs left in your pocket of the 400 francs that I sent you. I don't understand how you managed to go so quickly about it. It is not that I did not warn you. The money I have got is only enough for my present needs. You must understand that I have Félix ill and doctors in London and Paris to be paid. If I am not careful I shall not manage. As soon as you arrive, you take a maid, but Esther, how are you going to pay her?'

Esther replied sadly to this letter: 'It is no good being angry, there is an English proverb, "give a dog a bad name and you may hang him". My bad name was given me years ago.'

Pissarro was fond of Esther. He usually teased her gently for her carelessness, telling Lucien: 'Soon I hope we shall find, little by little, everything Esther lost in field and garden . . . It is a pity that all the things she sows cannot take root and blossom!' It was unusual for him to reprimand her, but Julie's continual harangue about her daughter-in-law's extravagant ways, and his concern about his sons' health had strained his patience.

He did his best to encourage Lucien to return to a normal life, sending him newspapers and magazines, and attempting to restore his interest in the world around him. He kept his fears about the state of

Félix's health from Lucien as far as possible.

He wrote to Dr MacNish, Félix's doctor, asking him whether he would advise that he and Julie should come to London. The doctor replied that there was no immediate need for this, since Félix seemed to be better. Nonetheless, Julie decided that she would return to England, and she left at once. Pissarro remained at Eragny because his eye was inflamed, and he feared that travelling would lead to further complications and prevent him from being of any assistance in London. He wrote to Lucien on 26 November that he had news of Félix's health from Georges, and that he seemed to be slightly recovered, but this information was not correct. Félix died on 25 November, aged 23.

The family feared to tell Lucien the news, but finally they could withhold it no longer. 'We were afraid to inform you and didn't know how to conceal our great grief from you', Pissarro wrote, 'but in such fatal circumstances we have to be resigned and think of those who are around us. To give way to discouragement would be terribly dangerous, and we must surmount what we could not prevent. In our misfortune I was able to see how well Georges rose to the occasion, he evidenced great strength of character, for he kept your mother from making herself ill. Well, dear Lucien, let us work, that will dress our wounds. I wish you strength, I want you to wrap yourself up, so to speak, in art; this will not keep us from remembering that fine, gentle, subtle and delicate artist, from loving him always.'

Pissarro found consolation in work, as he had when Minette died. He believed that it was important for the living to continue absorbing themselves in creative effort, rather than mourning passively. Julie could not understand his attitude. She felt that his ability to recover his serenity and to continue working indicated that he was unfeeling, and that he had already forgotten Félix.

Early in the new year, Pissarro told Lucien that he was very worried about Julie's condition. 'She has just recovered from 'flu, but what really worries me is her complete discouragement and state of nervous exasperation, such as I have never seen in her before. She weeps for our poor Titi night and day. That is understandable, but what is less so is her belief that we are all indifferent, that none of us thinks of our poor little one. Because I do my best not to awaken our grief, your mother regards me as a poor father, lacking in sensibility and without affection for the poor boy.'

Georges had returned to Eragny after Félix's death, and he and Pissarro were arranging Félix's pictures. Pissarro said: 'Everybody doesn't feel the same way, Georges and I live with Titi by arranging his drawings and paintings and we feel his absence when we see what a

subtle artist he was. Your mother's exasperation is of course the result of her grief and of overworking herself in London nursing our son. I have done my best to persuade her to rest, but she resists all advice. If I gave way to discouragement, what would become of us?'

His courageous acceptance of Félix's death was remarked on by Signac. Signac visited him in Paris in February 1898, expecing to find him depressed by Félix's death and Lucien's illness. He recorded in his journal: 'He has an admirable philosophy and a serene power of resignation. He is more vigorous than ever, works with enthusiasm . . . When one compares the old age of this artist - all activity and work with the dreary and senile decay of the old *rentiers* and the pensioned off, what a reward art holds for us!'

Head of Camille by Lucien Pissarro

The Dreyfus Affair, 1898

PISSARRO discussed the 'Zola case' with fire, Signac noted in his journal after his visit to Pissarro in February 1898. This was the Dreyfus affair, which Pissarro had been following closely for some time. Early in November 1897 Bernard Lazare, a journalist and the editor of a review called *Political and Literary Conversations*, whom Pissarro had known for several years, published a pamphlet entitled *A Judicial Error; the Truth about the Dreyfus Case*. Lazare had suspected the verdict, that Dreyfus was guilty of treason, from the beginning, and he had been assisted by Dreyfus's brother, Mathieu, to accumulate evidence. He distributed 3,000 copies of the pamphlet to ministers, editors, journalists and others, but it created little stir. Pissarro read it, and he commented to Lucien: 'The new brochure of Bernard ·Lazare, which has just appeared, proves that the document which the General Mercier gave the press is a forgery. Lazare's contention is supported by 12 scientists of different nationalities. Isn't it dreadful?'

There was little concern about the fate of Dreyfus at this stage. Georges Clemenceau said of Lazare's and Mathieu Dreyfus's attempts to persuade him of Dreyfus's innocence: 'They bore us with their Jew'. Socialists tended to feel that the miscarriage of justice as applied to a bourgeois army officer was an irony to be savoured rather than deplored, but Pissarro's concern with justice for the individual made him feel strongly about the iniquity of the Dreyfus decision.

Gradually the doubts about the verdict which Lazare had voiced in his pamphlet had an effect, and interest in the case grew steadily. By the end of October, the Dreyfusist adherents were increasing in number, and were beginning to be described as 'the Syndicate' by anti-Dreyfusist journalists.

On 10 November, the newspaper *Matin* published a reproduction of the *bordereau*, that is, the letter which Dreyfus was alleged to have sent to the German Embassy in September 1894 detailing the information he had available. The publication of this document aroused considerable interest, and a member of a financial house called Castro recognized the handwriting of Major Walsin-Esterhazy, with whom he

had done business. On 29 November *Le Figaro* published a batch of letters from Esterhazy to Mme de Boulancy, a relative, including one of them in facsimile next to the *bordereau*. In these letters Esterhazy told Mme de Boulancy his opinion of the French and the French army. Esterhazy was thoroughly alarmed by the publication of these documents, and wanted to flee, but he was warned of the implications of doing so, and he insisted instead that the letters were forgeries. The anti-Dreyfusist section of the press took up his statement, declaring that there was nothing of which the Jews were not capable.

By the end of 1897, the Dreyfus trial was a public issue, although there was as yet no coherent movement in favour of Dreyfus, since only a handful of people had any evidence that the trial of 1894, held in camera, at which Dreyfus was found guilty, was irregular in many aspects. The Dreyfus Affair became a burning issue, fanned by a reckless press, and suddenly everyone · was discussing the case, arguing bitterly and taking sides. Families were split over the Affair, and everywhere feelings ran high.

Clemenceau finally took up the case, and he pursued it without remission. In 109 days, he wrote 102 articles on the Dreyfus Affair, championing the cause of justice throughout. An old and close friend of Monet's, he drew Monet's attention to the matter, and Monet gave his full support to the movement in favour of a retrial for Dreyfus.

Pissarro found that although many of his friends, among them Monet and Signac, were as alarmed as he at the situation created in France by the Dreyfus Affair, there were others who believed that Dreyfus was a traitor who had been justly tried and punished. The anti-Semitism which was rife in the 1890s in France aggravated the inflamed feelings which the mere mention of Dreyfus aroused. Pissarro was not surprised to find that Degas, always extremely conservative in his political views, had broken with his close friends the Halévys over the Affair, expressing bitterly anti-Semitic views. Degas's anti-Semitism was so virulent that he had Drumont's newspaper *Le Libre Parole* read to him, his eyes beging too weak to enable him to read it himself. His friends used to bait him to provoke his venom. The collector Camondo sent his mistress to invite Degas to dinner. When he refused to come, she said: 'But I'm not Jewish.' 'That's true', Degas replied, 'But you're a whore'. Degas avoided Pissarro and Monet when he saw them in the streets, and pretended not to recognize them.

Renoir also avoided Pissarro at this time, because he wished to avoid embroiling himself in the case. He disliked conflict, and hoped to prevent it by steering clear of both Pissarro and Degas. He said of the case: 'Always the same camps but with different names for each century. Protestants against Catholics, Republicans against Royalists,

Communards against the Versailles faction. The old quarrel has revived again. People are either pro- or anti-Dreyfus. I would try to be simply a Frenchman . . .' His efforts to remain neutral failed, for Degas asked him, referring to Pissarro: 'How can you stand associating with that Jew?', while Pissarro was angry and upset at his snubs. He told Signac of Renoir's behaviour, and Signac wondered in his journal: 'What can there be in the minds of such intelligent men that leads them to become so silly?'

Guillaumin was another of Pissarro's colleagues who expressed strongly anti-Dreyfus views. Pissarro heard that Guillaumin said that Dreyfus should have been shot immediately, since this would have saved embarrassment. He did not speak to Guillaumin for some months as a result of this, but gradually his anger faded, and they renewed their contact.

Pissarro followed the events of the Dreyfus Affair with avid interest, writing to Lucien to keep him informed of the latest developments. Early in 1898 the blatant prejudice of the investigation into Dreyfus's guilt or innocence was revealed at the military court of seven officers assembled to court-martial Esterhazy. The Minister of War, General Billot, had already declared on three occasions that Dreyfus was the traitor, and the minds of the officers were made up before the trial began. In spite of glaring discrepancies in Esterhazy's evidence, he was found not guilty. The crowd in the courtroom broke into applause at the verdict, and those outside the court cheered the 'martyr of the Jews' with cries of 'Long live France! Down with the Syndicate!'

At this stage Emile Zola entered the arena with a dramatic statement, composed in great haste in two nights and a day after Esterhazy's acquittal in the form of a long open letter to Félix Faure, the President of France. It was published in *l'Aurore* on 13 January under the huge headline, *J'ACCUSE!* 300,000 copies of the newspaper were sold, many of them to anti-Dreyfusists who burned them in the streets. Zola attacked the War Office, the handwriting experts, the first court-martial, Esterhazy's court-martial, and other aspects of the case. He wrote: 'As for the people I accuse, I do not know them; I have never seen them. I bear them neither ill-will nor hatred. For me they are no more than entities, spirits of social evil . . . My fiery protest is only the cry of my soul. Let them dare bring me to the Assize Court and may the examination be made in the light of day. I wait!'

Pissarro wrote to Esther and Lucien on the day Zola's article was published: 'The Dreyfus case is causing many horrible things to be said here. I shall send you *l'Aurore*, in which there are the very fine pieces of Clemenceau and Zola. Today Zola accuses the General Staff. Ajalbert has published a very courageous article in *Les Droits de*

l'Homme, but the bulk of the public is against Dreyfus, despite the bad faith shown in the Dreyfus affair . . . Alas for a people so great in '93 and '48! The Third Republic had indeed been pernicious in its effects.'

Two years earlier, Zola had written an article called 'On Behalf of the Jews', published in *Le Figaro* on 16 May 1896. He had said: 'It is several years by now that I have been observing with increasing wonder and disgust the campaign against the Jews in France. To me it seems something monstrous, going beyond the bounds of common sense, truth and justice, something which will inevitably thrust us back several centuries or bring us to the worst, the ultimate of all horrors: religious persecution.'

Now, his words seemed to be coming true. The publication of *J'Accuse* caused a great stir, both on the left, where it shook many into action, and on the right, where it provokes a rash of anti-Semitic acts. These were mainly confined to the provinces, where there were riots and shops owned by Jews were smashed and looted. In Paris there were demonstrations, but little violence. Pissarro reassured Lucien, who was concerned about his father's safety: 'I repeat that you should not worry, the anti-Semitic ruffians are much less noisy and aggressive since the beating they received at the Tivoli Vauxhall, where they organized an anti-Semitic demonstration.' But anti-Semitism was the fashion, and people even had 'Down with Jews' printed on their parasols.

Pissarro interpreted the situation as threatening a clerical dictatorship, 'a union of the generals with the sprayers of Holy water.' He did not think that this would succeed, since, as he told Lucien: 'Indignation against the General Staff seems to be growing here and in the provinces the socialists are active, it is possible the clouds will lift. But will a review of the trial take place? No one knows . . .' At the end of January he wrote: 'You are right not to permit yourself to be too upset by the hue and cry about the Dreyfus case. For the present, these are little brawls, but behind the case a second *May 17* is being prepared, a clerical *coup d'état* and a *coup d'état* by the army . . .'

A petition was circulated calling for a revision of the Dreyfus trial. Octave Mirbeau wrote to Pissarro, requesting him to sign, and he did so. Signac wrote in his journal: 'In the face of the screams of cowardice and infamy aroused by the courageous intervention of Zola in the Dreyfus and Esterhazy affairs, I asked that my name be put on the list of protestors which is being published by *L'Aurore*. I am in good company there. All those who think freely, all those who put dignity before interest, sign these lists which are growing daily.' Many of those approached feared recriminations and refused to sign, but in all about 3,000 signatures were obtained.

Zola was prosecuted for his accusations, as he had anticipated. Ten days before his trial began, Pissarro said: ' . . . he will evidently be found guilty, for everybody declares that the government is in the right and that Zola should have minded his own business There speaks prejudice, you see, but one cannot with impunity conceal the truth, sooner or later it will come out.'

Zola's trial began on 7 February, and the court was packed with journalists, lawyers, army officers, and society ladies. A witness described the atmosphere at the *Palais de Justice* as smelling of 'suppressed slaughter', and remarked: 'What passion on people's faces! What looks of hatred when certain eyes met!' Outside the court, bands of youths organized by Guérin shouted anti-Semitic slogans and cheered and jeered as the crowd entered. Degas came to Durand-Ruel's house one day, and announced that he was off to the Law Courts. 'To attend the trial?', Durand asked. 'No', he replied, 'To kill a Jew.'

Pissarro wrote after the third day of the trial:

'Things have hardly improved. You can read the account of Zola's trial in the *Daily News*. It is favourable to Zola, since it was written by Duret. You will notice that all the witnesses for the prosecution were unwilling to answer the questions of Zola's attorney; nevertheless the truth emerges, breaks through. Zola will be condemned just the same, the mob is against him, he will be condemned even against the evidence! No, the people want a tyrant, they unanimously assert the infallibility of the army. Poor France! Who could have imagined this nation, after so many revolutions, enslaved by the clergy like Spain.'

Pissarro had not maintained contact with Zola since 1886, but the animosity he had felt then was forgotten in his respect for Zola's courage, and he wrote to him to express his whole-hearted admiration.

During the trial the atmosphere in Paris was electric, and an English visitor said that the city palpitated with the lust for blood. An employment office opened where bands of youths were hired for five francs a day or two francs an evening to march through the streets shouting 'Down with the Jews! Long live the Army! Spit on Zola!'

One evening, walking to Durand-Ruel's gallery, Pissarro found himself in the midst of one of these gangs, yelling 'Death to the Jews! Down with Zola!' With great dignity and self possession, he walked calmly on, looking every inch a patriarch with his flowing white beard and velvet jacket. He was not taken for a Jew, and he reached the gallery unmolested. The agitation which he managed to conceal so successfully at the time appeared later, when he described the incident

to Lucien, for he dated the letter incorrectly.*

The final speeches in Zola's trial began on 21 February. Zola replied to the speech of the Attorney General. *The Times* correspondent, Fullerton, commented: 'He began with an insult to the Prime Minister and at the same time to the jury; and such glorification of himself as must have displeased the unpretentious men who form the jury.' On the following day, after hearing speeches by Fernand Labori, Zola's lawyer, and Albert Clemenceau, representing *l'Aurore's* editor, the jury retired for only 40 minutes before finding both men guilty. Zola was sentenced to the maximum penalty under the Press Law of 1881, 12 months imprisonment and a fine of 3,000 francs, while Perrenx, the editor, was sentenced to four months imprisonment and the same fine. Signac wrote: 'Zola is condemned to one year in prison. It was inevitable. He attacked one of the cogs of society . . . The stupid, depraved crowd yells for death; the sword and the flag triumph . . .'

Pissarro told Lucien not to worry any more about the Zola case, for there had been no new anti-Semitic outbursts. He said that anti-Semitism had been condemned even in the Chamber of Deputies. In fact, the Prime Minister, Méline, said the day after the verdict that the incessant accusations made by the Dreyfusists were responsible for the trouble, and that the Jews who had undertaken the campaign were themselves the provokers of anti-Semitism, but he declared that where necessary, disciplinary measures would be taken. Pissarro concluded correctly: 'The government is mighty sick of the affair, but does not know how to dispose of it; people are beginning to reflect . . .'

An appeal was allowed on the grounds of a technicality, but the outcome of a new trial, held at Versailles, was a foregone conclusion. Zola fled to England in July on the advice of his lawyer Labori and the brothers Clemenceau, who persuaded him that this was in the best interests of the Dreyfus cause. The affair continued to rage until September of the following year when, after a retrial, Dreyfus was condemned again 'with extenuating circumstances' and accepted a pardon, despite Clemenceau's protests. But for Pissarro, the end of the Zola trial marked the end of his active concern with the issue.

*The letter which refers to this incident; to his letter to Zola; and to the petition of protest is dated 19 November 1898. However, it refers to 'after Zola's trial', implying that the trial was still in progress. The notepaper used is identical in every respect, colour, width of mourning-border, and watermark with that used in the letters written from the Hôtel due Louvre, from January to April 1898, and differs from the notepaper used in November. A letter of 22 November is addressed 'Hôtel du Rome', and there is no indication that Pissarro moved at this time.

The last years: 1897–1903

WHILE the Dreyfus Affair raged, Pissarro was hard at work on a series of views of Paris which he had begun soon after the death of Félix. He took a room at the Grand Hôtel du Louvre, a huge hotel at the intersection of the rue de Rivoli and the Place du Palais-Royal, and he painted views of the Avenue de l'Opéra and the corner of the Place du Palais-Royal. He commented to Lucien:

'It is very beautiful to paint! Perhaps it is not aesthetic, but I am delighted to be able to paint these Paris streets that people have come to call ugly, but which are so silvery, luminous and vital. They are so different from the boulevards. This is completely modern!'

He regarded it as a 'real painter's motif', and after making two preliminary studies in December 1897, he embarked on a series of pictures. For hour after hour he sat at the window of his room, with the window open if the weather permitted, applying himself with intense concentration to the task he had undertaken. He wore a beret or a battered old cap on his head, and paused occasionally to puff at his pipe. He found that the new spectacles which Dr Parenteau had prescribed assisted him with close work. These spectacles had half-lenses, and suggest that he had normal vision, and was presbyopic rather than myopic.

After he had completed his day's work, he often went to the rue Mouffetard to see Jean Grave, who was now editing *Les Temps Nouveaux*. In addition to the small gifts of money which he made Grave whenever he could afford to do so, on two occasions he paid the printing debts which the paper had incurred. He believed that it was essential that the anarchist voice which *Les Temps Nouveaux* represented continue to be heard.

Two years earlier, Grave had launched the publication of a series of lithographs as a companion album to *Les Temps Nouveaux*. He intended all the examples to represent social themes, but he allowed the artists considerable latitude in their choice of subject matter. Pissarro was interested in this publication, and he contributed three lithographs to

it, *Les Porteuses de Fagots*, *Les Trimardeurs*, and *Les Sans-gîtes*. Grave organized a tombola to raise funds, and various artists contributed paintings as prizes. Pissarro and three of his sons, Lucien, Georges and Rodo, gave work for the tombola.

Pissarro never tired of discussing the political issues of the day with Grave. He continued to take an active interest in the literature of anarchism and socialism. Grave sent him a copy of his book, *L'Anarchie: son but - ses moyens* in 1899, and Pissarro wrote him an appreciative note of thanks, telling him that he had begun reading the book with great interest and attention.

Pissarro worked steadily on his series until the end of April. He completed 12 canvases for Durand-Ruel, and three which he retained for himself. Early in May he returned to Eragny. He was happy to be in the country again, breathing the fresh air and seeing the flowers and the spring landscape. He started painting immediately after his return, so that he would not lose the habit of working.

After spending a few weeks at Eragny, he returned to Paris. Durand-Ruel was organizing an exhibition in which his paintings of the past two years were to be hung in a large room on their own,. Work by Renoir, Monet, Sisley and Puvis de Chavannes was on view in other rooms of the gallery. Pissarro was pleased with the results when he saw the pictures in the gallery. He thought that a picture on which he had been working for the past two years, *Printemps en fleurs*, was the best thing he had ever done. Durand-Ruel was happy with the work, and he considered that Pissarro's recent *Avenues* were so clear that they would not suffer beside the paintings of Puvis. Pissarro admired the submissions of Renoir and Monet, and he regarded the exhibition as a great artistic success.

He decided that it would be a good idea if he and Julie went away for a time. Julie continued to mourn Félix, and Pissarro feared that she would become seriously ill if she could not begin to think of other things. He hoped that a journey would help her return to a calmer frame of mind. They went on a visit to Dijon, Mâcon, Lyons and Julie's home town of Grancy-sur-Ource during June.

Pissarro found the countryside beautiful. The lovely promenades and fine views of Lyons appealed to him, and he was impressed with the collection at the museum in Lyons. He welcomed the opportunity to see Puvis de Chavannes' *Bois Sacré*, which hung on the staircase of the museum, and the collection of pictures by Tintoretto, Veronese and Claude Lorraine. Grancy, situated in the heart of the winelands, was an attractive village, and he thought it would be interesting to paint. But apart from a few watercolour studies he did not work a great deal. This was partly because he always found difficulty in painting an area

which was not familiar to him, believing that one did not make progress unless one painted what one knew well, and partly because the tear duct of his right eye was again enlarged and painful, and he was attempting to rest his eyes as far as possible.

He decided that he would return to Rouen after this journey, and by early August he was installed there, exploring the *motifs* of the harbour and the Cours-la-Reine. He continued to find Rouen a delightful town, and discovered new *motifs* which appealed to him on this visit. They included a view of the rue de l'Epicerie, which he painted three times, in different weather conditions, and an interesting market, held every Friday. He commented to Lucien that it was an expensive business, now that he was no longer content to remain at Eragny but felt compelled to seek new places. In spite of the cost of living at the hotel, he remained at Rouen until the middle of October, working constantly and completing a large number of pictures.

Restless again, he decided to travel to Holland at the end of the month with Julie. He wanted to see an exhibition of Rembrandt's work which was on view in Amsterdam, and he hoped to introduce himself to a collector in the Hague, Mr Uterwijk. He and Julie were accompanied by Federico Zandomeneghi. They spent eight days in Holland. Pissarro wrote to Lucien: 'What superb landscapes and beautiful pictures we saw! The Rembrandt show was comprised of some 40 or so works of the first order, and the museum of Amsterdam is very interesting. One really has to spend several months in Holland just to see the museums; what do eight days amount to? I can hardly remember all the masterpieces I saw.'

The exhibition of Rembrandt's work was held at the Municipal Museum, Amsterdam, to celebrate the coronation of Queen Wilhelmina. It consisted of 124 paintings and 350 drawings, most of them on loan from private collections. They included *The Night Watch, The Jewish Bride, The Syndics*, the *Portrait of Nic. Ruts* (now in the Frick collection), and the *Self Portrait* (now at Kenwood House).

In spite of his admiration for the work of Rembrandt, Frans Hals and Vermeer, Pissarro returned to France 'more than ever an admirer of Monet, Degas, Renoir, Sisley . . .' He believed that each epoch had its own approach to art, arising out of the needs and conditions of that period, and that the work of the Impressionists was as clearly of his own time as that of the Dutch masters was of the seventeenth century. 'I despise those painters who know so adroitly how to pastiche the old masters', he wrote, his contempt for the practices of the *Ecole des Beaux-Arts* undimmed through the years.

He and Julie returned to Eragny after the visit to Holland, but soon Pissarro decided to leave for Paris. Georges and Rodo were sharing a

studio in Montmartre, and with Cocotte away at school, Pissarro felt that it would be unwise for Julie to remain at Eragny with Paul Emile. He looked for suitable accommodation in Paris, and early in December he found a flat at 204 rue de Rivoli which fulfilled his requirements. It had a superb view across the Tuileries Gardens, with the Louvre to the left, and the dome of the Invalides to the right, and the steeples of Ste-Clothide visible behind a mass of chestnut trees.

After finding the flat he went back to Eragny, and in the second half of January, he and Julie moved to Paris. Pissarro settled down to work, but the bad weather hampered him. 'Until now I have only been able to paint effects of grey and rainy days', he told Lucien, 'for since our arrival we have had miserable weather with winds that could unhorn bulls. They sweep across this great open space and make a deafening racket.' The weather was still hindering him in mid-March, and he was 'awaiting the thrust of the leaves and flowers so as to get more varied effects.' He was forced to stop painting several times when the fog closed in for prolonged periods.

Signac who visited him in February with Luce, commented critically in his journal:

'On the wall some old canvases by him show how inferior are his latest ones. Really, in those muddy, dirty and flat tones, there is no longer to be found any of the qualities of the fine colourist he used to be; neither is there the charm and splendour of the beautiful scene before his eyes. On that lovely winter afternoon, the orange-tinted light gilds the whole landscape; the blue shadows lengthen and contrast with the warm tints of the light, or shade off along with them. In this beautiful scenery, the multi-coloured spots of the crowds. And all that so well part of the "Impressionist" note of life and light and colour! On leaving the reality seen from the window, one is quite saddened to fall back into the gloomy interpretation of the old artist. - And yet, in health and spirit, he is still young and strong.'

Pissarro was distressed to learn of the death of Sisley at the end of January. Georges and Rodo had spent part of the previous summer at Moret, and they had visited Sisley, but had not known that he was ill. Pissarro learned of his illness only a week before he died. 'He is a beautiful and great artist', he wrote to Lucien. 'I am of the opinion that he is a master equal to the greatest. I have seen again works of his of a rare scope and beauty, among others an *Inondation* which is a masterpiece.'

Sisley died completely destitute, and Monet set about organizing a charity sale in aid of his widow and children. Pissarro gave one of his

recently completed pictures, *Le Jardin des Tuileries, l'après-midi d'hiver*, to the sale. It fetched 4,800 francs. The sale included 33 of Sisley's own works, and it realized a sum of 160,000 francs.

Durand-Ruel held an important exhibition in April. It included a whole room of pictures by Pissarro, in addition to separate rooms of work by Corot, Sisley, Monet and Renoir. The 36 paintings by Pissarro illustrated his development from 1870 to the previous year. Signac was scathing about the recent work, and noted in his journal on 22 April:

'From year to year one can watch the deterioration, and in his latest canvases he sinks into complete mud. He paints the first subject he happens to see from the window, without looking for composition, and uses just any blend of colour, painting at random, without regard for light and colour . . . For him too, the good period is between 1882 and 1883 - Osny and Pontoise - blues, greens, reds, orange tints, juxtaposed in hatchings, becoming soiled perhaps through contact, but creating shades of beautiful optical grey, resulting in a delicate general harmony and a pearly unity. But the Boulevards, the Avenue de l'Opéras, the latest Rouens, these are truly nil, the low negation of all his lifetime searches.'

Many of the visitors to the exhibition disagreed with Signac's judgement, and praised Pissarro's recent paintings, but he himself was aware that they were not his best work. Two years later he was to write to Monet: 'The friends who told you that I had painted some fine canvases of the Tuileries were being most indulgent. These paintings do not quite satisfy me. I am fighting against old age.'

He continued to move about restlessly. In June he travelled to Arques, in August to Varengeville near Dieppe, where Monet had painted in the early 1880s. His improved financial position made these journeys possible, and he needed to vary his *motifs*, for he felt that he had exhausted everything Eragny had to offer. When he told Lucien in July that he had begun some studies in the field ajoining the house at Eragny, Lucien commented: 'How often will that field have been painted!'

In the autumn he returned to the rue de Rivoli flat. He continued to work steadily on his series of views of the Tuileries, capturing the view from his window in all weathers, at different times of day.

He decided to look for another place to live in the following year. He considered going to London to paint together with Monet, who had begun his first series of views of the Thames seen from the Savoy Hotel in the autumn of 1899, but he changed his mind. 'Did you know that it seemed necessary for a bit that I should find myself cheek by jowl with you at the Savoy Hotel', he told Monet, 'but my creole

passivity and I think the fear of autumn fog and winter chill prevented me. It is curious, despite the inconveniences, London has often attracted me and yet I have never been able to make my London pictures well-liked!'

He was delighted to find a flat in an old house on the Pont Neuf, at 28 Place Dauphine, once the home of Madame Roland. He told Lucien that it had a fine view, and that he was 'simply afraid of failing once again to avail myself of a picturesque part of Paris.' Lucien was slowly regaining his strength and vitality, and he proposed to visit Paris in the summer. Pissarro assured him that the move to the new apartment, which he planned to make in July, would not affect this visit at all.

Georges and Rodo had left Paris and were living at St Helier, on the Island of Jersey. Pissarro learned that Georges had remarried on 10 May, and that a child was born a month before the marriage, on 11 April. The child, a girl, was named Athée Camille, and later nicknamed Kikite. Georges's new wife was Amicie Lucie Jeanne Brecy. She was 23 years old, and came from Conflans, Loiret. She and Georges were married at the Registry Office in St Helier with Rodo as a witness, and Georges acknowledged the child as his at the wedding ceremony.

Pissarro was furious when he was told of this, for he felt that Georges had deceived him. Julie wrote to Lucien: 'Come quickly. Quarreling at home. Georges has a new wife.' Lucien and Esther hastened to travel to France, and Pissarro soon regained his composure. His relationship with Georges was often stormy, for Georges was restless and dissatisfied, and acted impulsively and thoughtlessly.

After spending some time at Eragny with Lucien and Esther, and painting in his studio, he decided to go to Berneval, six miles north-east of Dieppe, for a few days in July. He stayed at the Grand Hôtel de Berneval, which he found attractive. It had fine gardens, and was situated on the edge of the cliffs. He embarked on a series of views of the gardens looking towards the cliffs. Lucien joined him in Berneval, and with Pissarro's gentle encouragement, he painted three pictures, the first he had completed since his stroke three years earlier. He was overjoyed at this, and so was Esther, who had been a tender and compassionate nurse.

Pissarro visited the *Exposition Universelle* in Paris with Lucien and Esther. Paris was crammed with visitors, and special events of all kinds catered to every taste. The Impressionists were represented by a comprehensive exhibition, which was widely discussed and generally well thought of. But Gérôme, always a resolute opponent of their work, so contrary in intention to his own, stood defiantly in front of the entrance to the exhibition hall when it was visited by President

Loubet, saying : 'Halt, *M. le Président,* here is the dishonour of France.' Pissarro, Lucien and Esther explored the attractions of the *Exposition Universelle,* and Esther was delighted to find that her 70-year-old father-in-law enjoyed visiting the cabarets of Montmartre, and admired the dancing of Loïe Fuller, the rage of Paris.

Pissarro finally moved to the new flat on the Pont-Neuf in the autumn of 1900. He began work on a series of views of the Pont-Neuf immediately, but was hindered by his eye, which became inflamed as soon as the weather changed. The eye would be healthy one day, and so severely inflamed that it required cauterization on the following day. It was a constant source of annoyance to him. In addition to painting, he was assisting with the preparation of an exhibition which Durand-Ruel was arranging for early in the new year.

The exhibition opened on 14 January. It consisted of 42 canvases, all painted between 1898 and 1900, and it was a *succès d'estime.* Pissarro wrote to Lucien that the pictures of Eragny seemed better to him than those of Paris or Rouen.

Georges exhibited 10 paintings at Durand-Ruel's in March. Shortly afterwards, Pissarro went to stay with him at Moret-sur-Loing. He had reconciled himself to Georges's temperament, so different from Lucien's, and he was glad to see his granddaughter. He painted five views of Moret on this visit, before returning to Paris and resuming his Pont-Neuf series.

He was eager to visit new localities, and in June Rodo accompanied him on a journey to explore several places which Pissarro thought he might find interesting to paint. They travelled from Rouen to Trouville, which he did not like, and on to Villers-sur-Mer. He thought Villers was even uglier than Trouville, with atrocious chalets and a landscape entirely lacking in interest. Caen pleased him better, and he judged it worth the trouble of visiting it, for it had fine churches, old houses and interesting streets, but he felt that it had been spoiled by the large modern houses which had been built there.

He decided to go to Dieppe, and after returning briefly to Eragny he left for Dieppe on 20 July. He booked a room at the Hôtel du Commerce which afforded a view of the market place and the church of St Jacques. He set to work soon after his arrival, and after six days he was able to report to Lucien that he had started on eight canvases.

Julie and three of the children, Rodo, Cocotte and Paul Emile spent part of the summer at Berneval, where they hired a large cottage. They had a pony and a pony-cart at their disposal, and they enjoyed the seaside resort. Pissarro saw them frequently, but he was able to continue his work in Dieppe without interruption. He relished the bustle of the market place, and the intricacy of detail of the façade of

the church attracted him. He painted it several times, in various weather conditions. He remained in Dieppe after Julie returned to Eragny with the children.

While he was in Dieppe Pissarro sometimes saw Sickert, who had lived in a villa on the hill of Neuville since 1899. Sickert's work was influenced by Pissarro's at this time, as he himself later acknowledged: '. . . under the influence of Pissarro in France, himself a pupil of Corot, guided in England by Lucien Pissarro and by Gore, I tried to recast my painting entirely and to observe colour in the shadows.' This phase of his work was known in France as his 'Pissarro period'. Pissarro had met Sickert previously, and Sickert had been an admirer of his for some years. Now he had an opportunity to learn from Pissarro at first hand, and as always, Pissarro was courteous and willing to advise.

Lucien, Esther and Orovida came to France in the summer. They spent most of their time at Eragny, but Lucien joined his father in Dieppe for a few days. He wished to discuss the purchase of a house at Stamford Brook which Esther had discovered. During his stay, Pissarro and he visited Sickert together. Lucien and Sickert were to become close friends some years later, when Sickert returned to England.

Orovida and Esther remained at Eragny with Julie, and Julie's hostility to Esther was so noticeable that Orovida asked her mother: 'Why doesn't grandmother like you?' Lucien reproached Julie for her behaviour when he was back in London: 'I admit that you are very kind, but *bon dieu*, if you were not kind one could not stay five minutes in your company. You are like a volcano. So touchy, so severe. Don't get cross with what I tell you. You know these are but words, we love you from the bottom of our hearts.'

Pissarro spent only a month at Eragny after his stay in Dieppe before returning to the Pont-Neuf flat in Paris. He worked regularly, except when his eyes required treatment, and he found the view from his window continued to appeal to him.

His interest in world affairs and politics had not forsaken him. He followed the press reports of the Boer War with concern, and he told Lucien in February that he had received a friendly letter from Diana McGregor in London, thanking him for his subscription to the Boer cause. She sent him a list of subscribers, and he was surprised to find that even the smallest villages in France had rallied to this cause, including Eragny. He noted with alarm that there appeared to be a revival of militarism in the world, and Lucien agreed with him that this seemed to be the case, and was greatly to be feared.

Pissarro's relationship with Georges was particularly close during this year. After spending a few months in Paris, completing work for both Durand-Ruel and Bernheim, he went to stay with Georges at

Moret. He painted 12 pictures during this stay, views of the river Loing and of the people of Moret. Lucien envied his brother the opportunity to paint with Pissarro. and he told his father: 'Georges is really a lucky fellow to be able to be with you alone, so tempting to be able to paint with you.'

He returned to Dieppe for the summer. He painted prolifically, concentrating almost exclusively on the harbour. Julie came to spend a few days in Dieppe in July, accompanied by the two youngest children, Cocotte and Paul Emile. They celebrated the 14 July together before she went back to Eragny. Pissarro remained in Dieppe until August, for he thought the *motifs* were very beautiful, and he wished to record them in a variety of pictures.

He was shaken to hear of the death of Emile Zola in October. 'You have heard that Zola is dead', he wrote to Lucien on 3 October. 'It is a terrible loss to France! And coming after the Dreyfus case, it is, as you can see, a grave event. I sent my condolences to the widow, but I do not believe that I can attend the funeral; at my age, I would not dare to follow the procession . . .'

Zola died of carbon monoxide poisoning on 29 September, and the coroner returned a verdict of accidental death at the enquiry which followed. However, there was some doubt about this verdict, and the possibility existed that the chimney, which led to a neighbour's roof, had been deliberately blocked. Zola had received hundreds of threatening letters in the years following the publication of 'J'Accuse', and many people had expressed a desire to kill him. He was buried in a military funeral, at which Anatole France delivered an oration, and his ashes were transferred to the Panthéon six years later.

Pissarro returned to Paris in November, as was his custom, and he resumed work on the Pont-Neuf series. In March he moved to the Hôtel du Quai Voltaire, which was accustomed to accommodating painters, writers and composers. Baudelaire had lived there in the 1850s while he was writing *Les Fleurs du Mal*, Wagner composed *Die Meistersinger* there in the winter of 1861, and Oscar Wilde had frequently stayed there. Pissarro began a new series, views of the Pont-Royal, the Pont du Carrousel and the quai Malaquais.

Julie travelled to the South of France in January to visit Georges and Rodo. They were working at Martigues near Marseille, in the company of Francis Picabia. She wanted to see the region for herself, with the idea that she and Pissarro might move there, for she found the big house at Eragny difficult to maintain and she thought that the climate might be good for Pissarro. She told Lucien: 'It was nice, the climate good, the weather beautiful, but the sons said it was ugly, so your father doesn't want to hear about it any longer. He would have been

well there.' She spent a few days in Paris before going back to Eragny, and complained that since Georges and Rodo had returned there before her, she 'came home to do the washing since it is always me who does the slaving.'

It was not only his sons' description which dissuaded Pissarro from moving to the South of France. He had never had any desire to do so, neither during the 1870s when his friendship with Cézanne would have ensured him a welcome at Aix, nor in the 1880s when both Monet and Renoir explored the possibilities offered by the Riviera coast. He restricted himself to the Ile-de-France region in his search for new *motifs*; he preferred the quieter landscapes and softer colouration of this area to the vividness of the South of France. After his youth in the tropics, and his experience of the flamboyance and luxuriance of vegetation and colour there, he showed no wish to return to similar climes, although he still recalled the beauty of the Virgin Islands with pleasure, and often spoke of St Thomas to his family.

Now 72, he could not see himself making a major change such as a move to the South of France would entail. In spite of his boredom with Eragny, he did not feel equal to the difficulty and disturbance of selling the house. He had established a regular pattern of work, spending the winter months in Paris, the summer on the coast, and he was content with this way of life, preferring not to have his routine changed. He wrote testily to Lucien when he proposed coming to Eragny at the end of July, for he liked to begin his summer series early in July, to take advantage of the weather, and, as he said to Lucien, it was not at Eragny that he found his motif.

He went to Le Havre in the summer of 1903, and stayed at the Hôtel Continental. Julie accompanied him, and they went to Honfleur by boat. He told Lucien that Honfleur was a very pretty small village which had been spoiled by the many villas which surrounded it. He particularly liked the harbour. He and Julie stayed overnight at the Hôtel St Siméon in Honfleur, which had been the traditional haunt of artists since the 1830s - Boudin, Corot, Daubigny, Jongkind, Monet and others had stayed there, - but he was disappointed to find that it had a new owner who had been determined to modernize it, and it retained little of its former charm.

Pissarro and Julie were driven around Le Havre and its surroundings in the car of a collector of his work, M. van de Velde. They went as far as Ste-Adresse, but Pissarro saw little which attracted him. He thought that even the field at Eragny, so often painted, was preferable to what he saw in Le Havre, but he felt compelled to remain there and to undertake a series which would appeal to the collectors of his pictures, for his finances were shaky again. Once he started work on the series,

he found more enjoyment in it, and he completed 17 paintings of the harbour. He sold four immediately, two to the local Museum of Fine Arts, and two to collectors in the town.

Lucien arrived at Eragny at the end of July, accompanied by Esther and Orovida, and by Diana McGregor. Diana McGregor was, at first, taken aback by Julie's brusque manner, but she quickly recognized the kindness which this hid. She and Lucien went to Le Havre to visit Pissarro. Lucien grumbled that the weather was dreadful, but he painted a little himself, and he told Esther: 'The series that father is painting in spite of the bad weather, is marvellous, but as he works from his window the weather does not matter. There is one picture of people with umbrellas watching the boats returning to harbour, it is wonderful.'

Wynford Dewhurst, author of *Impressionist Painting*, saw the two canvases which the Le Havre Museum had purchased only a few weeks after their completion, and he agreed with Lucien's judgement of them:

'The canvases are charged with life, and are painted with a most unsuspected brilliance of colour and freshness of tone pitched in the highest possible key, an effect to be found only in the pure sea-washed atmosphere of the morning. In this work of his seventy-third year, the veteran artist had never arrived at stronger, happier, and more distinguished results.'

When Lucien and Diana McGregor returned to Eragny, he showed her his father's work. Pissarro enquired whether he had shown Diana enough to enable her to judge the work as a whole. Lucien assured him that he had. She was most impressed, and was fired with enthusiasm to begin painting again herself as a result of seeing Pissarro's work. Lucien commented that when one looked at the entire body of his work together, from the earliest studies, to the work done at Pontoise, the divisionist paintings, and the recent studies, there was a sense of unity, a sense that, in spite of the differences of approach, there had always been an underlying concern for the harmony of values, and that this constituted the major characteristic of his art.

Pissarro left Dieppe at the end of September. Julie told Lucien that he had been ill soon after returning, but that it was nothing serious. They had rented a flat on the Boulevard Morland, in the 4th *arrondissement* in Paris, and Pissarro hoped to begin a new series there. Lucien wrote anxiously to Julie, urging her to be careful that Pissarro did not catch cold when they moved.

On the day they arrived in Paris Pissarro suddenly collapsed as he stood in the doorway of the building watching the bags being carried

upstairs. Rodo wrote to Lucien on 22 October that their father was very ill. 'The greatest surgeon in the world has been consulted', he told Lucien, 'but he did not say what the trouble is. He only wrote a complicated prescription.'

Pissarro was suffering from an abscess of the prostate gland. Since he was still a firm believer in homeopathic medicine, the doctor attempted to cure the condition without operating. His state deteriorated steadily, until he was unconscious for most of the time. Julie remained devotedly by his bedside. Rodo told Lucien to come quickly if he wanted Pissarro to recognize him, and Lucien arrived in Paris the day after receiving Rodo's letter. He found his father in great pain. The whole family, with the exception of Georges, were gathered around him. Georges was unable to be there, for his wife was pregnant, and her second child, a girl who was called Blanche Marthe, was born on 31 October.

The surgeon, Dr Cartier, wished to operate as soon as possible to prevent the infection from spreading, but the homeopath, Dr Léon Simon, objected to the operation, and as a result, blood poisoning set in. Dr Cartier refused to return except in consultation with Dr Simon, since his instructions were otherwise ignored. Dr Simon, in spite of Pissarro's terrible pain, 'never even raised the blanket to see the condition of the patient', as Lucien told Esther. He advised Esther not to come to Paris, since the small flat was already so crowded that he was sleeping in the dining room.

Camille Pissarro died on 13 November 1903, at the age of 73. His funeral at the Père Lachaise cemetery was a modest one, attended by his family and close friends, and it was, as he would have wished, without any pomp and ceremony.

Monet was a source of comfort to the family, assisting them to sort through Pissarro's work and to value it. Durand-Ruel organized a full-scale retrospective exhibition of his work in the following year, showing 130 pictures covering the range of his artistic career.

His old friend Theodore Duret wrote:

'Pissarro was good natured in character and calm in temperament. Life built up a great fund of philosophy in him. He endured the years of misery and disappointment with serenity, and when success came and he was able to have the good things in life, he changed none of his ways, and never sought the honours, decorations, and recompense which, in the eyes of most artists, appear to be the most precious things to receive.'

He maintained to the end of his life his unshakable belief that *'Il n'y a que la peinture qui compte'* ('Only painting counts').

Notes

The major published sources for a life of Pissarro are:

L-R Pissarro and Lionello Venturi, *Camille Pissarro, son art, son oeuvre* (2 vols.) (1939)

Camille Pissarro, *Letters to his son Lucien* ed. John Rewald with the assistance of Lucien Pissarro (1943), and the more comprehensive French version, which includes some of Lucien's replies, *Lettres à son fils Lucien* (1950)

A. Tabarant, *Pissarro* (1925)

Georges Lecomte, *Camille Pissarro* (1922)

John Rewald, *Camille Pissarro* (1963)

Pissarro's correspondence is a valuable source of information. Major published sources are:

A. Tabarant, *Pissarro* (1925) (letters to Duret and Murer)

Lettres impressionnistes au Dr Gachet et à Murer ed. Paul Gachet (1957)

Jules Joëts, 'Lettres inédites de Pissarro à Claude Monet', *L'Amour de l'Art* 111 1946

Gustave Geffroy, *Claude Monet, sa vie, son oeuvre* (1922)

Charles Kunstler, Lettres inédites de Camille Pissarro', *La Revue de l'Art Ancien et Moderne*, 1930 (letters to Mirbeau)

Georges Lecomte, *Camille Pissarro* (1922) (letters to Mirbeau)

Lionello Venturi, *Les Archives de l'Impressionnisme* (2 vols.) (1939)

John Rewald, *Georges Seurat* (1948) (lettres to Fénéon, Verhaeren, Signac)

Robert L. and Eugenia W. Herbert, 'Artists and Anarchists: Unpublished letters of Pissarro, Signac and others', *The Burlington Magazine*, Nov and Dec. 1960.

John Rewald, *The History of Impressionism* (new edn.) (1973); and *Post-Impressionism from Van Gogh to Gauguin* (2nd edn.) (1962) are invaluable aids to a study of Pissarro and his colleagues, and contain detailed bibliographies.

The Pissarro Gift to the Ashmolean Museum, Oxford, is an invaluable collection of several hundred family letters, including Pissarro's letters to Lucien; letters to Julie; Lucien's letters to Julie and to other members of his family; and Lucien's correspondence with Esther Bensusan.

191

The Cabinet des Dessins, Musée du Louvre, Paris, contains Pissarro's correspondence with Théodore Duret.

The Bibliothèque Doucet, Institut d'Art et d'Archaeologie, Paris, contains Pissarro's correspondence with Eugène Murer, and several letters from Pissarro to Georges.

Where quotations are not specifically acknowledged in the chapter notes which follow, they are from Pissarro's letters to Lucien. The sources for letters to Duret and to Mirbeau cited in the text are indicated above, and are not repeated in the chapter notes. References sufficiently clear from the text are not repeated in the notes.

CHAPTER 1. pp9-18

For information about St Thomas in the nineteenth century, I have referred mainly to:
Waldemar Westergaard, *The Danish West Indies under Company Rule* (1917); John P. Knox, *A Historical Account of St Thomas, W.I.* (1852); Chas. Edwin Taylor, *Leaflets from the Danish West Indies* (1888); J. Crocker, *Bermuda, the Bahamas, Hispaniola, Puerto Rico and the Virgin Islands* (1968); Mary Slater, *The Caribbean Islands* (1968); George Hunte, *The West Indian Islands* (1972).
Useful sources for details about Pissarro's family and early life on the islands have been:
Isidor Paiewonsky, *Jewish Historical Development in the Virgin Islands 1665-1959* (1959); John Rewald, 'Camille Pissarro in the West Indies', *Gazette des Beaux-Arts*, October 1942; Jules Joëts, 'Camille Pissarro et la période inconnue de St Thomas et de Caracas', *L'Amour de l'Art* 2, 1947.
In addition, I am indebted to Miss Enid M. Baa, Director of Libraries and Museums, St Thomas; Mr. Jul. Margolinsky, Librarian, The Jewish Community, Copenhagen; and especially to Mrs Eva Ganneskov, Copenhagen, for supplementary information.
Information about Savary's school and about Pissarro's voyage to France mainly from A. Tabarant, *Pissarro* (1925) and from Charles Kunstler, *Camille Pissarro* (1972), with further details from W.R. Sickert, 'Camille Pissarro' in Osbert Sitwell (ed.), *A Free House!* (1947).
The major source for Pissarro's stay in Venezuela is Alfredo Boulton, *Camille Pissarro en Venezuela* (1966), and correspondence with Senor Boulton; supplemented by M.N. Benisovich and J. Dallett, 'Camille Pissarro and Fritz Melbye in Venezuela', *Apollo*, July 1966; and John Rewald, *Camille Pissarro in Venezuela*, Hammer Galleries, New York (1964).

Additional details from Edwin Lieuwen, *Venezuela* (1961)

The date of Melbye's arrival on St Thomas is usually stated as being 1850, but research of the archives of the island shows that he landed at Charlotte Amalie on 11 May 1852.

'The business of the islands was business', Winthrop D. Jordan, quoted in Eugene D. Genovese, *The World the Slaveholders Made* (1969); 'the slave plantation penetrated every aspect of life' is also quoted from Genovese. W.L. Burn, *Emancipation and Apprenticeship in the British West Indies* (1937) quotes a traveller in the West Indies in 1819 who found the society 'like a rotten apple'. The description of Christopher Columbus from Alexandre Cioranescu (ed.), *Oeuvres de Christophe Colomb* (1961).

Pissarro's letter to Murer quoted in A. Tabarant, *Pissarro* (1925). Cézanne's comment, 'He had the good fortune to be born in the Antilles' from Joachim Gasquet, *Cézanne* (1921).

Pissarro retained the Spanish spelling of his name for some years, alternating it with the French form. In 1882 he wrote to his step-brother, Rachel's eldest son by her first marriage, '. . . my birth certificate is wrongly made out, at least my name Camille is not mentioned, and the name Pissarro is written with a 'z'. It should be corrected if possible, and a new legal document made, that Camille Pissarro is the same person as Jacob Pissarro . . .' Letter published in Haavard Rostrup, 'Et brev fra Camille Pissarro', *Tilskueren*, July 1938.

CHAPTER 2. pp19-29

On Corot: Pierre Courthion (ed.), *Corot raconté par lui-même et par ses amis* (1946).

Corot's advice to Pissarro ('You are an artist . . .' and 'We do not see in the same way . . .') from Arsène Alexandre, *'Le Semaine Artistique au Salon d'Automne: Pour mieux honorer Camille Pissarro'* (1911); Press cutting, Fonds Louis Vauxcelles, Bibliothéque Doucet, Paris.

Corot's advice of 1857 quoted in R. Friedenthal (ed.) *Letters of the Great Artists*, Volume 2.

Monet's exasperation with Corot quoted in René Gimpel, *Diary of an Art Dealer* (1966).

On Thomas Couture, and on the *ateliers* of Picot, Dagnan and Lehmann: Albert Boime, *The Academy and French Painting in the Nineteenth Century* (1971).

The scanty information on Ludovic Piette available in dictionaries of painters supplemented by correspondence with M.P. du Pontavice, Maire de Melleray, and with M.H. Boullier de Branche, Conservateur d'archives de Mayenne.

On Chintreuil and his part in the Water-Drinkers: Robert Baldick, *The First Bohemian: The Life of Henry Murger* (1961).

Malcolm Easton, *Artists and Writers in Paris. The Bohemian Idea, 1803-1867* (1964).

Pissarro's advice to a young painter quoted in John Rewald, *History of Impressionism*.

Monet's comments on his meeting with Pissarro from an interview with Thiebault-Sisson published in *Le Temps* (1900) and translated in *Art News Annual* (1957).

Description of the *Académie Suisse* from Maria and Godfrey Blunden, *Impressionists and Impressionism* (1971).

There is some doubt about the expedition to Champigny-sur-Marne, but I have assumed that this and similar excursions to villages within easy reach of Paris which are postulated, but not confirmed by documentary evidence, probably took place. A similar situation occurs in Chapter 6, where a visit by Cézanne to Pontoise is likely, but not substantiated by documentation.

The 150 francs required by Chintreuil was the equivalent of £6, that is, 25 francs = £1 pound at this time.

CHAPTER 3. pp30-42

Cézanne's comments to Huot, Zola's letter to Baille, and Cézanne's verse in the ledger of his father's bank quoted from John Rewald, *Paul Cézanne* (1950).

On Guillaumin: Raymond Schmit, 'Armand Guillaumin dans son temps' in G. Serret and D. Fabiani, *Armand Guillaumin* (1971); Christopher Gray, *Armand Guillaumin* (1972); Pierre Cailler, 'Armand Guillaumin', *Art Documents* No. 206, 1964; Marc-Edo Tralbaut, *Armand Guillaumin en Famille et au motif* (1971); Charles Louis Borgmeyer, 'Armand Guillaumin', *Fine Arts Journal*, Feb. 1914.

The announcement of the *Salon des Refusés* quoted from John Rewald, *The History of Impressionism*, as is Zacharie Astruc's comment. Zola's fictional account of the *Salon des Refusés* quoted from F.W.J. Hemmings, *Culture and Society in France 1848-1898* (1971). Castagnary's advice to Pissarro in *Impressionnistes et Symbolistes devant la presse*, ed. Jacques Lethève (1959).

Renoir's remark about 'Fragonard's enticing bourgeois women', and his comment on simple subject matter, from Jean Renoir, *Renoir, my father* (1962).

Thoré-Bürger's criticism of Manet's 1964 *salon* submission quoted in G.H. Hamilton, *Manet and his critics* (1969).

Zola's review in *L'Evénement* quoted in John Rewald, *The History of Impressionism*, Cézanne's alleged remarks about Pissarro's pictures from Joachim Gasquet, *Cézanne* (1921).

Manet's reasons for exhibiting independently from John Rewald, *The History of Impressionism*, as is Castagnary's complaint about the 1868 *salon*; Redon's review; Renoir's letter to Bazille; and Pissarro's comments on his work of the 1860s.

Monet's exhibition proposal and Bazille's letter quoted from Lawrence Hanson, *Renoir, The Man, The Painter and His World* (1972).

Guillemet's letter to Pissarro from John Rewald, *Camille Pissarro* (1963), and the description of Guillemet from Henri Perruchot, *La Vie de Cézanne* (1956).

Zola's praise of the 1868 *salon* from *Impressionnistes et symbolistes devant la presse*.

Details about the cost of paints, canvas and studios, from Jacques Lethève, *Daily Life of the French Artists in the Nineteenth Century* (1972).

CHAPTER 4 pp.43-49

All Ludovic Piette's correspondence with Pissarro is quoted from John Rewald, *Camille Pissarro* (1963).

Julie's aversion to English from W.S. Meadmore, *Lucien Pissarro* (1962).

Bonvin's letter quoted in Etienne Moreau-Nelaton, *Bonvin raconté par lui-même* (1927). A.S. Hartrick recalled that Legros could not speak English fluently in *A Painter's Pilgrimage through fifty years* (1939).

Durand-Ruel's letter to Pissarro quoted in Lionello Venturi, *Les Archives de l'Impressionnisme* Vol. 11 (1939). Venturi gave the address of Durand-Ruel's gallery as 159 New Bond Street, but this was corrected in Alan Bowness's introduction to *The Impressionists in London* (1973).

Monet recalled his meeting with Durand-Ruel in an interview with Thiebault-Sisson in *Le Temps* in 1900, which was translated in *The Art News Annual* (1957). He repeated the story in conversation with Vuillard and Roussel in 1926, quoted in Jacques Salomon, 'Chez Monet avec Vuillard et Roussel', *L'Oeil* 197, May 1971.

Pissarro's letter to Dewhurst published in Wynford Dewhurst, *Impressionist Painting* (1904). His interest in Turner's snow and ice effects from Paul Signac, *D'Eugène Delacroix au néo-impressionnisme* (1899). Elisée Reclus discussed the hanging of Turner's works in his *Guide du voyageur à Londres et aux environs* (1860).

The relationship between the work of Turner and that of Pissarro and Monet has frequently been discussed, *inter alia* by Alan Bowness in *The Impressionists in London* (1973), and by John Gage, *Colour in Turner* (1970).

The letters to Pissarro from Béliard and Mme Ollivon about the destruction of his Louveciennes home are quoted from John Rewald, *Camille Pissarro* (1963).

CHAPTER 5. pp50-61

Details of the conditions of acceptance at the 1872 *salon* from Carl R. Baldwin, 'The Salon of '72', *Art News* 71, 3 May 1972.

Lucien's letter to Paul Gachet *fils* in *Lettres impressionnistes au Dr Gachet et à Murer* ed. Paul Gachet (1957).

Guillemet's letter quoted from John Rewald, *Camille Pissarro* (1963).

Eugène Murer and Guillaumin were at school together in Moulins, and according to Christopher Gray, *Armand Guillaumin* (1972), Guillaumin introduced Pissarro to Murer in 1870.

Information on *père* Tanguy compiled from the following: Emile Bernard, 'Julian Tanguy', *Mercure de France,* 16 Dec. 1908; Alain Le Goaziou, *Le 'Père Tanguy' Compagnon de lutte des Grands Peintres au début du Siècle* (1951); Gerstle Mack, *Paul Cézanne* (1935); G. Rivière, *Le Maître Paul Cézanne* (1923); Ambroise Vollard, *Cézanne* (1919); Cecilia Waern, 'Some notes on French Impressionists' *Atlantic Monthly*, April 1892.

Pissarro's relationship with Cézanne has frequently been discussed, notably by John Rewald in *Cézanne et Zola* (1936) and in *Paul Cézanne* (1950); by Kurt Badt in *The Art of Cézanne* (1965); by Gustave Coquiot, *Paul Cézanne* (1919); by Theodore Reff, 'Cézanne's Constructive Stroke', *Art Quarterly*, Autumn 1962; and by Lucien Pissarro in his recollections to Paul Gachet in *Lettres impressionnistes*. I have discussed the relationship between the two men in 'Aspects of Camille Pissarro c. 1871-1883', unpublished M.A. thesis, University of London (1969).

The quotation 'Pissarro was sensitive to every intention . . .' is from Georges Lecomte, 'Un fondateur de l'impressionnisme Camille Pissarro', *La Revue de l'Art Ancien et Moderne*, LVII 1930.

Cézanne's views on theory in a letter to Charles Camoin in *Paul Cézanne Correspondance* ed. John Rewald (1937). His letter to his mother from the same source.

Details of the Hoschede sale and the other auctions of Impressionist paintings in the 1870s from Merete Bodelsen, 'Early Impressionist Sales 1874 - 94 in the light of some unpublished *procès-verbaux'*, *The Burlington Magazine*, June 1968.

Renoir's explanation for the anonymity of the First Impressionist Exhibition's title from Ambroise Vollard, *Renoir: An Intimate Record* (1925); and his objections to Pissarro's 'egalitarian theories' from Georges Rivière, *Renoir et ses amis* (1921).

Degas's letter to Tissot from *Lettres de Degas* ed. Marcel Guéin (1931).

CHAPTER 6. pp42-70

All Cézanne's letters from *Paul Cézanne Correspondance* ed. John Rewald (1937).

Guillaumin's letter to Pissarro quoted from John Rewald *Camille Pissarro* (1963).

The following comments and reviews are quoted from Jacques Lethève, *Impressionnistes et symbolistes devant la presse* (1959):

Gygès' comments on the 1875 auction; Albert Wolff's hostility to Pissarro's pictures at the 1876 exhibition; Armand Silvestre's review of the 1876 exhibition; 'Baron Grimm's' review of the 1877 exhibition; Georges Rivière's praise of the 1877 exhibition in *l'Impressionniste*.

Lucien Pissarro recalled to Paul Emile Pissarro that his father and Cézanne had used palette knives at one stage of their association, quoted in W.S. Meadmore, *Lucien Pissarro* (1962). Cézanne's visit to Pontoise in 1875 postulated by Theodore Reff, 'Cézanne's Constructive Stroke', *Art Quarterly*, Autumn 1962, and discussed in my M.A. thesis (unpublished) on Pissarro.

Details of the constitution of the *Union* group from the archives of the Durand-Ruel Gallery, Paris.

Renoir's objections to Pissarro's politics quoted in Lionello Venturi, *Les Archives de l'Impressionnisme*, Vol 1 (1939). The quotation from Kropotkin's *Modern Science and Anarchism* in James Joll, *The Anarchists* (1964).

Pissarro's meeting with Personnaz from Christopher Gray, *Armand Guillaumin* (1972).

Guillaumin's letter to Gachet, and Duret's comments on the 1877 exhibition quoted from John Rewald, The *History of Impressionism*.

CHAPTER 7. pp.71-78

Degas's letter to Faure from *Lettres de Degas* ed. Marcel Guérin (1931)

Renoir's and Monet's letters to Charpentier quoted from *Letters of the Great Artists* Vol.11 ed. R. Friedenthal (1963).

Renoir's annoyance at a buyer's reaction to Pissarro from A. Tabarant, *Pissarro* (1925).

Piette had a house at 31 rue Veron, Montmartre, in addition to the Normandy farm. Pissarro's advice to his friends to 'buy Piette' quoted by A. Tabarant in the preface to an exhibition, 'Peintures et gouaches de L. Piette', *Galerie Dru*, Paris (1929).

Guillaumin's acknowledgement of the similarity of the ideas of himself, Pissarro and Cézanne at a certain time from Charles Louis Borgmeyer, 'Armand Guillaumin' *Fine Arts Journal*, Feb. 1914.

Gauguin's defence of Pissarro from Paul Gauguin, *Racontars de rapin* (1951).

W. Jaworska, in *Gauguin and the Pont-Aven School* (1972), says that it was Schuffenecker who introduced Gauguin to Pissarro.

Renoir's letter to Durant-Ruel explaining his reasons for returning to the *salon* quoted from John Rewald, *The History of Impressionism*.

On Martelli and the Macchiaoli, see N.F. Broude, *Art Bulletin* 52: Dec. 1970.

Lucien's employer's comment from W.S. Meadmore, *Lucien Pissarro* (1962).

CHAPTER 8. pp79-85

Caillebotte's comments to Monet on Degas from Denys Sutton, 'Gustave Caillebotte', Wildenstein, London (1966).

Huysman's comments quoted from Jacques Lethève, *Impressionnistes et symbolistes devant la presse* (1959).

On Pissarro's graphic work and *La Jour et le nuit:* Loys Delteil, *Pissarro, Sisley, Renoir* Vol XV11 of *Peintre-Graveur Illustré* (1923); Théodore Duret, 'Les eaux-fortes et les lithographies de Camille Pissarro', *Catalogue du Salon d'Automne*, Paris (1911); L-R Pissarro 'The Etched and Lithographed Work of Camille Pissarro', *Print Collectors' Quarterly*, October 1922; Jean Leymarie and Michel Melot, *The Graphic Works of the Impressionists* (1972);Barbara S. Shapiro, *Camille Pissarro the Impressionist Printmaker* (1973).

Sickert recalled the propensity of Pissarro and Degas for ignoring Bracquemond's advice in *A Free House!* ed. Osbert Sitwell (1947).

Mary Cassatt's comment on Pissarro's ability as a teacher from A. Segard, *Mary Cassatt* (1913).

Caillebotte's letter to Pissarro quoted in John Rewald, *The History of Impressionism.*

On Raffaëlli: Georges Lecomte, *Raffaëlli* (1927).

CHAPTER 9. pp86-98

Albert Wolff's scorn of the Independents quoted in John Rewald, *History of Impressionism.* His comments on Degas quoted in Jean Bouret, *Degas* (1965).

Gauguin's mockery of Cézanne's search for the means to express his 'sensations' quoted from John Rewald, *Paul Cézanne* (1950).

On Gauguin's collection of Cézanne's work, see Merete Bodelsen, 'Gauguin's Cézannes', *The Burlington Magazine*, May 1962.

On Cézanne's copy of Pissarro's gouache, see Theodore Reff, 'Cézanne's drawings 1875-1885', *The Burlington Magazine*, May 1959.

Gauguin's letter to Pissarro quoted from John Rewald, *The History of Impressionism.*

Pissarro's letter to Monet appear in Jules Joëts, 'Lettres inédites de Pissarro à Claude Monet', *L'Amour de l'Art.* II 1946.

Renoir told Vollard that the break in his work appeared about 1883. From Ambroise Vollard, *Renoir: An Intimate Record* (1925).

Eugène Manet's comments to Berthe Morisot from *Correspondance de Berthe Morisot* ed. D. Rouart (1950).

Information about Lucien's stay in London from W. S. Meadmore, *Lucien Pissarro* (1962), and John Rewald, 'Lucien Pissarro: Letters from London 1883 - 1891', *The Burlington Magazine*, July 1949.

Murer had a collection of Impressionist paintings in the breakfast room and the dining room of his hotel in Rouen. Alfred Isaacson, Pissarro's nephew, reported seeing '9 Pissarros, 1 Sezanne *(sic)*, 2

Sisleys, 1 Gaugain *(sic)* and 1 Guillaumin' at the hotel in September 1884. (Unpublished letter in the Ashmolean Museum, Oxford).

CHAPTER 10. pp99-112

The description of the garden at Eragny is from Charles Kunstler, *Paul Emile Pissarro* (1928), and from a letter from Julie to Mlle Marie Meunier, published in *Lettres impressionnistes au Dr Gachet et à Murer* ed. Paul Gachet (1957).

Signac recalled his meeting with Pissarro and Pissarro's interest in the approach he and Seurat were formulating in his 'Le néo-impressionnism - Documents', *Gazette des Beaux-Arts,* Jan 1934.

Jules Christophe's description of Seurat quoted from John Russell, *Seurat* (1965).

Georges Lecomte discussed Pissarro's bewilderment at Charles Henry's theories in *Camille Pissarro* (1922). Gustave Kahn's and Félix Fénéon's view of Seurat's art from Robert Herbert, *Seurat's Drawings* (1962). Signac's letter to Pissarro about his courage in embracing Neo-Impressionism from John Rewald, *Post-Impressionism*.

Robert Herbert in *Neo-Impressionism* (1968), noted that Pissarro's canvas was the first in the new manner to be exhibited.

Tabarant recorded the reaction of Pissarro's colleagues at his attempts to convert them to divisionism in *Pissarro* (1925).

Renoir's dislike of all theories from Vollard *En écoutant Cézanne; Degas; Renoir* (1938).

Pissarro's attempts to organize the 1886 exhibition discussed in Sven Lövgren. *The Genesis of Modernism* (1959).

George Moore's comments from *Modern Painting* (1898).

Details of Durand-Ruel's American venture from Hans Huth, 'Impressionism comes to America', *Gazette des Baux-Arts,* April 1946, and Wesley Towner, *The Elegant Auctioneers* (1971).

Pissarro's reaction to Rousseau recorded by Gustave Kahn in *Mercure de France,* 1 Aug. 1923, quoted in Henry Certigny, *La Vérité sur le Douanier Rousseau* (1962).

Details about Pissarro's participation in the 1887 and subsequent exhibitions of *Les XX* from Octave M. Maus, *Trente Années de Lutte pour l'Art: Les XX, 1884 - 1893. La Libre Esthétique, 1894 - 1914* (1926).

Signac's report to Pissarro on his submission to the 1887 *Les XX* exhibition quoted from John Rewald, *Post- Impressionism.*

CHAPTER 11. pp113-122

Julie's letter to Lucien translated in John Rewald, *Camille Pissarro* (1963).

Renoir's desire to satisfy bourgeois taste, and to obscure any details of his private life which would detract from his reputation in *haut bourgeois* society discussed in Barbara Ehrlich White, 'The Bathers of 1887 and Renoir's Anti-Impressionism', *Art Bulletin* LV, Mar, 1973.

Theo van Gogh's description of Pissarro from a letter to Vincent of 5 September 1889 in *The Complete Letters of Vincent Van Gogh* (1958).

Description of Octave Mirbeau from Barbara Tuchman, *The Proud Tower* (1966), and Françoise Cachin, 'Un défenseur oublié de l'art moderne', *L'Oeil* 90, June 1962.

On Dubois-Pillet and his visit to Rouen, Jean Sutter, *Les Néo-impressionnistes* (1970).

Information about Maximilian Luce from A. Tabarant, *Maximilian Luce* (1928); Tristan Klingsor, 'Maximiliam Luce', *L'Art et les artistes*, Apr. 1921; Paul Moreau-Vauthier, 'Maximilian Luce', *L'Art et les artistes*, Nov. 1930.

Jean Sutter discusses the group at Lagny-sur-Marne in *Les Néo-Impressionistes* (1970), and information about Hayet and Gausson is also from this source.

A.S. Hatrick's description of Vincent Van Gogh is from *A Painter's Pilgimage through fifty years* (1939).

On the discussions between Pissarro, Lucien, Guillaumin, Theo and Vincent Van Gogh, see John Rewald, 'Theo Van Gogh, Goupil and the Impressionists', *Gazette des Beaux-Arts*, Jan. 1973.

The description of Theo Van Gogh is from Gustave Kahn, 'Au temps du pointillisme', *Mercure de France*, May 1924, translated in John Rewald, *Post-Impressionism*.

The gathering at the *Revue Indépendante* described by Paul Alexis quoted in John Rewald, 'Félix Fénéon', *Gazette des Beaux-Arts*, 32 1947.

CHAPTER 12. pp123-127

Pissarro's letter to Signac about Seurat's affiliation to the *École des Beaux-Arts* from John Rewald, *Georges Seurat* (1948).

Information on Reclus: Hemday (psuedonym of Reclus), *Elisée Reclus en Belgique. Sa vie, son activité 1874-1905* (1905); Barbara Tuchman, *The Proud Tower* (1966). On Kropotkin: Barbara Tuchman, *The Proud Tower* (1966); James Joll, *The Anarchists* (1964); Eugenia W. Herbert, *The Artist and Social Reform. France and Belgium 1885-1898* (1961); Donald Egbert Drew, *Social Radicalism and the Arts* (1970).

On Grave: Charles Malatato, 'Some Anarchist Portraits', *Fortnightly Review*, Sept. 1894; James Joll, *The Anarchists* (1964).

On Pouget: George Woodcock, *Anarchism* (1962).

Pissarro's attitude to labour discussed in Robert L. Herbert, 'City vs. Country: The Rural Image in French Painting from Millet to Gauguin', *Art Forum*, Feb. 1970.

Information on the *Club de l'art social* from Eugenia W. Herbert, *The Artist and Social Reform* (1961); Donald Drew Egbert, *Social Radicalism and the Arts* (1970); Benedict Nicolson, 'The Anarchism of Camille Pissarro', *The Arts* 2, 1947; A. Tabarant, *Maximilian Luce* (1928).

Turpitudes Sociales published in a fascimile edition in 1972.

Correspondence between Pissarro and Grave, Pouget and others on matters relating to anarchism: Robert L. and Eugenia W. Herbert, 'Artists and Anarchism: Unpublished letters of Pissarro, Signac and Others', *The Burlington Magazine*, Nov. and Dec. 1960.

CHAPTER 13. pp128-138

Vincent Van Gogh's comments on the *Antibes* Monets; Theo Van Gogh's letter to Pissarro about the 1890 exhibition, and his letter in reply to Pissarro's thanks quoted from John Rewald, 'Theo Van Gogh, Goupil and the Impressionists', *Gazette des Beaux-Arts*, Jan. 1973.

Pissarro's explanation to van der Velde from John Rewald, *Georges Seurat* (1948).

Details about Pissarro's eye complaint, and the assumption derived from the half-spectacles he wore that he suffered from the presbyopia normal to old age, and was not myopic, supplied by Dr J.E. Wolff, Johannesburg.

Details of Esther's visit to Eragny from her diary in the Ashmolean Museum, Oxford. Pissarro's reply to her letter of thanks in W.S. Meadmore, *Lucien Pissarro*. Information about *Le Guignol* from Charles Kunstler, *Pissarro: Villes et Campagnes* (1967).

On the Whitechapel Guild and School of Handicrafts: Niklaus Pevsner, *Academies of Art Past and Present* (1940).

Jacob Bensusan's letters to Lucien and to Esther in the Ashmolean Museum, Oxford.

Octave Maus discussed van der Velde's lecture *Le paysan en peinture* in his *Trente années de lutte pour l'art* (1926).

Lucien's letter to his mother about Pissarro's success translated in W.S. Meadmore, *Lucien Pissarro* (1962).

Monet's comments in an interview with Marcel Pays, *Excelsior*, 26 Jan. 1921, quoted in John House, 'Aspects of the Work of Claude Monet c. 1877-1887', Unpublished M.A. thesis, University of London (1969).

CHAPTER 14. pp139-144

Details about the relationship between Lucien and Esther Bensusan, and the objections of Jacob Bensusan and Julie Pissarro from letters in the Ashmolean Museum, Oxford, and from W.S. Meadmore, *Lucien Pissarro* (1962).

Esther Isaacson's comments on Pissarro and her letter to Esther Pissarro, whom she called 'Sterbee', from letters in the Ashmolean Museum, Oxford.

Pissarro's letters to Octave Mirbeau from Charles Kunstler, 'Des lettres inédites de Camille Pissarro, 11', *Revue de l'Art Ancien et Moderne*, Jan. 1930.

Pissarro gave Monet a painting in thanks for his assistance with the purchase of the house. It was *Woman with Sticks*, which was exhibited earlier in the year at Durand-Ruel's.

CHAPTER 15. pp145-156

W.S. Meadmore quotes Georges's letter to Lucien about Julie's rudeness to Esther in *Lucien Pissarro* (1962), and he gives details of the accommodation Lucien and Esther found in London.

Mr Tommy Pissarro, Colchester, provided the information that he was brought up in England by his aunts.

Details about the Neo-Impressionist Gallery from Jean Sutter, *Les Néo-Impressionnistes* (1970).

On Pissarro's Paris paintings of the 1890s, see Ralph T. Coe, 'Camille Pissarro in Paris. A Study of his Later Development', *Gazette des Beaux-Arts*, Feb. 1954.

Monet's comments to Geffroy from Gustave Geffroy, *Claude Monet, sa vie, son temps, son oeuvre* (1922).

Jean Renoir records Aline's remarking of Pissarro's 'gentlemanly behaviour' in *Renoir, my father* (1962).

Paul Signac's journal was published in *Gazette des Beaux-Arts*, July and September 1949, and April 1952.

Tanguy died in February 1894, and his widow found herself unable to continue the business. Caillebotte died on 24 February 1894. His will, stipulating that his collection of Impressionist paintings be hung in the Luxembourg Museum and transferred to the Louvre on the death of their respective authors, caused a tremendous furore.

René Gimpel discussed Groult's fake Turners in *The Diary of an Art Dealer* (1966).

Details of the anarchist attacks from various sources, including George Woodcock, *Anarchism* (1962), and Barbara Tuchman, *The Proud Tower* (1966).

The description of Fénéon's trial is from John Rewald, 'Félix Fénéon', *Gazette des Beaux-Arts* 32, 1947.

On Pissarro and Judaism: Eugenia W. Herbert, *The Artist and Social Reform* (1961); Simon Dubnov, *History of the Jews from the Congress of Vienna to the Emergence of Hitler* Vol. V (1973).

CHAPTER 16. pp157-162

Natanson's comments on Pissarro's personality from his *Peints à leur tour* (1948).

Notes

Lecomte's friendship with Pissarro, and their afternoon visits to the
galleries and bookshops discussed in his *Camille Pissarro* (1922).
George Moore recalled Pissarro's explanations to young painters in
Reminiscences of the Impressionist Painters (1906).
Pissarro's advice to a young artist from L-R Pissarro and Lionello
Venturi, *Camille Pissarro, son art, son oeuvre* (1939).
Pissarro's discussion with Matisse from G. Duthuit, *The Fauvist Painters*
(1950).
On Vollard: René Gimpel in *The Diary of an Art Dealer* (1966)
commented on his accent. Renoir's remarks quoted from Jean
Renoir, *Renoir, my father* (1962).
The exhibition of Cézanne's paintings is discussed in Ambroise
Vollard, *Paul Cézanne* (1919).
Cézanne's strange behaviour is discussed in John Rewald, *Paul Cézanne*
(1950).
Cézanne's praise of Pissarro from Emile Bernard's letters to his mother,
Art Documents 50 Nov. 1954; and Jules Borély, 'Cézanne à Aix' *L'Art
Vivant*, Jul. 1926.

CHAPTER 17. pp163-172

Depeaux purchased one of Pissarro's pictures on this visit to Rouen. It
was *Crue de la Seine à Rouen*, and it was sold at the Vente Collection
Depeaux, 31 May - 1 June 1906, Hôtel Drouot.
On the Rouen artists, see Pierre Kjellberg, 'Rouen: une capitale pour
les peintres', *Connaissance des Arts*, Apr. 1971.
Details about Lucien's illness from W.S. Meadmore, *Lucien Pissarro*
(1962).
Signac's comments on his visit to Pissarro from his journal, published
in the *Gazette des Beaux-Arts*, Apr. 1952.

CHAPTER 18. pp173-178

Information on the Dreyfus Affair in largely drawn from Guy
Chapman, *The Dreyfus Trials* (1972); and Barbara Tuchman, *The
Proud Tower* (1966).
Degas's venom about Jews from René Gimpel, *The Diary of an Art
Dealer* (1966).
Renoir's desire to avoid involvement in the Affair from Jean Renoir,
Renoir, my father (1962),
Signac's comments from his journal, published in the *Gazette des
Beaux-Arts*, Apr. 1952.
Zola's article on the Jews in *Le Figaro* in 1896 published in Simon

Dubnov, *History of the Jews from the Congress of Vienna to the Emergence of Hitler* Vol. V (1973).

Pissarro wrote to Zola to express his admiration on 14 January 1898, the day after the publication of *'J'Accuse'*, and on 26 February 1898. Both letters are in the Bibliothèque Nationale, Paris. Information by courtesy of B.H. Bakker, Director, Research Program on Zola and Naturalism, University of Toronto.

CHAPTER 19. pp179-190

The description of Pissarro at work is from Georges Lecomte, *Camille Pissarro* (1922).

Pissarro's letter to Grave from Robert L. and Eugenia W. Herbert, 'Artists and anarchism: Unpublished letters of Pissarro, Signac and Others', *The Burlington Magazine*, Nov. and Dec. 1960.

Details of the Rembrandt exhibition in Amsterdam kindly supplied by Mr F.J. Duparc, Assistant Curator, Koninklijk Kabinet van Schilderijen 'Mauritshuis', The Hague.

Pissarro's letter to Monet about the *Tuileries* series quoted in *Camille Pissarro. His Place in Art*, Wildenstein, New York (1945).

His letter to Monet about London from Gustave Geffroy, *Claude Monet* (1922).

Details of Georges's second wife, the date of their marriage, and the date of the birth of their daughter from the Register of Marriages and the Register of Births of the Parish of St Helier in the island of Jersey.

Gérôme's injunction to President Loubet from Jacques Lethève, *Impressionnistes et symbolistes devant la presse* (1959).

Sickert's acknowledgement of Pissarro's influence from *A Free House!* ed. Osbert Sitwell (1947).

Orovida's enquiry about Julie; Lucien's letter to Julie; Julie's letter about the South of France; and Rodo's letter to Lucien about their father's illness quoted from W.S. Meadmore, *Lucien Pissarro* (1962).

Dewhurt's comments on Pissarro's Le Havre pictures in his *Impressionist Painting* (1904).

Duret's review of the retrospective exhibition of Pissarro's work, and his comments on Pissarro's personality published in the *Gazette des Beaux-Arts*, May 1904.

Pissarro's creed, 'Only painting counts', quoted by Sickert in 'Camille Pissarro', *A Free House!* ed. Osbert Sitwell (1947).

Index

207